LIGHT IT
SHOOT IT
RETOUCH IT

Learn Step by Step How to Go from Empty Studio to Finished Image

SCOTT KELBY

Light It. Shoot It. Retouch It.
Book Team

CREATIVE DIRECTOR
Felix Nelson

TECHNICAL EDITORS
Cindy Snyder
Kim Doty

ASSOCIATE ART DIRECTOR
Jessica Maldonado

ASSOCIATE DESIGNER
Taffy Clifford

TRAFFIC DIRECTOR
Kim Gabriel

PRODUCTION MANAGER
Dave Damstra

PHOTOGRAPHY BY
Scott Kelby

PRODUCTION & PRODUCT PHOTOGRAPHY BY
Brad Moore

Published by New Riders

Copyright ©2012 by Scott Kelby

Composed in Gill Sans and Musee by Kelby Media Group, Inc.

Trademarks

Warning and Disclaimer

ISBN 13: 978-0-321-78661-6

ISBN 10: 0-321-78661-0

9 8 7 6 5 4 3 2 1

http://kelbytraining.com
www.newriders.com

To my dear friend Terry White:
Your wisdom, humor, insights, and advice
have helped me in more ways than I can
ever count, or ever hope to repay. Thanks T.

ACKNOWLEDGMENTS

After writing books for 13 years now, I still find that the thing that's the hardest for me to write in any book is the acknowledgments. It also, hands down, takes me longer than any other pages in the book. For me, I think the reason I take these acknowledgments so seriously is because it's when I get to put down on paper how truly grateful I am to be surrounded by such great friends, an incredible book team, and a family that truly makes my life a joy. That's why it's so hard. I also know why it takes so long—you type a lot slower with tears in your eyes.

To my remarkable wife, Kalebra: We've been married nearly 22 years now, and you still continue to amaze me, and everyone around you. I've never met anyone more compassionate, more loving, more hilarious, and more genuinely beautiful, and I'm so blessed to be going through life with you, to have you as the mother of my children, my business partner, my private pilot, Chinese translator, and best friend. You truly are the type of woman love songs are written for, and as anyone who knows me will tell you, I am, without a doubt, the luckiest man alive to have you for my wife.

To my son, Jordan: It's every dad's dream to have a relationship with his son like I have with you, and I'm so proud of the bright, caring, creative young man you've become. I can't wait to see the amazing things life has in store for you, and I just want you to know that watching you grow into the person you are is one of my life's greatest joys.

To my precious little girl, Kira: You have been blessed in a very special way, because you are a little clone of your mom, which is the most wonderful thing I could have possibly wished for you. I see all her gifts reflected in your eyes, and though you're still too young to have any idea how blessed you are to have Kalebra as your mom, one day—just like Jordan—you will.

To my big brother Jeff, who has always been, and will always be, a hero to me. So much of who I am, and where I am, is because of your influence, guidance, caring, and love as I was growing up. Thank you for teaching me to always take the high road, for always knowing the right thing to say at the right time, and for having so much of our dad in you.

I'm incredibly fortunate to have part of the production of my books handled in-house by my own book team at Kelby Media Group, which is led by my friend and longtime Creative Director, Felix Nelson, who is hands down the most creative person I've ever met. He's surrounded by some of the most talented, amazing, ambitious, gifted, and downright brilliant people I've ever had the honor of working with.

Thank God for Kim Doty, my Editor. She is amazing, and single-handedly keeps me from jumping off the Sunshine Skyway Bridge (although it's still somewhat tempting when it's getting close to deadline). Kim is just an incredibly organized, upbeat, focused person who keeps me calm and on track, and no matter how tough the task ahead is, she always says the same thing, "Ah, piece of cake," and she convinces you that you can do it, and then you do it. I cannot begin to tell you how grateful I am to her for being my Editor.

Working with Kim is Cindy Snyder, who relentlessly tests all the stuff I write to make sure I didn't leave anything out, so you'll all be able to do the things I'm teaching (which with a Photoshop book is an absolute necessity). She's like a steel trap that nothing gets through if it doesn't work just like I said it would.

The look of the book comes from an amazing designer, a creative powerhouse, and someone whom I feel very, very lucky to have designing my books—Jessica Maldonado. She always adds that little something that just takes it up a notch, and I've built up such a trust for her ideas and intuition, which is why I just let her do her thing. Thanks Jess!

I owe a huge debt of gratitude to my Executive Assistant and Chief Wonder Woman, Kathy Siler. She runs a whole side of my business life, and a big chunk of our conferences, and she does it so I have time to write books, spend time with my family, and have a life outside of work. She's such an important part of what I do that I don't know how I did anything without her. Thank you, thank you, thank you. It means more than you know.

A special thanks to my photo assistant, Brad Moore, who not only assisted me during all these shoots, but also came up with the rig for taking the overhead shots in the studio and on location. I am so grateful to him, not just for what he did for this book, but for what he does all year long to help me get the shot. Thanks Braddo!

Thanks to my best buddy, our Chief Operating Officer and father of twin little girls, Dave Moser, first for handling the business end of our book projects, but mostly for always looking out for me.

Thanks to everyone at New Riders and Peachpit Press, in particular, my way cool Editor Ted Waitt, my wonderful Publisher Nancy Aldrich-Ruenzel, marketing maven Scott Cowlin, marketing diva Sara Jane Todd, and the entire team at Pearson Education who go out of their way to make sure that we're always working in the best interests of my readers, and who work tirelessly to make sure my work gets in as many people's hands as possible.

Thanks to my friends at Adobe: John Nack, Mala Sharma, John Loiacono, Cari Gushiken, Julieanne Kost, Tom Hogarty, Bryan O'Neil Hughes, Thomas Nielsen, and Russell Preston Brown. Gone but not forgotten: Barbara Rice, Jill Nakashima, Rye Livingston, Addy Roff, Bryan Lamkin, Jennifer Stern, Kevin Connor, Deb Whitman, and Karen Gauthier.

My thanks to Matt Kloskowski for letting me bounce ideas off of him for this book, and for his input and suggestions along the way.

I want to thank all the talented lighting wizards who I've learned so much from over the years: Joe McNally, Frank Doorhof, Jim DiVitale, Helene Glassman, Jack Reznicki, David Ziser, and Jim Schmelzer. Also, thanks to my mentors, whose wisdom and whip-cracking have helped me immeasurably, including John Graden, Jack Lee, Dave Gales, Judy Farmer, and Douglas Poole.

Most importantly, I want to thank God, and His son Jesus Christ, for leading me to the woman of my dreams, for blessing us with two amazing children, for allowing me to make a living doing something I truly love, for always being there when I need Him, for blessing me with a wonderful, fulfilling, and happy life, and such a warm, loving family to share it with.

OTHER BOOKS BY SCOTT KELBY

The Adobe Photoshop Lightroom Book for Digital Photographers

Professional Portrait Retouching Techniques for Photographers Using Photoshop

The Digital Photography Book, volumes 1, 2 & 3

The Adobe Photoshop Book for Digital Photographers

The Photoshop Channels Book

Photo Recipes Live: Behind the Scenes, parts 1 & 2

Scott Kelby's 7-Point System for Adobe Photoshop

Photoshop Down & Dirty Tricks

The iPhone Book

The Photoshop Elements Book for Digital Photographers

ABOUT THE AUTHOR

Scott Kelby

Scott is Editor, Publisher, and co-founder of *Photoshop User* magazine, host of the top-rated weekly videocast *Photoshop User TV*, and co-host of *The Grid* (the weekly videocast for photographers and Photoshop users).

He is President of the National Association of Photoshop Professionals (NAPP), the trade association for Adobe® Photoshop® users, and he's President of the training, education, and publishing firm, Kelby Media Group, Inc.

Scott is a photographer, designer, and an award-winning author of more than 50 books, including *The Adobe Photoshop Lightroom 3 Book for Digital Photographers, The Adobe Photoshop CS5 Book for Digital Photographers, Professional Portrait Retouching Techniques for Photographers Using Photoshop, Photoshop Down & Dirty Tricks, The Photoshop Channels Book, The iPhone Book,* and *The Digital Photography Book*, vols. 1, 2 & 3.

Scott's book, *The Digital Photography Book*, vol. 1, is the best-selling book ever on digital photography. In 2010, Scott became the #1 best-selling author across all photography book categories. From 2004–2009, he held the honor of being the world's #1 best-selling author of all computer and technology books, across all categories.

His books have been translated into dozens of different languages, including Chinese, Russian, Spanish, Korean, Polish, Taiwanese, French, German, Italian, Japanese, Dutch, Swedish, Turkish, and Portuguese, among others, and he is a recipient of the prestigious Benjamin Franklin Award.

Scott is Training Director for the Adobe Photoshop Seminar Tour and Conference Technical Chair for the Photoshop World Conference & Expo. He's featured in a series of Adobe Photoshop online courses at KelbyTraining.com, and has been training Adobe Photoshop users since 1993.

For more information on Scott, visit his daily blog, *Photoshop Insider*, at www.scottkelby.com.

CONTENTS

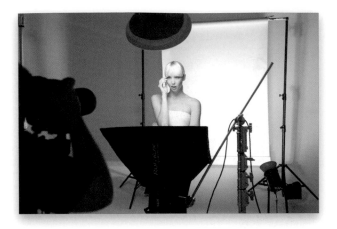

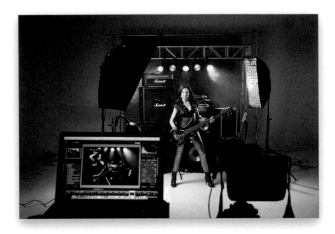

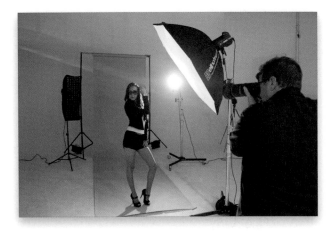

CONTENTS

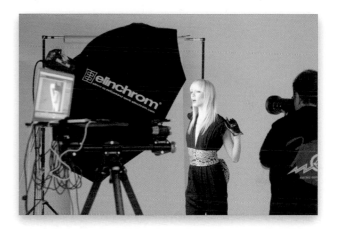

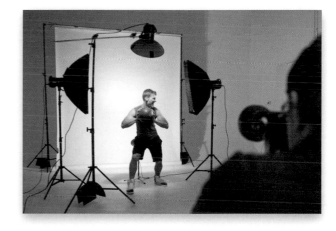

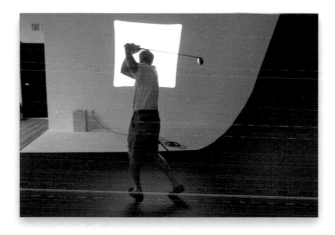

11 THINGS YOU'LL WISH YOU HAD KNOWN BEFORE READING THIS BOOK

It's really important to me that you get a lot out of reading this book, and one way I can help is to provide you with these 11 quick things about the book that you'll wish later you knew now. For example, it's here that I tell you about where to download something important, and if you skip over this, eventually you'll send me an email asking where it is, but by then you'll be really aggravated, and well…it's gonna get ugly. We can skip all that (and more), if you take two minutes now and read these 11 quick things. I promise to make it worth your while.

1 You don't have to spend a ton of money to get these looks.

I didn't want to write a book where you need $15,000 worth of high-end gear to get these looks. That's lucky for me, because I don't have $15,000 worth of gear. In fact, I actually use value-priced strobes that I think are a great deal for the money. For example, you know those hot shoe flashes (like a Nikon SB-900 or a Canon 580EX II)? Well, the street price of those is around $500. Here in the book (and in my own studio), I use studio strobes that cost only $100 more (around $600). Plus, they have wireless transceivers built-in, so that saves quite a few bucks not having to buy those. The reason I'm telling you this now is so you know that throughout the book I tried to really keep an eye on costs. That being said, to get certain looks, sometimes you need certain light modifiers. But, most of the ones I use here are around the $100 range, and the most expensive modifier in the entire book is currently just $315 (hey, did anyone tell you to get into photography because it was cheap?). Also, I tried to use as few lights as possible—usually one or two. Anyway, just wanted to let you know that I always try to keep an eye on the bottom line, and I always try to use gear that gives the most bang for the buck, while still being good-quality gear.

2 Download the practice images, so you can follow right along with me.

I've made all of the high-resolution project photos I used here in the book available for you to download, so you can follow right along with me as we do the post-processing. You can download them at **http://kelbytraining.com/books/lsr** (see, this is one of those things I was talking about that you'd miss if you skipped this and went right to Chapter 1). Also, the term "retouching" doesn't just mean removing blemishes, and brightening eyes, and stuff like that (known as "portrait retouching"). Here, retouching includes everything I do after the shoot in post-production in Photoshop to make the final image. So, while we do some portrait retouching to every image, I also include all the other stuff (toning effects, sharpening, desaturation, etc.) that goes into making a final image (which I know is very different for a book on lighting, but that's exactly why I wanted to include it).

3 You don't have to read this book in order.

I designed this book so you can turn right to the lighting setup you want to learn and start there. I explain everything as I go, step by step, and because of that, you might hear how to create a merged layer quite a few times as you read the book. But, that's because you might choose to start with Chapter 9, and in the post-processing section, I don't want you to read "Create a merged layer," and have you say, "Huh?" So, I spell everything out, so you don't have to go hunting for keyboard shortcuts or reasons why we do a certain thing a certain way.

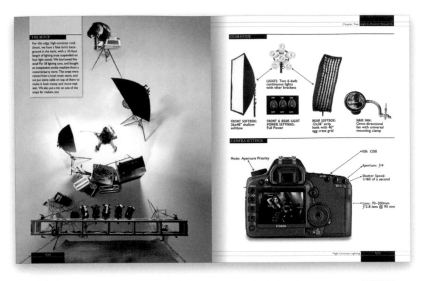

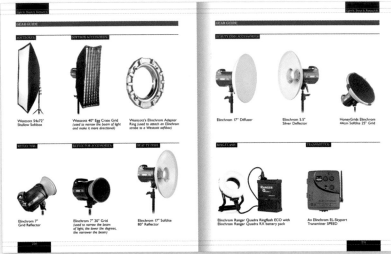

4 I list all the equipment used in each shoot, but I keep it kinda generic.

In this book, I use my own studio equipment, which is all made by either Elinchrom (strobes and softboxes) or by Westcott (continuous lights and softboxes), and I'm telling you this up front, so that I don't have to mention their brand names and models in every chapter's Gear Guide (which would get old, fast). So, although you may see "STROBE: 500-watt unit," the exact make and model I use is the Elinchrom BXRi 500 model, with a built-in EL Skyport wireless transmitter (the one I mentioned earlier that's just $100 more than a hot shoe flash unit). I included a complete Gear Guide in the very back of the book with the make and model of every piece of gear used in the lighting setups, but outside of that, I keep it generic. You absolutely do *not* need to use the same strobes I use to do any of the shoots in the book. You just need something that creates a bright flash of light, which is pretty much any strobe. It's not so much the type or brand of light, it's the modifier (softbox, beauty dish, strip bank, etc.) that you put in front of that flash, and how you aim and position it, that makes the difference.

5 Where are all the power cords?

You know those overhead shots near the beginning of each chapter that show you a bird's eye view of the lighting layout? Well, when we created the first one, one thing that immediately jumped out was how distracting it was seeing power cables and extension cords running all over the place. So, we used Photoshop's Spot Healing Brush to remove them. That way, you can focus on where the lights are positioned and not be distracted by all the annoying power cables that don't matter anyway (well, they matter in that the lights won't turn on without them, but you don't need to see them in the context of the book). Also, you may notice in some of the production shots (also near the beginning of each chapter) that part of our studio's floor is hardwood. In some of the shots, you'll see me standing on this floor, but you won't see it in the overhead shot. Why? Because I felt that it was also distracting, so we removed it from the overhead shots, as well. Just thought I'd mention it.

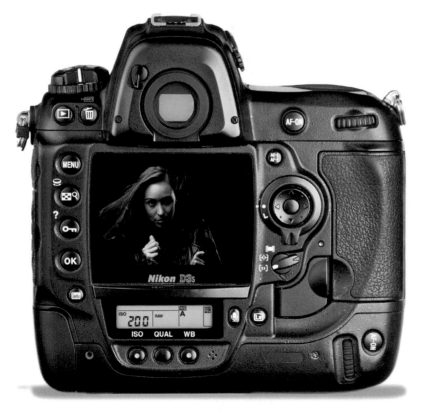

6 You'll see both Nikon & Canon camera bodies in the book.

I have a section near the beginning of each chapter that shows the exact camera settings used for each project, and I chose to show the back of a camera as a visual reference. The images I shot here in the book were taken with my Nikon D3s. But, I own both Nikon and Canon cameras, so I wanted to show both in the Camera Settings sections (so the book doesn't feel like it's for just Nikon shooters, because, of course, it isn't). I didn't take advantage of either of the D3s's special features that set it apart (its High-Speed Continuous Shooting mode or the low noise at high ISOs that is its claim to fame), so I would have gotten the same results with a $600 Nikon or Canon camera (but I would have had to wrestle that one away from my son, so I just shot with my own camera). In short, you don't need an expensive camera for your shots to look exactly the same.

7 I trigger all the gear with a Skyport transmitter.

I don't include this piece of gear in each chapter's Gear Guide, because I use the same wireless trigger for every shoot, so it would get really redundant (and you'd get tired of seeing it over and over again). So, I'll just cover it here. I use Elinchrom EL Skyport SPEED transmitters, because with my Elinchrom BXRi strobes, it lets me raise/lower the power of the lights from right on top of my camera (like most wireless triggers, the Skyport sits in the hot shoe mount on top of your camera). It's about the size of a matchbook, and it lets you assign your strobes to different groups, so you can change the power of any individual light without leaving the camera (for example, you can put your background light on one group, and your main light on another, and then just flip a switch to change the power of either one in 1/10 of a stop increments). If you don't have an assistant helping you, these are huge time savers. One more thing: Although I use Elinchrom strobes (one of my buddies turned me on to using them), I don't get paid or get a kickback from Elinchrom for using their lights (or from any company, for that matter). I had a bunch of different strobes before I bought my first BXRi (I had everything from White Lightning to Photogenics to ProFoto strobes with Chimera softboxes), but I put them all on eBay once I used the Elinchroms with the Skyport transmitters. Anyway, I thought you'd want to know that I can use or recommend anything from anybody, but I only show the stuff I actually use myself here in the book. One more thing: I made a little video for you (my esteemed reader of this book) to show you how this Skyport triggering thing works, because describing it is nothing like seeing it. You can find it on that download page I mentioned back in #2.

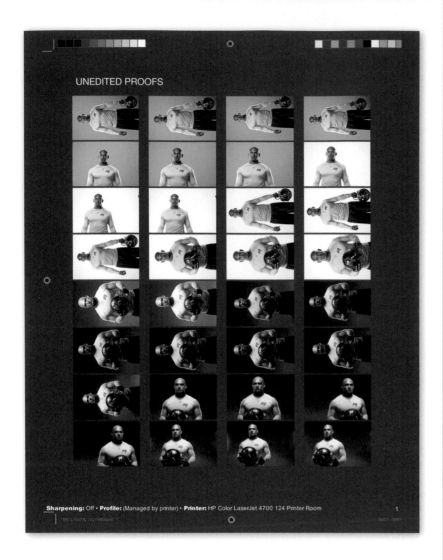

UNEDITED PROOFS

Sharpening: Off • Profile: (Managed by printer) • Printer: HP Color LaserJet 4700 124 Printer Room 1

8 What's with the contact sheets?

I thought it would be cool to include a contact sheet from each shoot, so you could kind of see the progression of the shoot, and I marked the frame that we actually use in the project that becomes our final image. Of course, if the flash didn't fire, or I took a totally out-of-focus shot (hey, it happens), I removed those "dead frames," so I don't look totally stupid (of course, I probably shouldn't have told you that, because I just admitted that sometimes my flash doesn't fire, and sometimes I take out-of-focus shots. Okay, forget I ever said that). Also, since I shoot both horizontal and vertical orientation during a typical shoot, you'll see both in the same contact sheet, which means some of the shots will appear sideways. When that happens, to see them upright, it's okay to: (a) turn the book sideways, or (b) turn your head sideways.

9 There's a special bonus chapter for hot shoe flash users.

So, can you do all the stuff I'm showing you using studio strobes, using just those portable off-camera hot shoe flashes (like the Canon 580EX II or Nikon SB-900)? Absolutely! That's why I added a special bonus chapter near the end of the book that shows each chapter's overhead shot recomposed using off-camera flash. The difference is really just the modifiers (softboxes, beauty dishes, grids, etc.) that you use with hot shoe flash. But, don't worry, there are versions of this stuff made for hot shoe flash, and it's all fairly inexpensive. Some of it comes from Westcott, some from ExpoImaging, and some from other places, but I list all the hot-shoe modifiers I use for getting these same looks at the end of Chapter 13. See, I care.

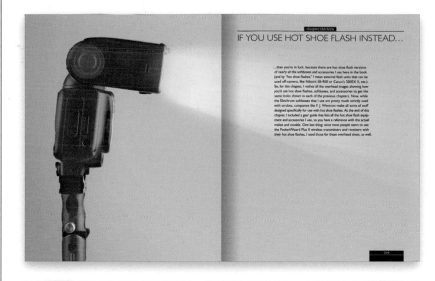

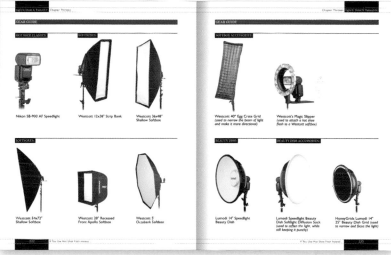

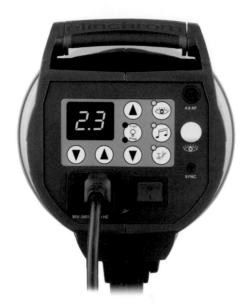

10 Why I included the power settings.

In the chapter Gear Guides, I thought it might be helpful to include the power settings my strobes were set at for each shoot. Now, you might be thinking that if you don't have the exact same make and model of strobe that I used, that info would be useless, but it's actually still kinda helpful. Here's why: The strobes I use go from a power setting of 2.3 (its lowest setting, which is an output of approximately 30 watts) to 6.3 (its highest setting, which is the full 500 watts). So, you know if you see a setting of 2.3, that's your cue to set your power at, or near, the lowest setting your strobe can go (no matter which brand or model you have). Of course, that's just a starting point, but at least you have one. If you see my setting at 4.0, you know I'm around half power, and so on. My settings will put you in the ballpark if your strobe is around 500 watts, but of course, if your strobe is 1,200 watts, you'll have to do a little math, because your half power will be more than my full power. So, to get down to 250 watts (my half power), you'd set yours at a little less than 1/4 power. Got it? Cool.

11 Strobes vs. continuous lighting.

In my studio, I use two different types of lights: (1) flash strobes (that have low-power modeling lights built into them that stay on, giving you a general idea of where the flash from the strobe will be aiming. The modeling lights are also helpful in a dark studio, because your autofocus will have enough light to focus) and (2) continuous lights (these stay on all the time). I know a lot of folks these days have continuous lights, so I included a couple shoots using them. But, if you don't have them, don't sweat it—you can put your lights in the same exact positions and get the exact same looks (just power them at their lowest settings, which should be plenty). The advantages of continuous lights are: (1) What you see is what you get. Since they're always on (and don't really produce any heat), you can just move them at will and see exactly how moving them an inch or so in either direction affects your subject. (2) They create absolutely beautiful, very soft, wrapping light. (3) They're particularly great for people who are scared of strobes and dealing with watt seconds, strobe power, etc. (4) They're not as bright as strobes, so you can shoot at wider apertures, like f/4 and f/2.8, creating a shallow depth-of-field that puts your background out of focus. The downside of continuous lights is that they're not as bright as strobes, so they work best for things that stay pretty still—like when you're posing adults or doing product shots. I wouldn't recommend them for photographing children (who move a lot!), unless you're cool with shooting at a higher ISO, like 800, so you can get a fast enough shutter speed to freeze motion (you don't have to worry about that with strobes, because they freeze motion almost automatically).

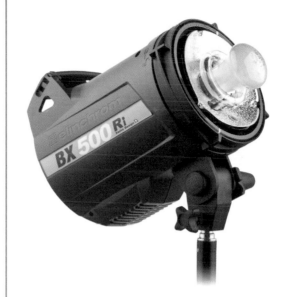

10 THINGS I WISH SOMEBODY HAD TOLD ME WHEN I FIRST STARTED USING STUDIO LIGHTING

If you've been shooting with studio lighting for a while now, you already know this stuff, but I wish somebody had told me a few of these things when I first started—it would have saved me a lot of time and trouble, and would've gotten me better looking shots a lot sooner. If you're an old pro at this stuff, skip these 10 things and go check out a chapter that interests you. Of course, I know how human nature is—if you tell someone "this isn't for you," then they want it 10 times more than if you had said "everyone needs to read this." So, I kept this pretty short for that very reason. :)

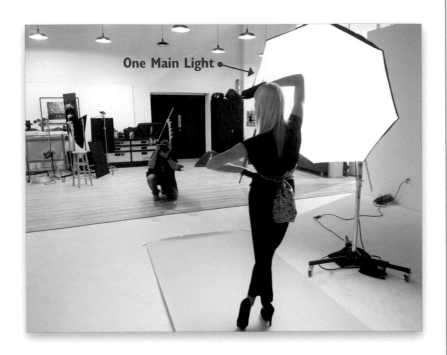

One Main Light

1 Start with just one light.

A lot of people are tempted to throw up a bunch of lights, but honestly, this is usually an area where less is more. Start by setting up just one main light. Once you're happy with the quality and position, if you think you need to add a second light (maybe a hair light, or a background light), turn off the first light, and get the second light looking just like you want it before you turn the main light back on. Also, never lose sight of what you can create using just one light (remember, beautiful window light usually comes from just one window). So, build your look one light at a time, and you'll have better results.

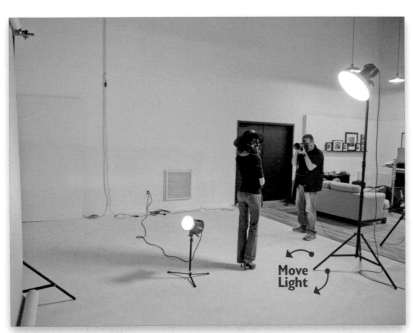

Move Light

2 If something doesn't look right, you're probably only off by a few inches.

If you've got your light in position, and it just looks either blah or bad, don't get frustrated, or think it's all messed up—you're probably just off by a tiny bit. Literally inches. Move the light around your subject in an arc, as if your subject was the center of your wristwatch, and your light circles around it like the hands of your watch. Try moving the light around that arc just two or three inches in either direction, and see what a difference that makes. Chances are, you're only a few inches from fantastic light.

3 Spend more on your modifiers than your lights.

You know the old saying: "Spend more on your lenses than you do on your camera body?" A similar thing also applies to flash. I've found that all flashes emit a bright flash of light when you fire them. Really expensive ones, really cheap ones, studio strobes, hot shoe flashes—they all do basically the same thing: they create a bright flash of light. So, spend more on your modifiers—the softboxes and accessories that shape and craft your light—than you do on the "bright flash of light" makers.

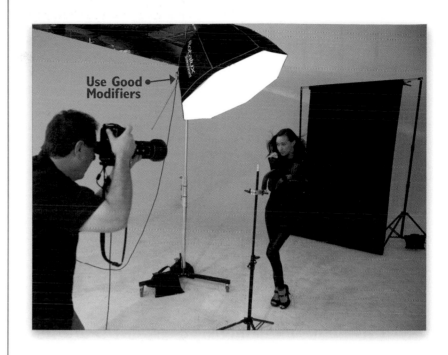

4 Buy lighting stands with wheels.

You'll thank me one day. Plus, you're more likely to experiment if all you have to do to reposition your lights is roll them. And, you're less likely to accidentally tip one over while you're moving them (since they're top heavy by nature).

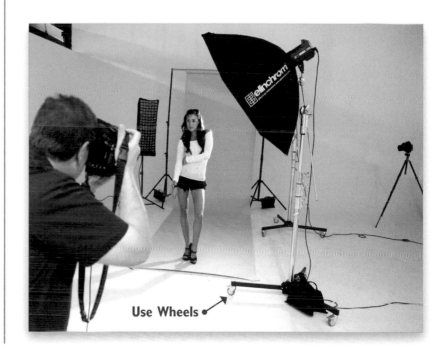

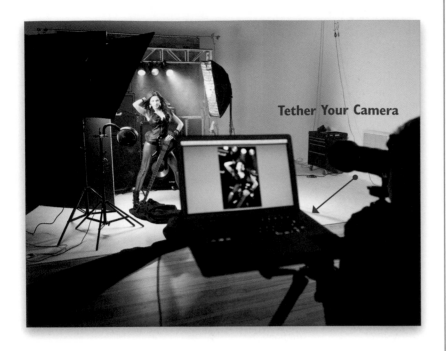

Tether Your Camera

5 Shoot tethered to your computer.

It's really hard to judge the quality of your light on that tiny 3" display on the back of your camera. So, in the studio, connect a USB cable to your DSLR, plug the other end into your computer (or laptop), and start seeing your images onscreen full size. I guarantee you'll make better images, and have better quality light. You can shoot straight into Lightroom 3 (like you see here), or you can use one of a dozen free applications that let you tether, so you can view your targeted folder full-screen in Adobe Bridge. Do this once, and you'll always shoot tethered in the studio. Yes, it makes that big a difference.

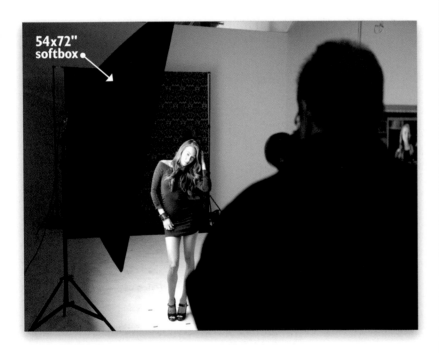

54x72" softbox

6 When it comes to softboxes, bigger is better.

The bigger the softbox, the more beautiful and wrapping the light. If you get one that's 53" or even larger, it's like cheating. It's nearly impossible to make someone look bad with one of these huge softboxes, plus it makes lighting more than one subject a whole lot easier.

7 Closer is better.

If you want really, really soft, beautiful light, get it really, really close to your subject. Get it to where it's literally just outside your frame in the view-finder. You'll love what getting it that close does.

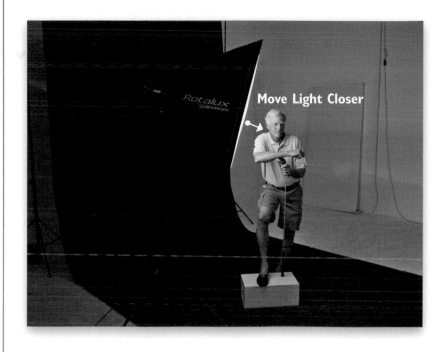

8 You probably don't need high-wattage strobes.

Ninety-nine percent of the time, we run our studio strobes at 1/4 power or less. That's because we keep our lights fairly close to our subjects (again, closer is better), and if we turned them up a lot brighter, they'd be way too bright. Much of the time, we run our strobes down at their lowest power setting, and rarely do we ever get a chance to use the 500 watts of power our strobes may have. Now, if you're taking your strobes outdoors on location at 3:00 p.m. on a sunny day, then maybe you'll need a 1,200-watt strobe. But, if you just read that and thought, "I'll never be doing that," then don't blow all your money on high-powered strobes that will never get used at high power.

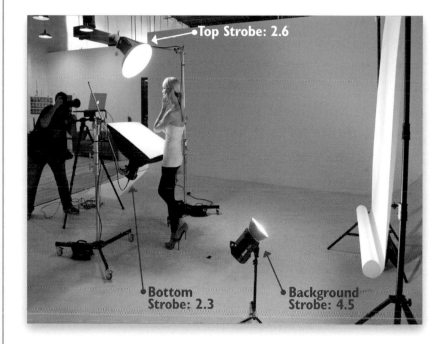

9 You're not going to change your ISO or shutter speed very often, if at all.

You'll notice that throughout the book, my ISO usually stays on 200 (which is the lowest native ISO for most Nikon DSLR cameras. For most Canon DSLRs, it's 100 ISO), because that ISO creates the cleanest, noise-free images. So, in the studio, ISO is kind of a "set it and forget it" setting. For shutter speed, with studio strobes, the fastest speed you can use (and still have your flash sync up to your camera) is 1/200 of a second (it's 1/250 of a second with hot shoe flashes, unless you turn on high-speed sync, which is an entirely different topic). If you change to a faster shutter speed, you'll see a dark gradient appear across the bottom of your photo (that's a good warning sign to let you know your shutter speed is set above 1/200). A lot of pros use 1/125 of a second for their shutter speed (don't worry, the flash itself will freeze your subject's motion). By the way, 1/125 is my starting point, but occasionally you'll see me use 1/160 of a second here in the book. That's because, at some point during the shoot, I accidentally turned the dial that controls the shutter speed. Now, 1/160 is perfectly fine, as is 1/200, so if I notice it changes, I don't worry about it—it won't change the look of my shot, so I don't sweat it (this rule is different when shooting on location with hot shoe flash, where you're using the shutter speed to balance the ambient [available] light with the light from your strobe. However, in your studio, there won't really be any ambient light— we keep the lights down low).

10 Picking an f-stop for portraits.

There is no really "right" f-stop for portraits, but a very popular f-stop for shooting studio portraits is f/11, because it keeps everything on your subject in focus. Plus, when you know your shutter speed is 1/125 of a second, and your ideal f-stop is f/11, then all you have to do is power up/down the lights until the lighting looks right at those settings. By the way, you don't have to get married to f/11—f/8 works great and f/9 is lovely, but if you get down around f/4, your subject's eyes might be in focus, but their hair will be somewhat out of focus. This is popular for glamour photography, but in most cases here in the book, you'll see my f-stops up in the f/8 to f/11 range. Because of this, in the studio, it makes sense to set your camera to Manual mode, then just dial in your shutter speed, dial in the ISO and f-stop you want, and then you really don't have to be messing with your camera settings all the time. Instead, you can work on what really makes a great photo (besides the light), which is connecting with your subject.

Okay, that's your "pre-flight briefing" and now it's time to get to work. Turn the page and let's start lighting, shooting, and retouching.

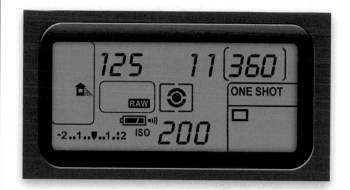

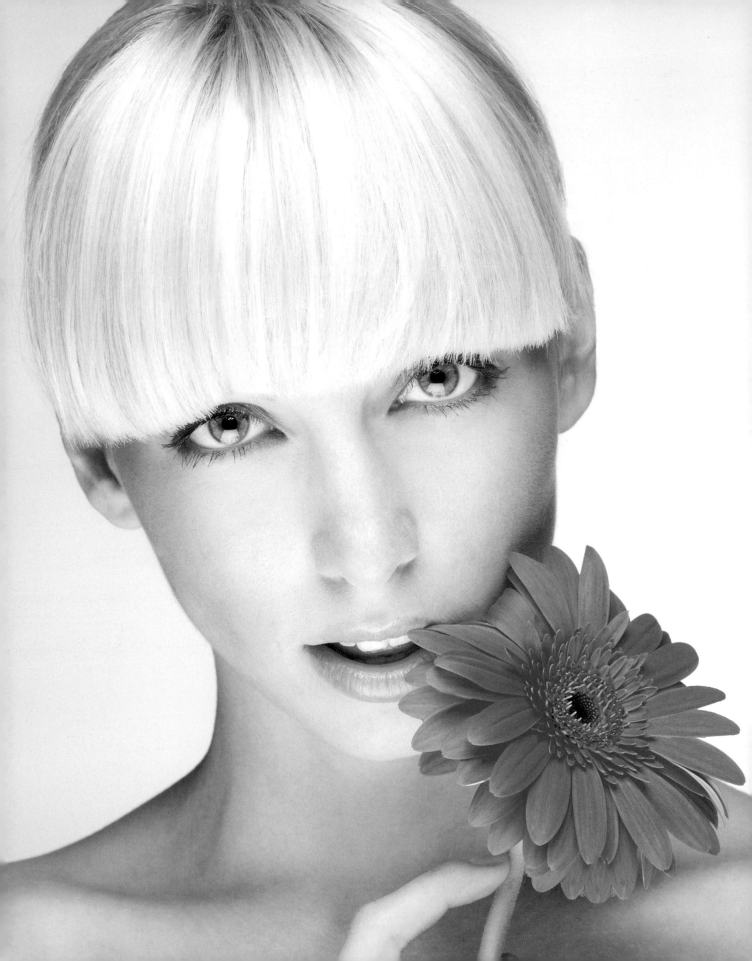

3-LIGHT CLASSIC BEAUTY SETUP

Clamshell Lighting

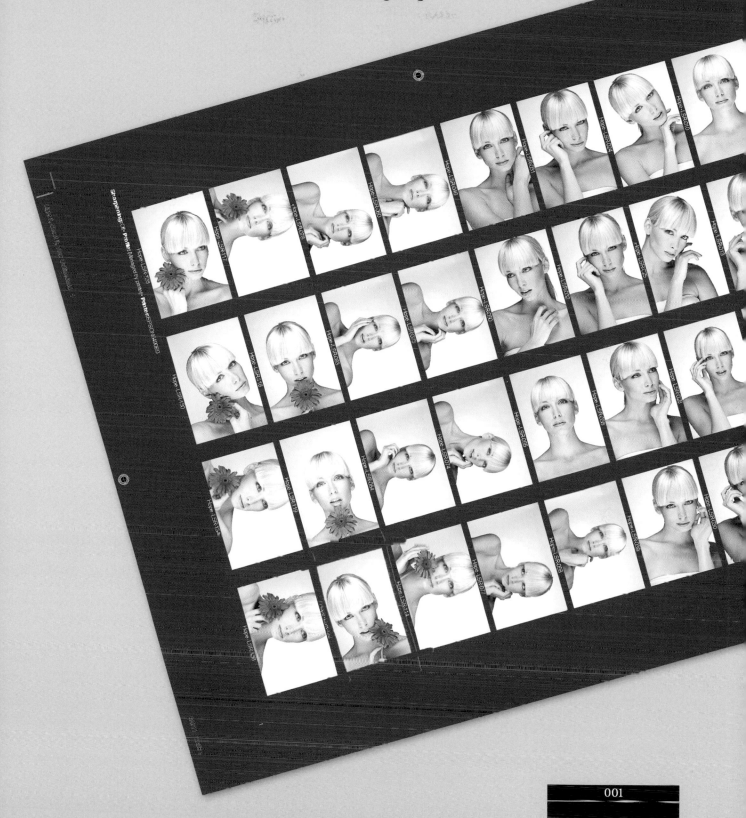

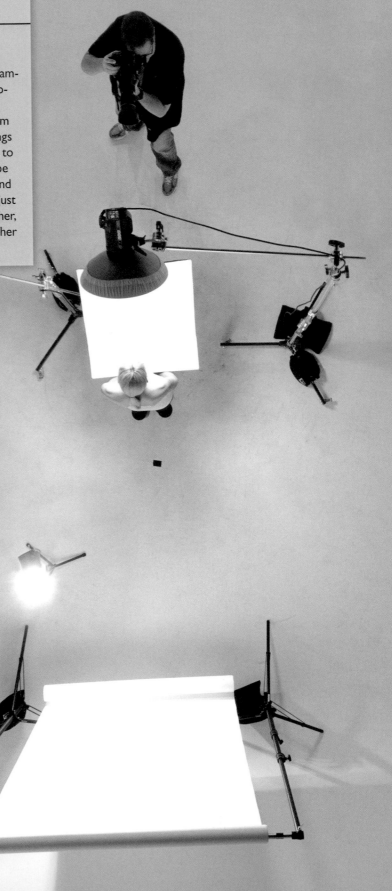

THE SETUP

To get this high-key portrait, we placed a 5-foot roll of white seamless paper in the background, supported by two light stands with an extender pole between them (and two sandbags to keep things steady), with a strobe aiming up to light it. We used another strobe with a beauty dish attachment and diffusion sock as our main light, just in front of our subject, and another, with a 27" softbox, aiming up at her and filling in the shadows.

GEAR GUIDE

TOP STROBE: 500-watt unit with 17" beauty dish and diffusion sock

BOTTOM STROBE: 500-watt unit with 27x27" softbox

BACKGROUND STROBE: 500-watt unit with 7" reflector

TOP STROBE'S POWER SETTING: 2.6

BOTTOM STROBE'S POWER SETTING: 2.3 (its lowest setting)

BACKGROUND STROBE'S POWER SETTING: 4.5

CAMERA SETTINGS

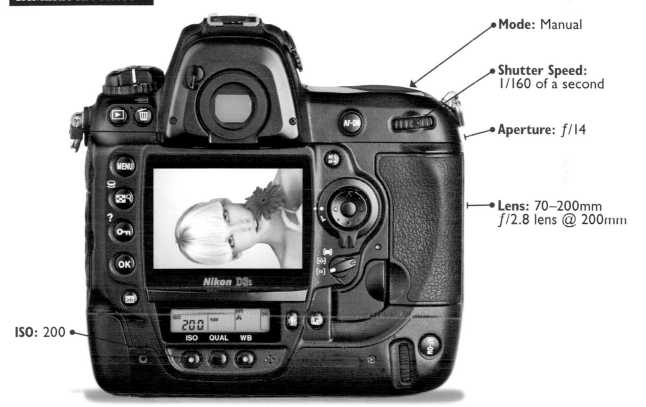

Mode: Manual

Shutter Speed: 1/160 of a second

Aperture: f/14

Lens: 70–200mm f/2.8 lens @ 200mm

ISO: 200

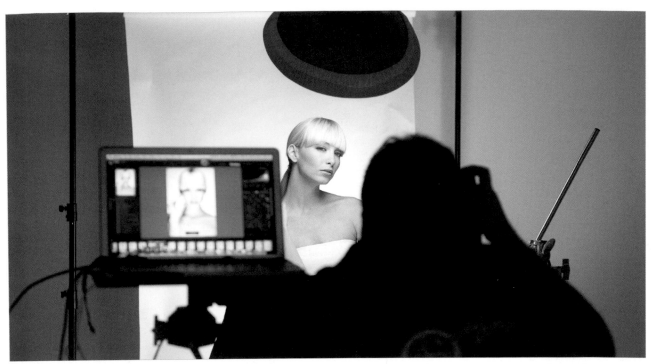

FRONT VIEW: I'm positioned directly in front of the subject. The top light has a beauty dish attachment (it attaches just like a softbox) with a diffusion sock over the front to make the light softer, while still keeping it punchy. It's positioned up high, aimed back at the subject at a 45° angle, and it's very close to her (easier to see in the other shots).

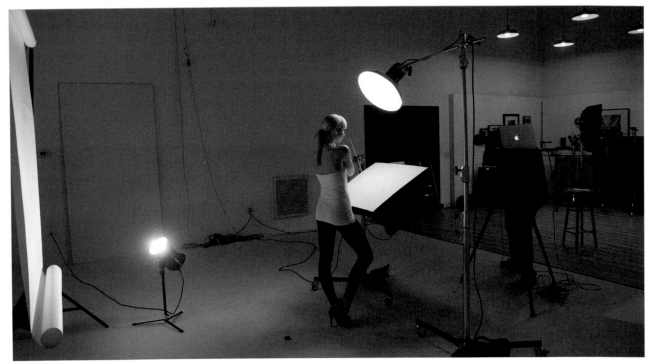

LEFT SIDE: You can clearly see the light below her in this shot. This strobe with a 27x27" softbox fills in the shadows on her neck, under her eyes, and below her nose, and really makes a big difference. It's angled back toward the subject at a 45° angle, as well. You can also see the background light, aiming up at the white seamless paper to create a solid white background.

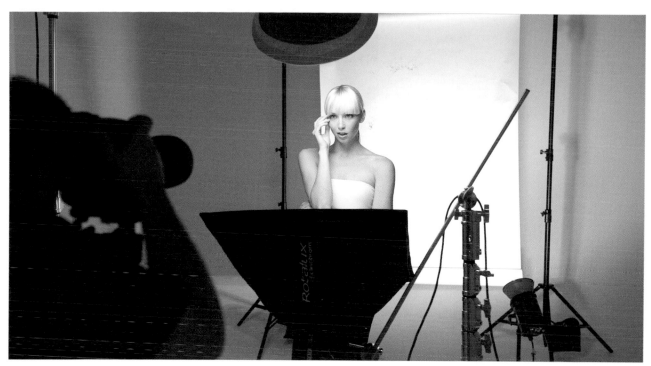

RIGHT SIDE: You sometimes hear this two-light setup referred to as "clamshell" lighting, because from the side it resembles an open clam. If you don't have a second light, you can have your subject hold a silver reflector right at chest level to reflect the top light.

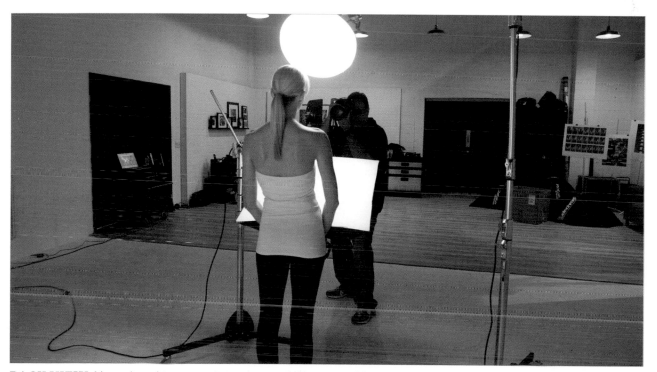

BACK VIEW: I have the subject move in so close to the bottom softbox that it touches their waist. Because they're this close, you'll have to power the bottom strobe down as low as it can go, but the top light needs to be a little brighter than the bottom light (mine is 3/10 of a stop brighter on top). If the bottom light is brighter, they kind of get a bit of an eerie Frankenstein look.

THE POST-PROCESSING

Since this is a beauty headshot, the focus is really on the face, so we'll have to do a little more facial retouching than usual. Plus, the fact that she's holding a flower near her face, and that it's so prominent in the photo, means we'll have to make sure the flower looks really good, too. So, this particular photo is going to take a few extra steps to get it where we want it. I shot the image in RAW, so we'll start our processing in Camera Raw (or you can use Lightroom's Develop module, which is basically Camera Raw).

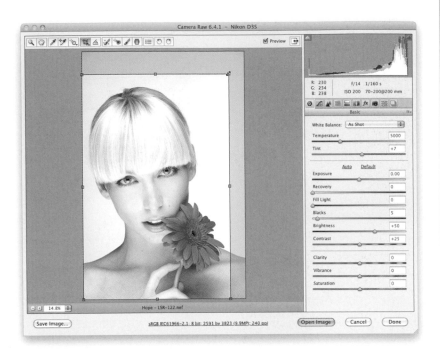

STEP ONE:
I didn't do a super job on the composition of this image (I feel like there's too much space above her head), so let's start by cropping the image in Camera Raw. Get the Crop tool **(C)** from the toolbar up top and click-and-drag out the cropping border, so it surrounds the entire image. Press-and-hold the Shift key (so everything maintains the same proportions), then click-and-drag the top-right corner point inward (as shown here), until the composition looks about right. When it looks like what you see here, press the **Return (PC: Enter)** key on your keyboard to confirm your cropping, and the preview adjusts so you just see the final cropped image (as seen in the next step).

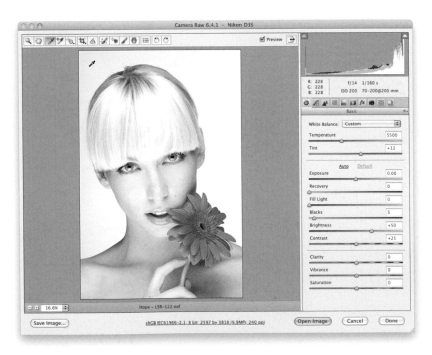

STEP TWO:
The light gray background behind her looks a little bluish, so get the White Balance tool **(I)** from the toolbar and click it once on a light gray area (as shown here, where I'm clicking in that gray around the top left of her head) to choose that as our white balance. Now, the background looks gray, and her skin looks a little warmer, too.

STEP THREE:

One last thing to do in Camera Raw: If you look up in the top-right corner of the histogram in the previous image, you'll see a white triangle. That's a clipping warning, telling you that there are parts of the image that are so bright that there are no pixels there (they've been "clipped" off). If you clicked on that white triangle, you'd see those areas appear in red on your image, and you'd see that some of those areas are on her face. To fix that (without changing the overall exposure), just drag the Recovery slider to the right a bit, until the triangle isn't white anymore (as shown here, where I dragged to 16). The triangle here is now red, which means there's still some clipping, but it's only in the Red channel. So, thankfully, there will actually be some pixels there. I think it looks good at this point, so go ahead and click the Open Image button to open it in Photoshop.

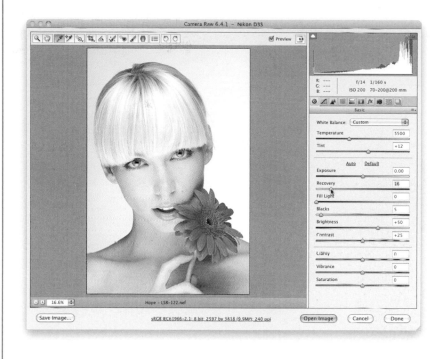

STEP FOUR:

We'll start by getting rid of any major facial blemishes, and we'll do this using the Healing Brush tool. So, choose it from the Toolbox (or press **Shift-J** until you have it), zoom in, and then use the **Left** and **Right Bracket keys** on your keyboard to resize the brush, so that it's just slightly larger than the blemish you want to remove. Press-and-hold the Option (PC: Alt) key and click once in an area right near the blemish (as shown here). Just make sure that where you click doesn't have any blemishes—choose a nice clear area to sample from.

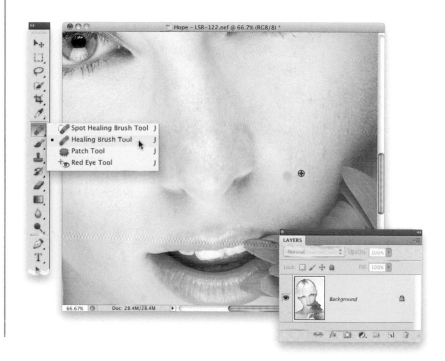

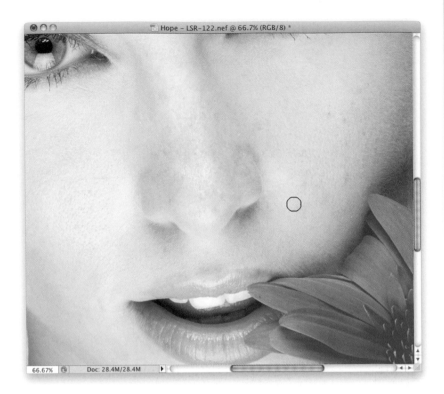

STEP FIVE:

Now, just move your cursor right over the blemish, click once, and it's gone. Don't paint, just click. Move around the face and shoulders (any skin areas), and when you see a blemish: (1) sample a nearby area, (2) make your brush size slightly larger than the blemish, and (3) just click to remove it.

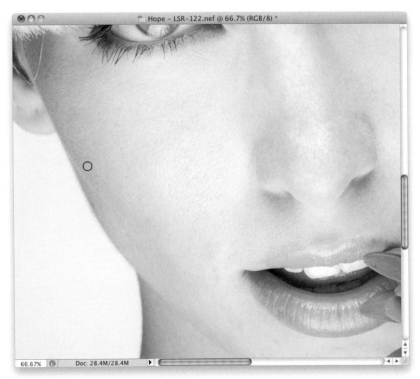

STEP SIX:

Once all the obvious blemishes are removed, let's work on removing any stray hairs. Here, there's one coming right around her face on the left. Now, when what we need to remove is not just an individual spot, that's when we have to paint a stroke with the Healing Brush. So, sample a nearby area, and then paint right over the stray hair. Be careful not to go all the way to the edge of her face, though, because if there's one thing that the Healing Brush doesn't like, it's edges—it will smear. So, stop before you reach the edge (if you're painting from right to left). If you need to get close to the edge, use the Clone Stamp tool the same way you would the Healing Brush tool, just use a very small brush size near the edges (it doesn't smudge. So why don't we use it all the time? It doesn't work as well, but it's great around the edges).

STEP SEVEN:

My favorite tool for getting rid of stray hairs outside the face is actually the Clone Stamp tool **(S)**, so go ahead and grab it. Then, up in the Options Bar, click on the brush thumbnail to open the Brush Picker and drag the Hardness slider to the right to 70%, so it's got more of a hard edge, but it's not totally harsh. Shrink your brush size, so it's a bit larger than the hair you'll be removing, then Option-click (PC: Alt-click) in a nearby area without any hair, and start cloning away those strays around her head (as shown here).

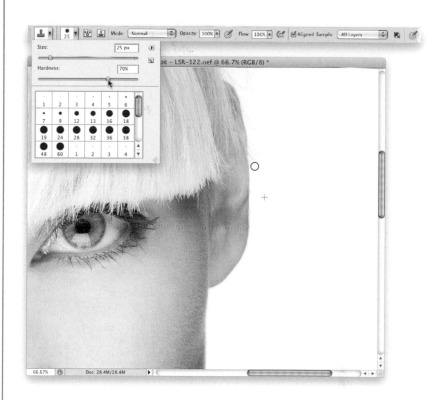

STEP EIGHT:

If you look at the top of her head, you'll see there's a bit of a dent where the hair kind of parts back, so we'll need to fix that next. Unfortunately, using the Clone Stamp tool here is tricky business, so we'll use a different technique that is faster and better. We're going to select some hair from somewhere nearby, copy it, move it over the indented area, and then rotate it into place. It works like a charm. Start by getting the Lasso tool **(L)** and make a selection of some smooth hair nearby (as shown here). Now, to hide your tracks, you'll need to soften this selection, so go under the Select menu, under Modify, and chose **Feather**. When the Feather dialog appears, enter 10 pixels for a nice soft blend, and click OK.

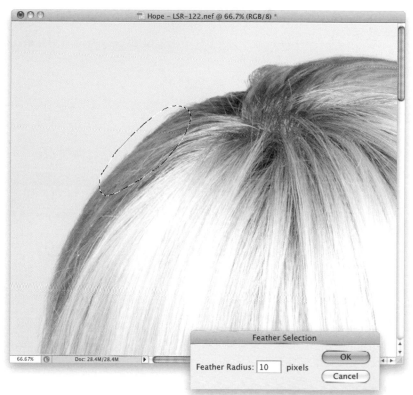

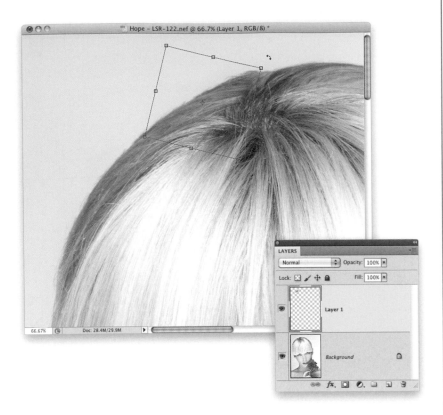

STEP NINE:
Press **Command-J (PC: Ctrl-J)** to put this selected area up on its own layer. Then get the Move tool **(V)** and drag this chunk of hair over the indented spot, so it covers it up (well, somewhat). To really make this cover the spot, you'll need to rotate it, so it follows the shape of the head, so press **Command-T (PC: Ctrl-T)** to bring up Free Transform. Move your cursor outside the bounding box, and your cursor changes into a two-headed arrow. Click-and-drag in a circular motion to rotate the hair into place (as shown here). There's still a little bump to the right, but we'll fix that next using a different feature. For now, when it's in place, press **Return (PC: Enter)** to confirm your transformation.

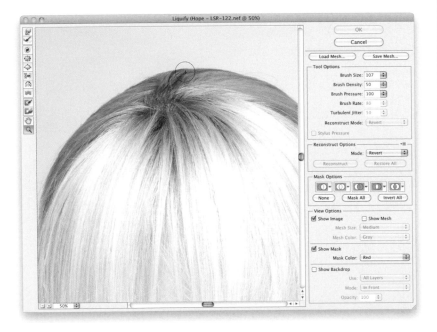

STEP 10:
The easiest way to fix that little bump that's left over is by using Liquify, but you'll need to flatten your layers first. So, choose **Flatten Image** from the Layers panel's flyout menu, then go under the Filter menu and choose **Liquify**. When the Liquify dialog appears (shown here), choose the Forward Warp tool (**W**; it's the first tool in the Toolbox on the left, and it lets you move things in your image as if they were made of a thick liquid). Use the Left and Right Bracket keys to shrink/increase the brush size, so it's just a little larger than the dent you want to fix, and then just click below the dent and push some hair upward to fill in that dented area (as shown here). When you're done, click OK.

STEP 11:

There are also some gaps within her bangs that should be fixed, and again, the best method is to copy hair from other areas to fill in those gaps. So, get the Lasso tool again, and select a nearby area. Add a 10-pixel feather, so the edges aren't hard, and then press Command-J to put that selected area up on its own separate layer.

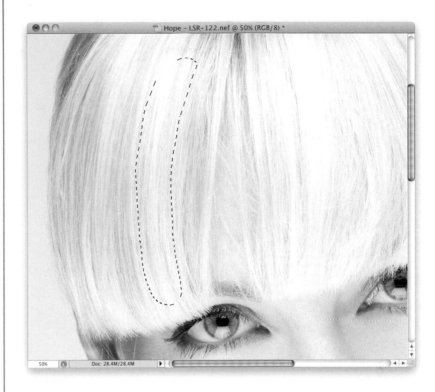

STEP 12:

Switch to the Move tool and click-and-drag this copied chunk of hair over, so it covers as much of the gap as possible. Of course, it won't match up perfectly, so you'll have to rotate it a little to make it match (just like you did on the top of her head). Go to Free Transform again, move your cursor outside the bounding box, and click-and-drag to rotate the chunk of hair, so it lines up with the existing hair around it (as shown here). When it looks good, press Return to lock in your changes. We're not done yet with the hair, though. There's still another big gap.

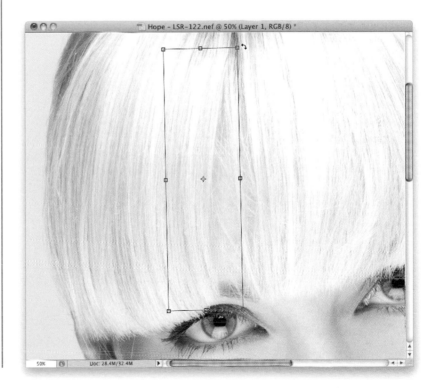

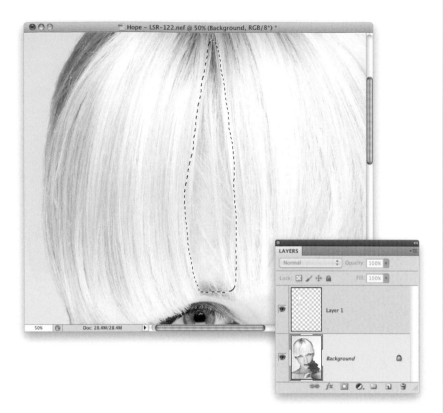

STEP 13:
If you want to make sure you cover that next gap over in her hair, you can start by clicking on the Background layer in the Layers panel to target it, and then with the Lasso tool, make a selection around the entire gap (like the one shown here). Then, add a 10-pixel feather (just like before), to soften the edges quite a bit.

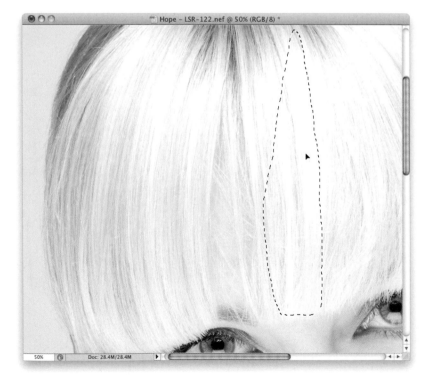

STEP 14:
Now, while you still have the Lasso tool selected, click right inside that selected area and drag the selection over to an area of her hair that doesn't have a big gap (as shown here). Then, press Command-J to put that chunk of hair up on its own separate layer.

STEP 15:

Switch to the Move tool again, and drag this chunk over, so it covers the big gap (which it should do just about perfectly). The only problem is it doesn't follow the curve of her head or her hair. So, you'll need to flip this chunk of hair horizontally by bringing up Free Transform again. But, this time, you're going to Right-click inside the bounding box, and from the pop-up menu that appears, choose **Flip Horizontal** (as shown here), and now it matches the direction of her hair. Don't lock in your transformation just yet.

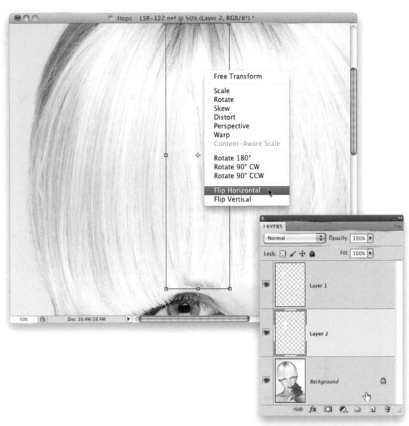

STEP 16:

To make it match up perfectly, you'll need to rotate your Free Transform bounding box a bit. So, move your cursor outside the bounding box and click-and-drag to rotate the chunk of hair into position (as shown here). Now you can press Return to lock in your transformation. If you see any other hair gaps you want to fix, use the same technique of copying some nearby hair up onto its own layer, and using that to cover the gap, keeping in mind that you might have to rotate or flip it horizontally to make it look right.

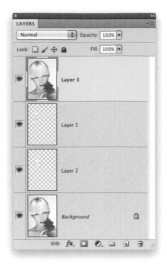

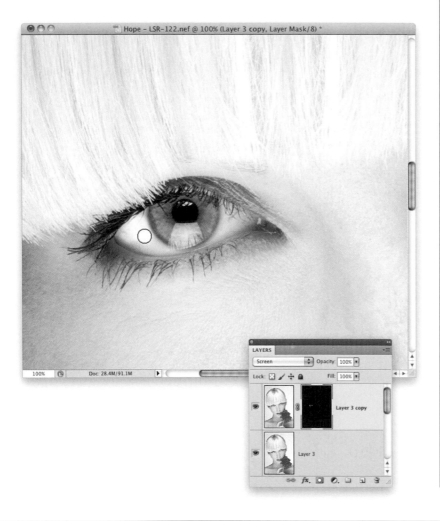

STEP 17:
Now, click on the top layer in the Layers panel and press **Command-Option-Shift-E (PC: Ctrl-Alt-Shift-E)** to create a merged layer on top of all your other layers that looks like a flattened version of your image (this keeps everything intact underneath, just in case you need to go back and undo something).

STEP 18:
Next, let's zoom in and do some quick retouching to her eyes. This is something I do to almost every portrait, because even when you have a lot of light aimed at the eyes, you still usually wind up with the whites of the eyes looking more gray than white. But, luckily, it's an easy fix. Start by pressing Command-J to duplicate the new merged layer and then, at the top of the Layers panel, change the layer's blend mode to **Screen**. This makes the image look very bright. But, we only want her eyes to be brighter, so press-and-hold the Option (PC: Alt) key and click on the Add Layer Mask icon at the bottom of the Layers panel. This adds a black layer mask over your brighter Screen layer, so the image looks normal again. Get the Brush tool **(B)**, and then, in the Options Bar, choose a small, soft-edged brush from the Brush Picker. Press **X** to set your Foreground color to white, then start painting over the whites of her eyes (as seen here), and the brighter version of her eyes will appear where you paint. If you make a mistake and accidentally paint over a part you didn't want brighter, press X, again, to change your Foreground color to black, and paint over your mistake to fix it. Then, press X, once again, to go back to white and keep painting areas you want brighter.

STEP 19:

Chances are the eyes will look too white, so start by lowering the Opacity of this Screen layer to 50% (as shown here) and see how that looks. If it's still too bright, take it down to 40% or 30%, if necessary. But, I find between 40% and 50% usually does the trick. Also, don't try to choose this amount while you're zoomed in tight like we are here—zoom your view back out quite a bit, and you'll make a better decision on how white to leave the eyes.

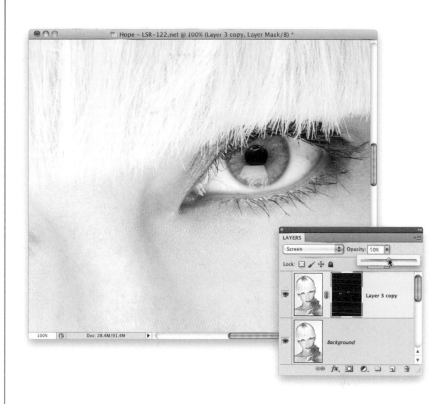

STEP 20:

While we're there working on the whites of the eyes, let's get rid of any red veins. Start by clicking on the Create a New Layer icon at the bottom of the Layers panel to create a new blank layer. Then, with the Brush tool still active, up in the Options Bar, lower the brush Opacity to 20%. Now, choose a very small brush size—just slightly larger than the veins you want to remove—and then Option-click (PC: Alt-click) right beside a vein in a clean area of the eye to sample that color as your Foreground color. Next, just click-and-paint a few strokes over the vein until it's gone. It works like magic—I know. As you move around the eye to different veins, don't forget to resample the color right next to the vein, and then begin painting.

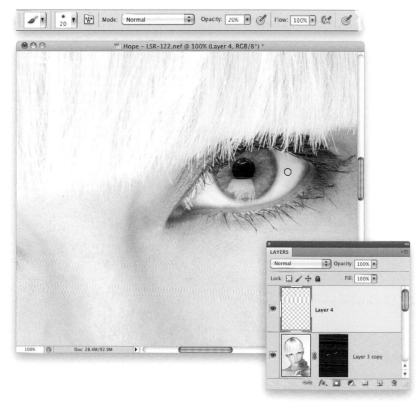

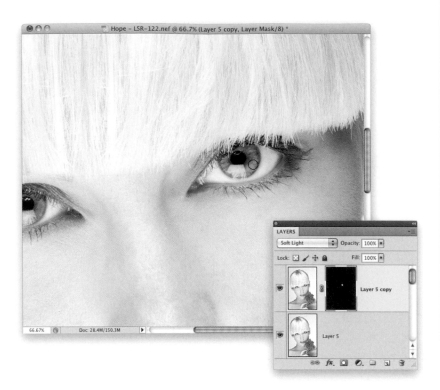

STEP 21:
Press Command-Option-Shift-E again (to create another merged layer at the top of your layer stack) and then duplicate this merged layer, because we're going to use it to create more contrast in her irises. Change the blend mode of this duplicate layer to **Soft Light**, which makes the entire image more contrasty. Of course, we only want her irises to be more contrasty, so Option-click (PC: Alt-click) on the Add Layer Mask icon to hide this Soft Light layer behind a black layer mask. With the Brush tool active, choose a small, soft-edged brush and set your brush Opacity back to 100%. With your Foreground color set to white, start painting over her irises and the more contrasty version of them will appear where you paint.

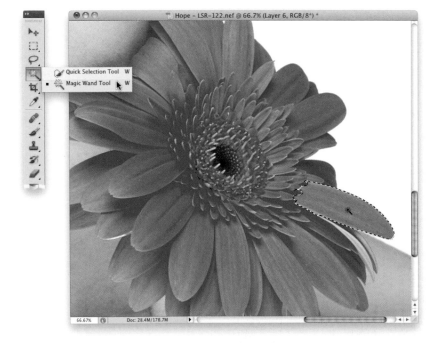

STEP 22:
Next, let's work on the flower, because it has a few petals that are missing, and that looks kinda distracting. So, create another new merged layer on top of your layer stack, then get the Magic Wand tool (press **Shift-W** until you have it, or get whichever selection tool you're comfortable with), and select one of the petals (as shown here). Here's the plan: We're going to copy that selected petal up onto its own layer, drag it over to fill the gap, resize it, and maybe darken it a bit, so it looks realistic. We might even have to do a little masking, but nothing too strenuous.

STEP 23:

Once the petal is selected, press Command-J to put it up on its own separate layer. Now, switch to the Move tool and move that petal up to cover part of the gap (one petal won't fully cover that gap on the right side, though. This looks like a two-petal fix). Go into Free Transform, press-and-hold the Shift key, and click-and-drag a corner handle inward to make it a little bit smaller (as shown here). Then, rotate it so it matches the rotation of the petals around the flower and press Return to lock in your transformation.

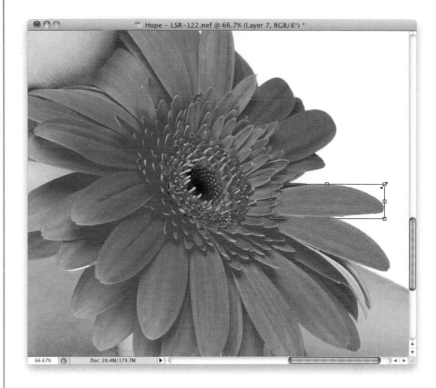

STEP 24:

Duplicate your single petal layer, then move it up into position to cover the rest of the gap. Again, use Free Transform to scale the petal down in size a bit, rotate it into place (as shown here), and then lock in your transformation.

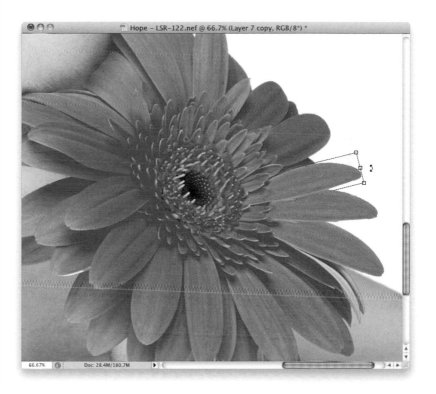

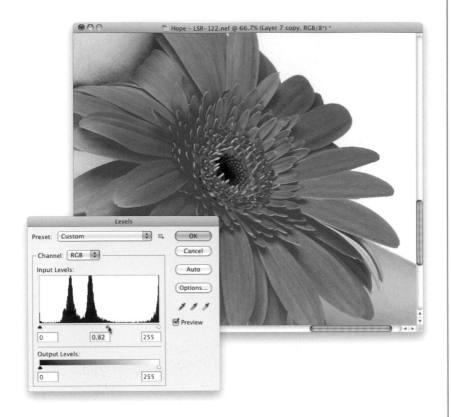

STEP 25:

To make this look a bit more realistic (and help hide the fact that you copied the same petal twice), we're going to darken the second petal. So, press **Command-L (PC: Ctrl-L)** to bring up the Levels dialog, and drag the center midtones Input Levels slider to the right a little to darken the petal just a bit (as shown here). It doesn't need to be a huge move, the petal just needs to look a little bit darker. When you're done, click OK.

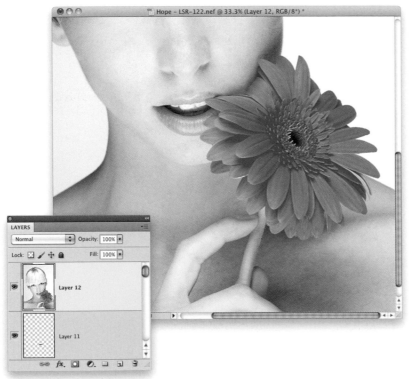

STEP 26:

Create another merged layer at the top of your layer stack, and then do the same thing with the gap at the bottom of the flower. Make a selection around a bottom petal, copy it to a new layer, move it into place, then use Free Transform to make it match the rotation of the other petals. After you've filled in the bottom gap, fill in the gap on the left side (the one at the 10 o'clock position. The final fixed flower is shown here, but if you go back and look at earlier steps, you'll see both gaps clearly). I ended up adding white layer masks to the bottom petal layers, then painting in black to hide parts of the copied petals, so that they looked more realistic beneath the existing petals. When you're done, create another merged layer. Now, let's do some dodging and burning to sculpt the face.

STEP 27:

Click on the down-facing arrow at the top right of the Layers panel, and from the flyout menu, choose **New Layer**. By creating a new layer this way, it brings up the New Layer dialog (shown here). In the dialog, change the new layer's blend Mode to **Soft Light**. When you choose this mode, the Fill with Soft-Light-Neutral Color (50% Gray) option below it becomes active. Turn on that checkbox and click OK to create a new layer that's filled with gray, but looks totally transparent in the image. This is the layer where we'll do our dodging and burning.

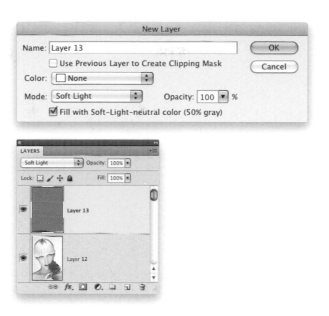

STEP 28:

Get the Brush tool and choose a medium-sized, soft-edged brush. Lower your brush Opacity to around 15%, and then set your Foreground color to black. Now, softly click-and-paint a stroke or two over all the shadow areas in your photo. Anything that's dark, make it a little darker, as shown here where I'm darkening her cheek. Basically paint over her cheeks, the sides of her nose, right below her lips, and the shadow areas on her neck and shoulders.

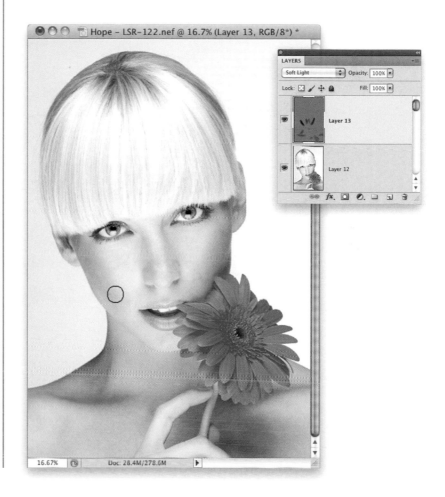

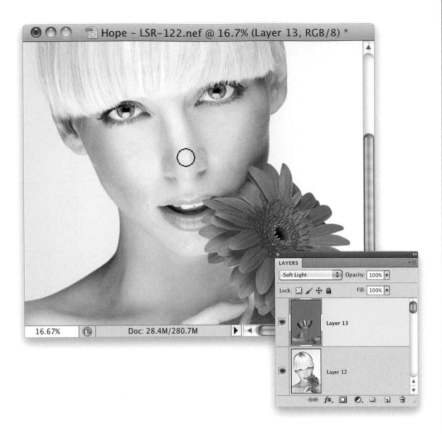

STEP 29:
Now, press X to set your Foreground color to white and paint over any areas that have highlights, like the bridge of her nose, her upper cheeks, just below her nose, her chin, and the bright areas on her neck and shoulders. Just make the bright areas even brighter (as shown here, where I'm painting over the bridge of her nose in white).

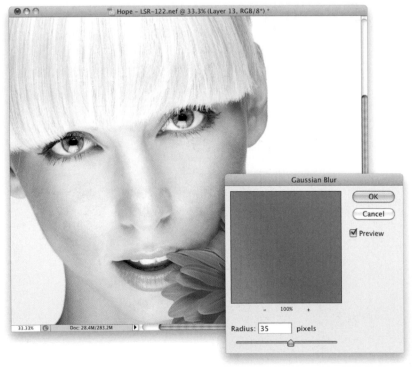

STEP 30:
To make the dodging and burning we just did blend very smoothly, we're going to blur the living daylights out of it. So, go under the Filter menu, under Blur, and choose **Gaussian Blur**. When the dialog appears, enter around 35 or so pixels (as shown here) and click OK. This really softens and blends those areas.

STEP 31:

Now, you're going to lower the Opacity of this dodge and burn layer until it looks natural. It helps to toggle the visibility of this layer on/off a few times (by clicking on the Eye icon to its left) to really see the effect. Here, I've lowered the Opacity down to 65%, and for this particular image, it looks about right to me.

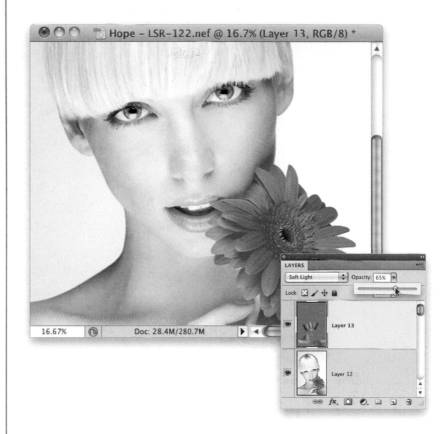

STEP 32:

Our final step is to sharpen the image in a way that won't accentuate her skin texture (after all, we want to keep that nice and soft). So, create one last merged layer at the top of the layer stack and then go to the Channels panel (choose **Channels** from the Window menu) and click on the Red channel. The Red channel has lots of important details, like hair, eyes, lips, and so on, but it doesn't have much skin texture, so it's an ideal place to sharpen on women. Now, go under the Filter menu, under Sharpen, and choose **Unsharp Mask**. Enter 120% for the Amount, 1 for the Radius, and 3 for the Threshold (as shown here), and then click OK to apply the sharpening. Lastly, click back on the RGB channel in the Channels panel to return to your full-color image.

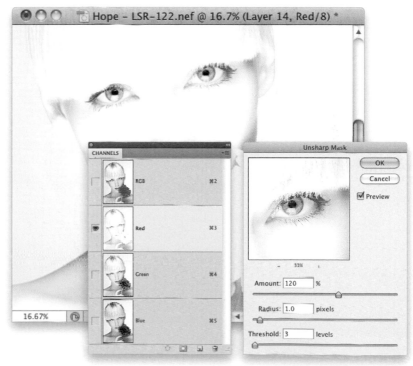

You can see the finished image shown full-page size at the beginning of this chapter.

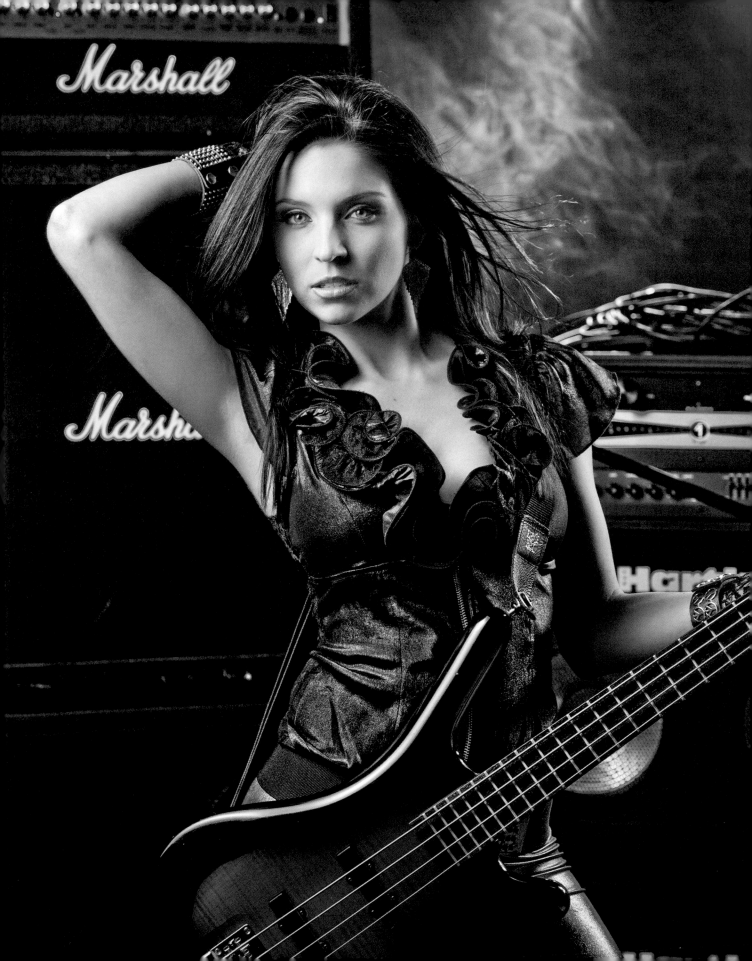

2-LIGHT EDGY SETUP

High-Contrast Lighting

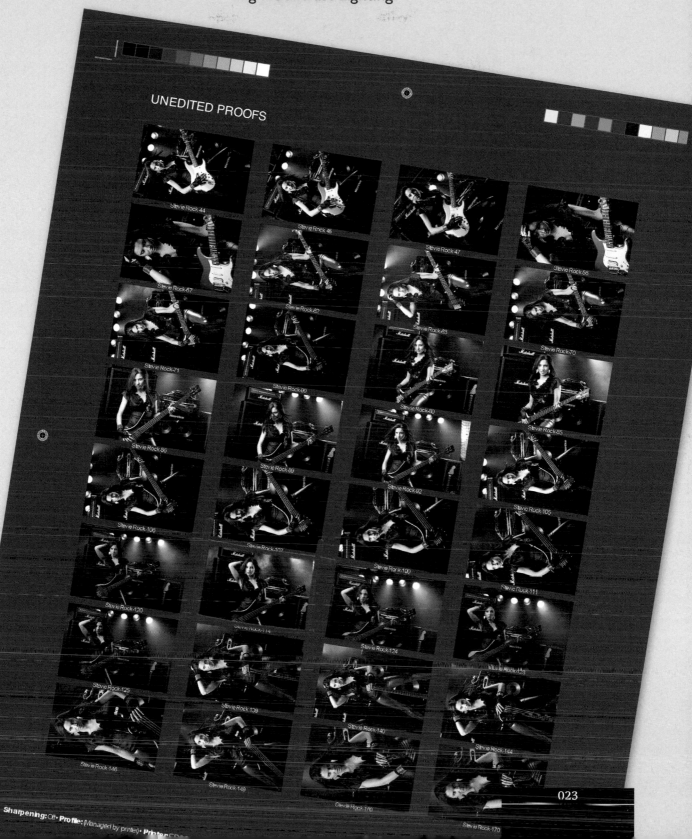

UNEDITED PROOFS

Sharpening: Off • Profile: (Managed by printer) • Printer

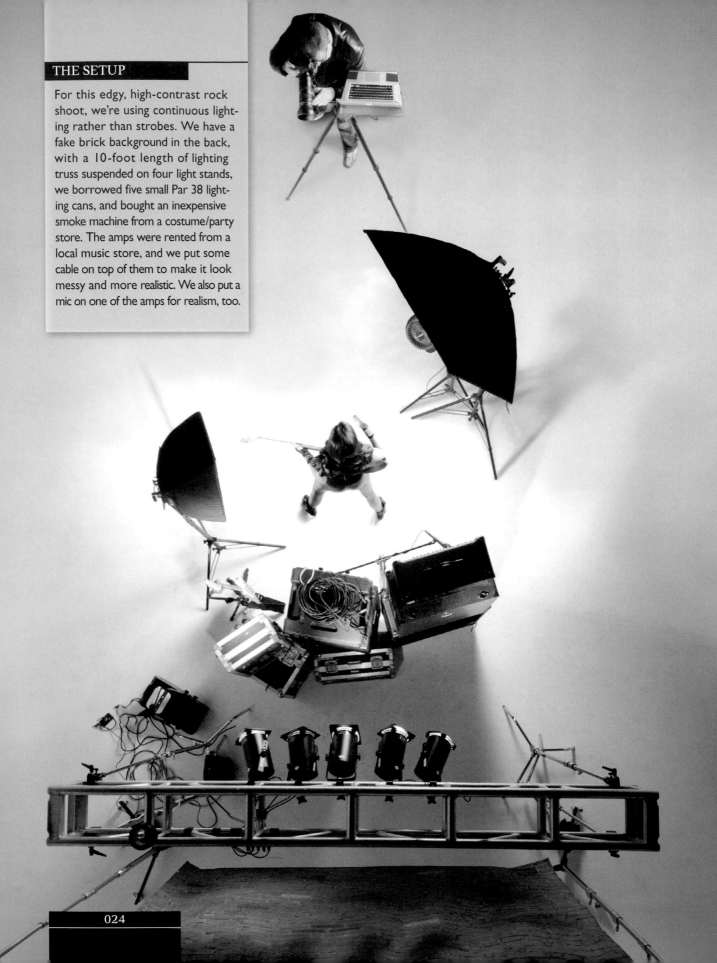

THE SETUP

For this edgy, high-contrast rock shoot, we're using continuous lighting rather than strobes. We have a fake brick background in the back, with a 10-foot length of lighting truss suspended on four light stands, we borrowed five small Par 38 lighting cans, and bought an inexpensive smoke machine from a costume/party store. The amps were rented from a local music store, and we put some cable on top of them to make it look messy and more realistic. We also put a mic on one of the amps for realism, too.

GEAR GUIDE

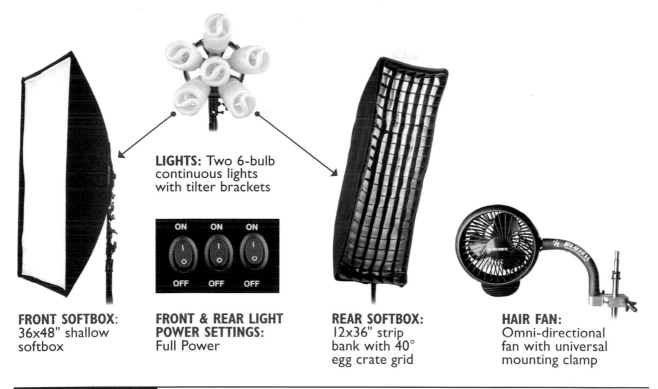

LIGHTS: Two 6-bulb continuous lights with tilter brackets

ON	ON	ON
OFF	OFF	OFF

FRONT SOFTBOX: 36x48" shallow softbox

FRONT & REAR LIGHT POWER SETTINGS: Full Power

REAR SOFTBOX: 12x36" strip bank with 40° egg crate grid

HAIR FAN: Omni-directional fan with universal mounting clamp

CAMERA SETTINGS

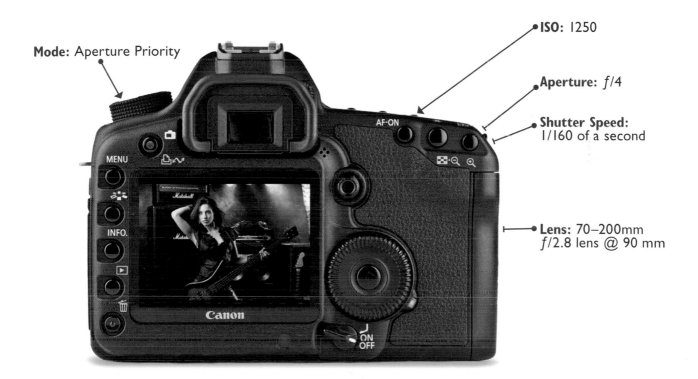

Mode: Aperture Priority

ISO: 1250

Aperture: ƒ/4

Shutter Speed: 1/160 of a second

Lens: 70–200mm ƒ/2.8 lens @ 90 mm

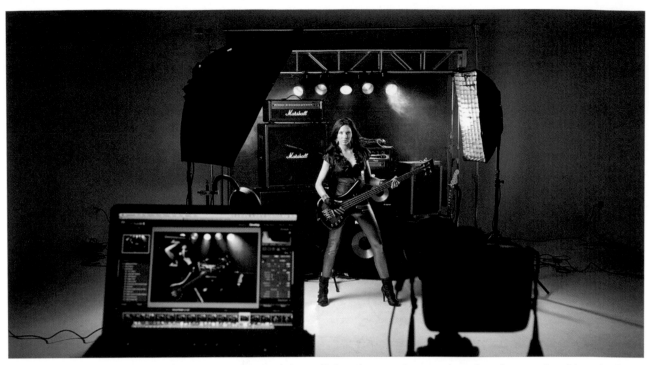

FRONT VIEW: This time, we're using continuous lighting (lights that are always on), rather than strobes (though, if you were using strobes, the placement of the lights, and the size and type of softboxes, would be exactly the same). I'm shooting on a tripod because the shutter speed is only 1/160 of a second and there's no flash to freeze the action.

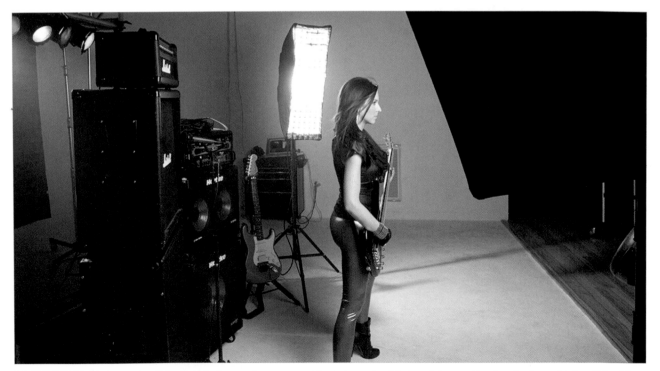

LEFT SIDE: To keep the light tightly focused on our subject, I used a fabric grid over the front of our kicker light (the strip bank) behind our subject (you can see it in the photo here). Start with only the rear kicker light turned on (turn off the front main light), and make sure the kicker lights your subject's hair and adds a rim light (back light) down her entire side.

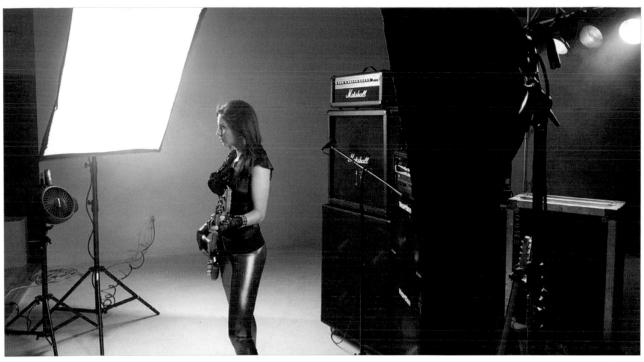

RIGHT SIDE: The main light (shown here) is positioned up high, aiming down at the subject at a 45° angle. By moving the light a little farther to her side, it puts shadows on the opposite side of her face—right between where the light from the main light ends and the kicker light begins is in shadow. You can see the placement of the hair fan here, too.

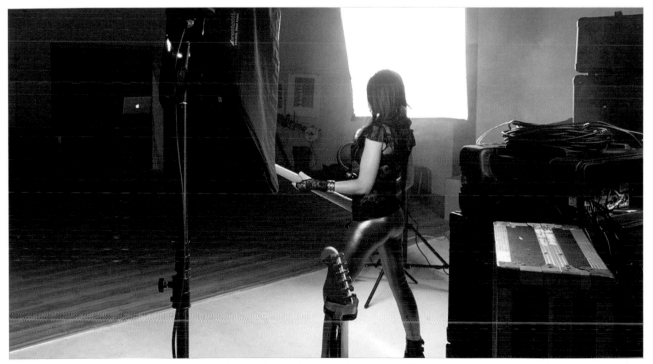

BACK VIEW: This view gives you a good idea of exactly where the main and kicker lights are positioned. You can see that they're almost directly across from each other. In fact, they're almost aiming at each other.

THE POST-PROCESSING

We'll start by processing the image in Camera Raw, and then afterward do some light retouching in Photoshop (some minor stuff). But, the biggest thing we'll do in Photoshop is to add a high-contrast effect to parts of the image.

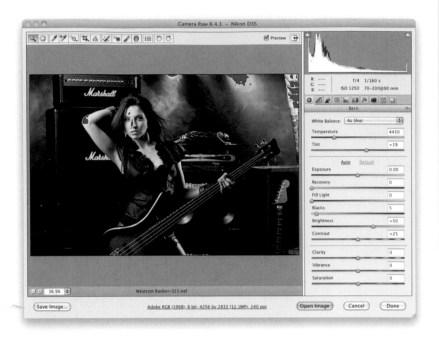

STEP ONE:

The first thing we need to check is the highlight clipping, so open the image in Camera Raw (if it's a JPEG or TIFF, navigate to the image in Adobe Bridge, click on it, then press **Command-R [PC: Ctrl-R]** to open the image in Camera Raw). Now, press the letter **O** on your keyboard, and any areas that are so bright that they're clipping will appear in red (as seen here). The red is there to warn you that there will be absolutely no detail whatsoever in these areas. The clipping on the lights doesn't bother me (there wouldn't be any detail there anyway), but the clipping on her elbow, nose, and forehead is a huge problem we're going to have to deal with first.

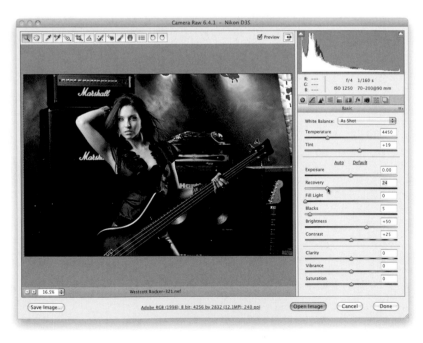

STEP TWO:

To bring back those clipped highlights, drag the Recovery slider to the right (as shown here) until they're gone. Just drag until they disappear on her face and elbow (I dragged it to 24 here), because dragging this slider up too high tends to make things look a little funky. So, I always try to use just the amount of Recovery I need and no more. You can still see some clipping in the light bulbs themselves, but, again, they wouldn't have any significant detail either way, so we don't need to worry about them.

STEP THREE:

After fixing the clipping, the next thing this photo really needs is more detail in her dark clothing, and that's where the Fill Light slider works wonders. Just drag it to the right a bit to bring out some details in her clothing. Here, I dragged the Fill Light slider to the right until it read 14. Of course, I wasn't looking at the number; I was looking at her clothing. I stopped dragging when I could clearly see the detail in her clothes, and that just happened to be 14. I wanted to let you know that, so you didn't think that 14 is some magic number—it just happened to work for this one particular photo. Some images will need more or less Fill Light, and as the retoucher, you're going to have to make the call as to how much is right for your image.

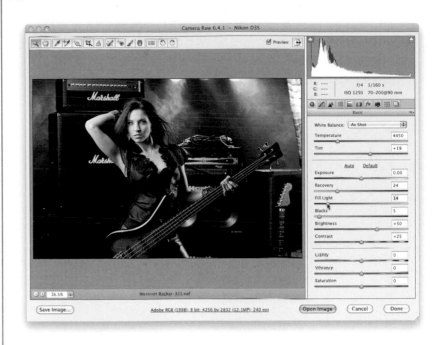

STEP FOUR:

To focus the light more on our subject, we'll darken the outside edges of the photo all around by adding a vignette effect. Click on the Lens Correction icon at the top of the Panel area (it's the fifth icon from the right), then click on the Manual tab. At the bottom of the panel, you'll see the Lens Vignetting section. Drag the Amount slider to the left to darken the edges (I dragged over to –75), then drag the Midpoint slider (which controls how far in from the edges the darkening extends) to around 27 (as seen here), so it darkens pretty far in from the edges.

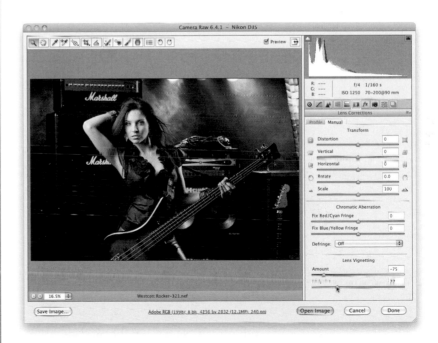

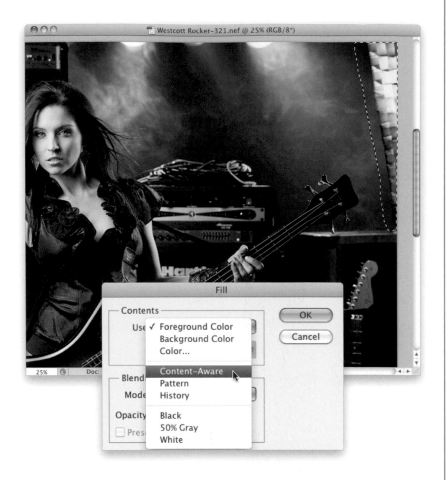

STEP FIVE:

Now, we have to get rid of the strip bank softbox that you see in the top-right corner of the image. So, click the Open Image button to open the photo in Photoshop, then get the Lasso tool (**L**) and draw a loose selection around it (as shown here). Then, go under the Edit menu and choose **Fill**. When the Fill dialog appears (shown here), from the Use pop-up menu at the top, choose **Content-Aware**, and then click OK.

STEP SIX:

Press **Command-D (PC: Ctrl-D)** to Deselect, and you can see the results of Content-Aware Fill—the softbox is gone! (I know—I'm still amazed by this feature.) By the way, I've found that if you try removing something like this and it doesn't work, try pressing **Command-Z (PC: Ctrl-Z)**, and then try it again. Sometimes you get a completely different effect. Also, here's something else to try: If it did an okay job removing some of the things you need removed, but not all of them, go ahead and deselect, then put a Lasso selection around just what it left behind and try Content-Aware Fill again. That'll usually do the trick.

STEP SEVEN:

Next, we're going to add a high-contrast effect based on a technique I learned from my friend, Germany-based retoucher Calvin Hollywood. Start by pressing **Command-J (PC: Ctrl-J)** to duplicate the Background layer. Then change the blend mode of this layer to **Vivid Light**. Next, Invert this layer by pressing **Command-I (PC: Ctrl-I)**. Now, you're going to apply a Surface Blur to this gray, messed-up looking layer. So, go under the Filter menu, under Blur, and choose **Surface Blur**. When the dialog appears, for Radius, enter 40 pixels, and for Threshold, enter 40 levels, and click OK. (*Note:* The Surface Blur filter is one of the slowest filters, so depending on the speed of your computer, it might take a minute or two.)

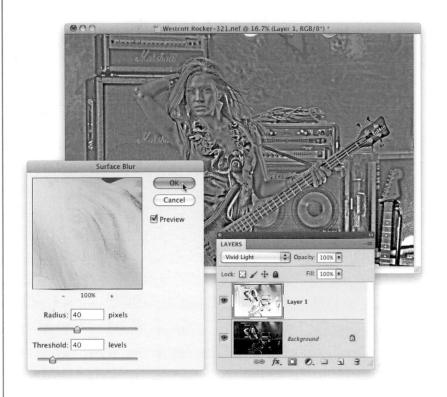

STEP EIGHT:

Now, you're going to create what's called a merged layer by pressing **Command-Option-Shift-E (PC: Ctrl-Alt-Shift-E)**. This creates a new layer on top of your existing layers that looks like you flattened the image. Once you've created this layer, you can delete Layer 1 (the layer directly beneath it—the one where you added the Surface Blur). Next, you need to remove the color from this merged layer by pressing **Command-Shift-U (PC: Ctrl-Shift-U)**. Now, change the blend mode of this top layer from Normal to **Overlay**, and the high-contrast effect is applied to your entire image (as you see here). It looks good in most places, but you can see a few areas—like near the lights, to the left of the Marshall amps, the middle of the bass, and on her skin—where it looks blotchy. We'll fix that next.

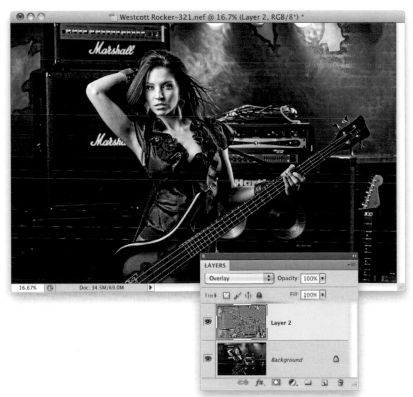

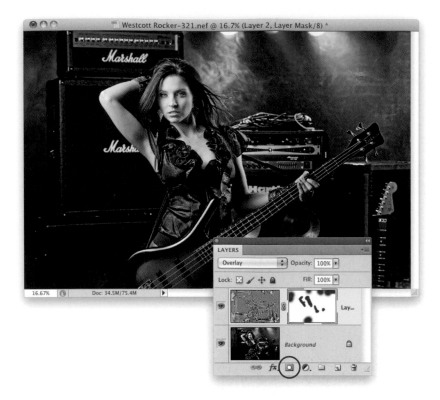

STEP NINE:

Click once on the Add Layer Mask icon at the bottom of the Layers panel (it's circled in red here) to add a layer mask to this layer. Now, get the Brush tool **(B)**, choose a medium-sized, soft-edged brush, and make sure your Foreground color is set to black. Then, paint over the blotchy areas near the lights, to the left of the Marshall amps, and in the center of the bass (the reddish-brown area where the pick-ups are). Shrink the brush size down and then paint over her skin, because this high-contrast look wreaks havoc with women's skin, even though it usually looks pretty good on guys (guys look good with lots of enhanced texture on their skin. Girls, well, not so much). As you paint in black over those areas, the effect is removed from just those spots.

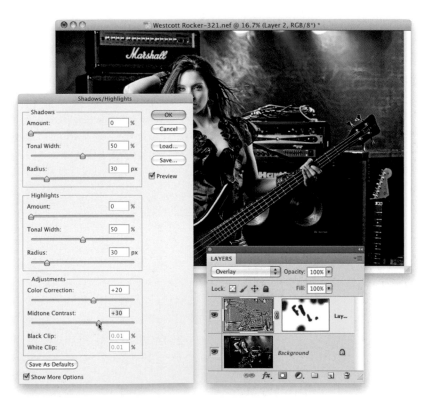

STEP 10:

Now that those problem areas are gone, let's crank up the high-contrast effect even more. Start by going to the Layers panel and clicking directly on the gray thumbnail for the top layer (you were working on the layer mask, but now we need to work on the image instead). Next, go under the Image menu, under Adjustments, and choose **Shadows/Highlights**. When the dialog appears, set the Shadows Amount down to 0% (by default it cranks it up to 35%, but you don't want to lighten the shadows now). Then, go down to the Adjustments section near the bottom of the dialog (if you don't see this section, turn on the Show More Options checkbox), and drag the Midtone Contrast slider to the right to make this layer even more con-trasty (as seen here). Now click OK.

STEP 11:

One last thing to really take the high-contrast look up a notch: Go to the Layers panel's flyout menu and choose **Flatten Image**, then go to the Channels panel and click on the Red channel (seen here). When sharpening photos of women, we try to avoid sharpening skin texture, because we want women's skin to look soft, not rugged and textured. By clicking on the Red channel before you apply any sharpening, you're avoiding sharpening the skin texture (which is found mostly in the Green and Blue channels). Now, you're sharpening everything else but her skin (for the most part, anyway). Once you've clicked on the Red channel, go under the Filter menu, under Sharpen, and choose **Unsharp Mask**. When the dialog appears, enter 120% for the Amount, set the Radius to 1, set the Threshold to 3, and click OK. This is one of my favorite settings for adding some punchy sharpening to an image.

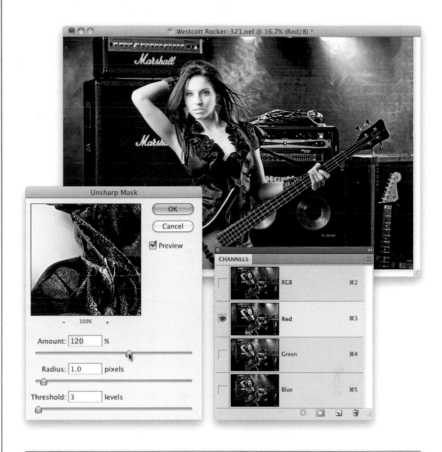

STEP 12:

Now, click on the RGB channel to return to the full-color image. There is one little thing I'd retouch, and that's the shadows under her arm on the left, above her armpit. To do that, get the Clone Stamp tool **(S)**, then go up to the Options Bar and change the tool's blend Mode to **Lighten** (so it will only affect pixels that are darker than where you sample from). Then, lower the Opacity of this tool to around 40%. Now, Option-click (PC: Alt-click) in a lighter area of her arm, a little bit above where the dark area is located, then clone right over that dark area until it's gone (as shown here) to complete the retouch.

You can see the finished image shown full-page size at the beginning of this chapter.

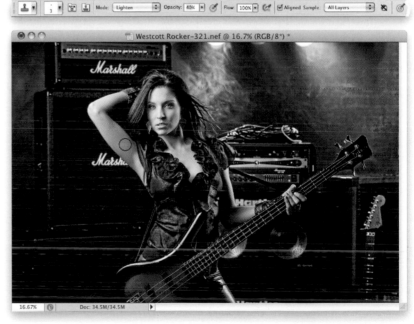

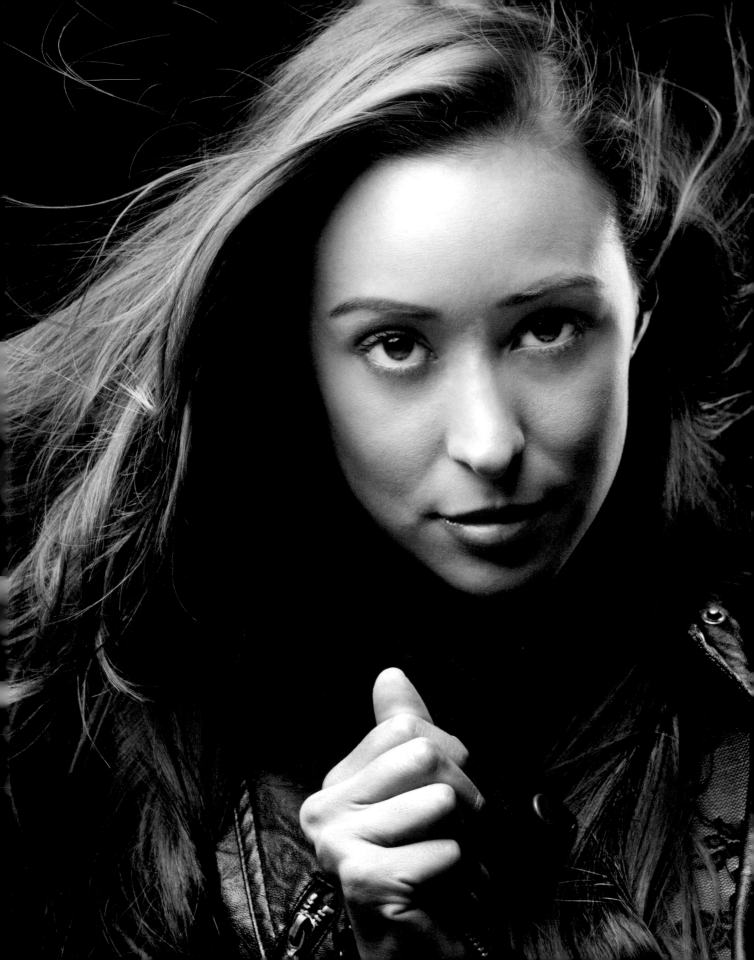

2-LIGHT DRAMATIC SETUP
Dramatic Glamour Lighting

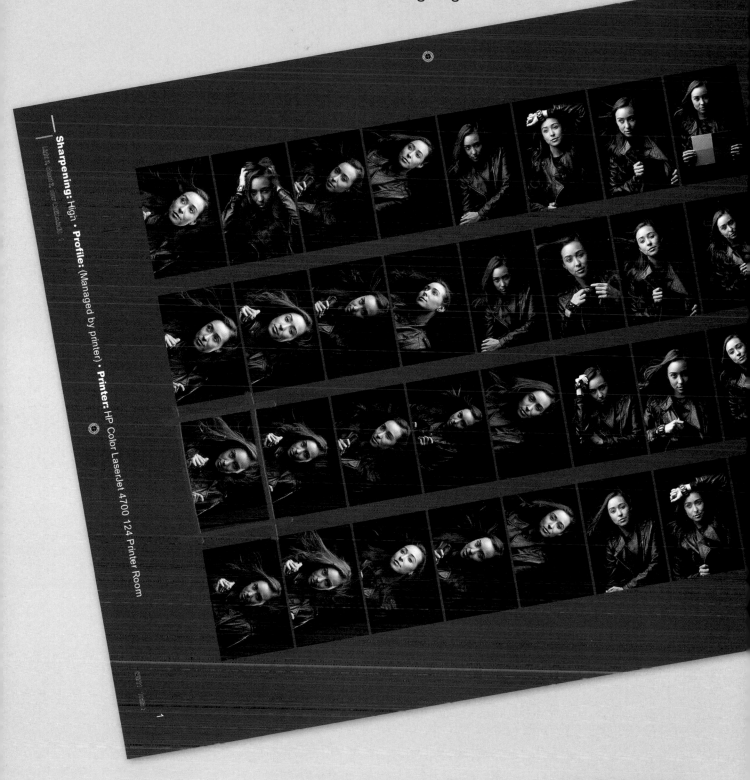

Sharpening: High • **Profile:** (Managed by printer) • **Printer:** HP Color LaserJet 4700 124 Printer Room

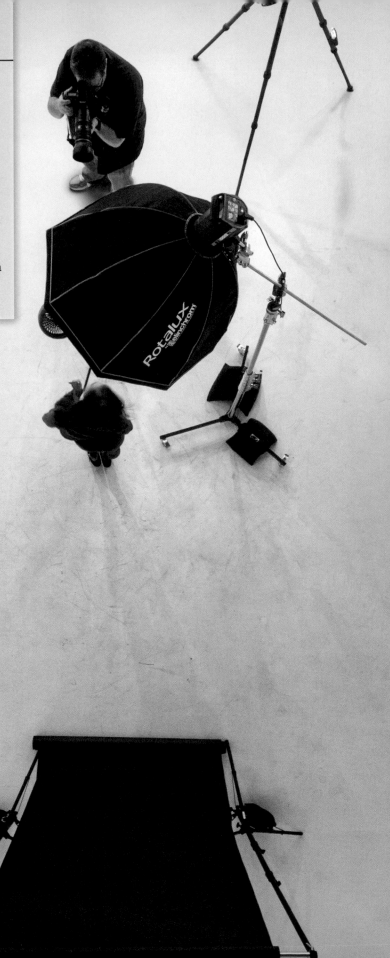

THE SETUP

The idea here is to create a very dark, dramatic look. You can create this look with either one or two lights, and if you look at the thumbnails on the previous page, you'll see my shoot started with just the one main light you see here to the right. But, because her hair was dark against the dark black seamless paper, I added a strip bank in the back to light the other side of her hair, yet still leave some shadows and drama on the left side of her face.

GEAR GUIDE

FRONT STROBE: 500-watt unit with 39" octabank softbox

REAR STROBE: 500-watt unit with 12x36" strip bank and 40° egg crate grid

HAIR FAN: Omni-directional fan with universal mounting clamp

FRONT STROBE'S POWER SETTING: 4.5

REAR STROBE'S POWER SETTING: 3.1 (its lowest setting)

CAMERA SETTINGS

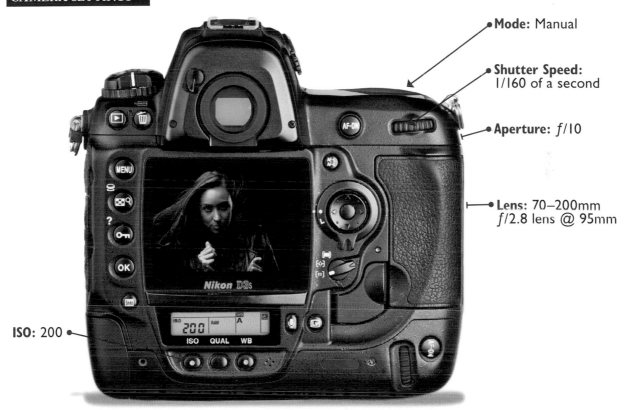

Mode: Manual

Shutter Speed: 1/160 of a second

Aperture: f/10

Lens: 70–200mm f/2.8 lens @ 95mm

ISO: 200

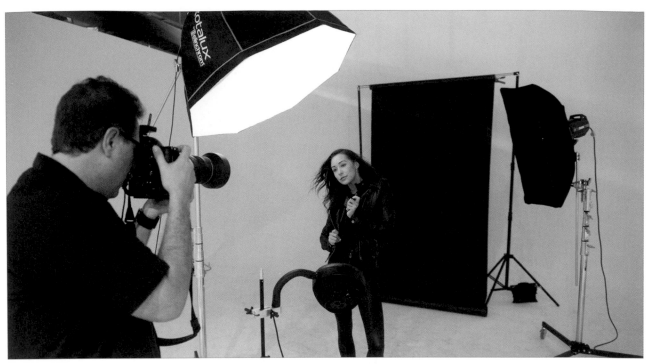

FRONT VIEW: You can see from this shot, our subject is positioned nearly behind the main light. The softest light is near the edges, and you'll hear this technique of putting your subject right near the edge of the light called "feathering the light."

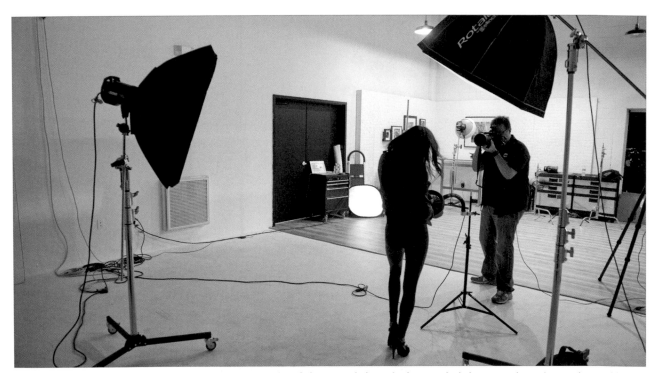

LEFT SIDE: This view lets you see the sharp angle of the main light, which is angled down at the subject almost like a showerhead. In this shot, we're using a boom stand to hold the light, but this also works with a regular stand by just tipping the light down as far as it will go, and then raising it up high.

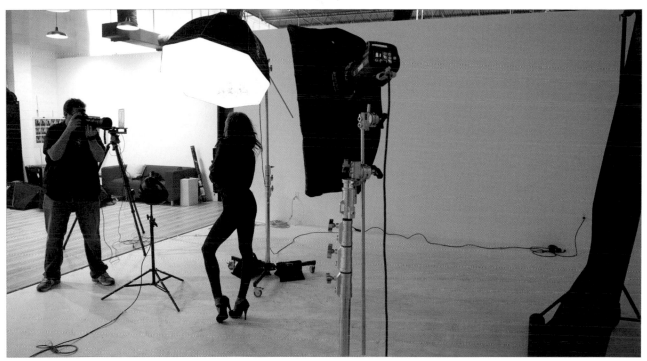

RIGHT SIDE: You can really see our subject's position, relative to the main light, in this shot. You can see the kicker light (the strip bank) from here, as well. It's opposite the main light (look at the position of the light stands, not the angle of the Deep Octa softbox up front).

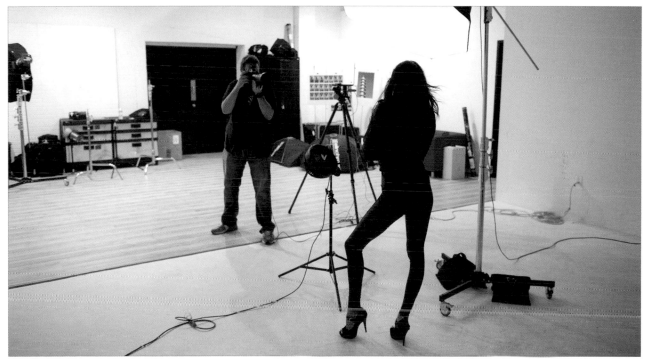

BACK VIEW: From this view (shot from the kicker light's position), you can also see the light-stand-mounted fan I'm using to give some movement to the subject's hair.

THE POST-PROCESSING

A lot of our retouching here is using Photoshop to take the quality of our lighting up a notch by brightening certain areas and darkening others. Also, we have to paint over one of the supports for the black seamless (you can't really see it right now, but when you brighten things up a bit, all of sudden it appears, so we have to deal with it. Don't worry—it's easy).

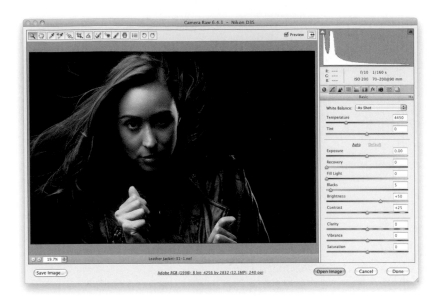

STEP ONE:
Here's the image open in Camera Raw. There are only two things we need to do here, and they are: brighten the overall exposure (I meant it to be dark and dramatic, but this might be a little too dark), and add a little more light in her eye sockets.

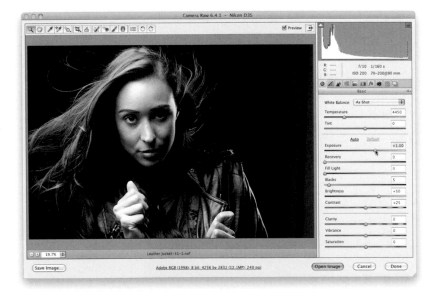

STEP TWO:
To increase the overall exposure, just drag the Exposure slider to the right until it reads +1.00 (as shown here). Now you can see that background support stand on the right side of the image—we're going to have to darken that area to hide it, and we might as well do that now in Camera Raw.

STEP THREE:

Before we fix that background, though, let's brighten the eye sockets: Get the Adjustment Brush from the toolbar (**K**; it's shown circled here in red), and then in the Adjustment Brush panel, click the + (plus sign) button to the right of the Brightness slider to zero out the rest of the sliders and increase the Brightness by 25. Now, take the brush and paint over the right eye to brighten it up a bit. Once you're done painting, if you think +25 is not quite enough, you can drag the slider to the right to make it brighter (I ended up dragging it to +30). Click the New radio button, and then click the – (minus sign) button to the left of the Brightness slider two times to set the Brightness to –50. Now, paint over the far-right side of the image (right over the background support) with this brush to darken it enough so that you can't see the stand any longer. Click the Open Image button to open it in Photoshop.

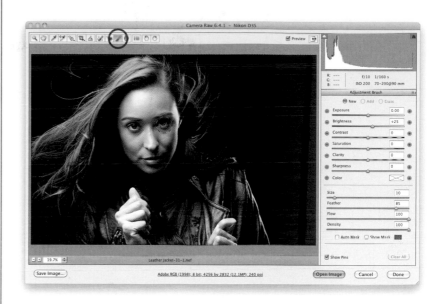

STEP FOUR:

Now that we're in Photoshop, let's do some portrait retouching. Of course, start with removing any obvious blemishes or lines using the Healing Brush (as shown in Chapter 1). Then, let's get rid of the dark circles under her eyes (caused by the lighting coming down at such a steep angle). Get the Healing Brush tool (**J**), and up in the Options Bar, change the brush's Mode to **Lighten**. That way, it only affects the pixels that are darker than where you sampled. Press-and-hold the Option (PC: Alt) key, and click in a clean area right below the dark circles, then paint them away (as shown here).

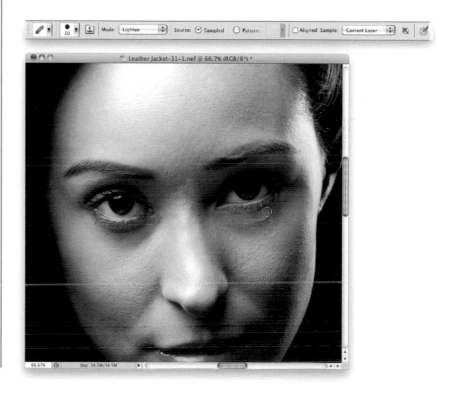

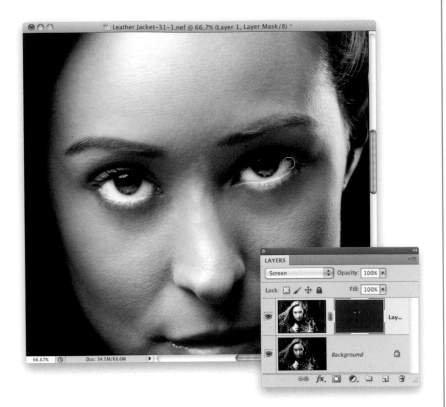

STEP FIVE:

Now let's brighten the whites of the eyes and her irises (they're both fairly dark). Press **Command-J (PC: Ctrl-J)** to duplicate the Background layer, then change the blend mode of this layer from Normal to **Screen**. This makes everything much brighter, but we only want parts of her eyes brighter, so Option-click (PC: Alt-click) on the Add Layer Mask icon at the bottom of the Layers panel. This puts a black mask over that brighter Screen layer. Now, get the Brush tool **(B)**, set your Foreground color to white, choose a small, soft-edged brush from the Brush Picker, and paint over the whites of her eyes and the insides of her irises (but stay away from the dark ring around the edge of the iris). When you're painting over the whites of the eyes, don't sweat it if you spill a little below the whites, onto her lower eyelid (like I have here), just switch your Foreground color to black and paint away those mistakes.

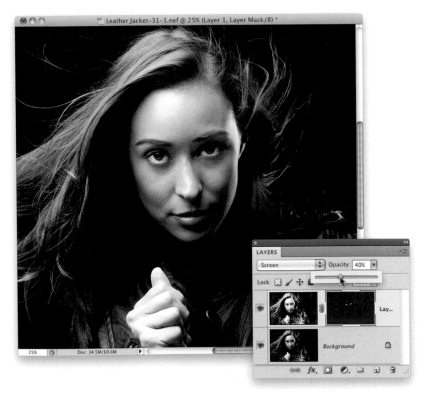

STEP SIX:

Now, zoom back out and let's lower the opacity of this Screen layer. The reason we zoom back out at this point is that it's really hard to judge how bright the whites should be when you're zoomed in tight, and generally, I've found that we're more likely to overdo the whitening, which looks really bad, so zoom out to make better decisions on stuff like this. When we zoom out, it looks like we should lower this eye whitening layer's Opacity to around 40% (as shown here).

STEP SEVEN:

You might not have noticed this, because it's one of those things that doesn't drive everybody crazy like it does me, but if you look at her hands in the previous step, they look a lot brighter than they should (her face should be the brightest thing in the image). As a matter of fact, they're so bright they're almost glowing. Luckily, it's an easy fix. Go to the Adjustments panel and click on the Levels icon (the second one in the top row). Then, in the Levels options, drag the center midtones slider to the right, until her hands look much darker and better match the skin tone in her face in the last step (here, I dragged it to 0.50). By the way, if you try this and it makes the skin tone change color (not just darken), then change the blend mode of this adjustment layer to Luminosity.

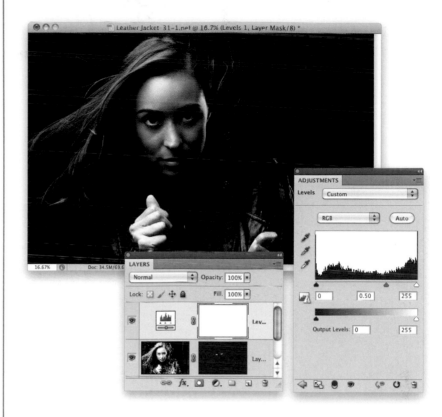

STEP EIGHT:

Now, since we only wanted her hands to be darker, press **Command-I (PC: Ctrl-I)** to Invert the layer mask and make it black. This hides the Levels adjustment. So, set your Foreground color to white, get the Brush tool, and with a medium-sized, soft-edged brush, paint over her hands.

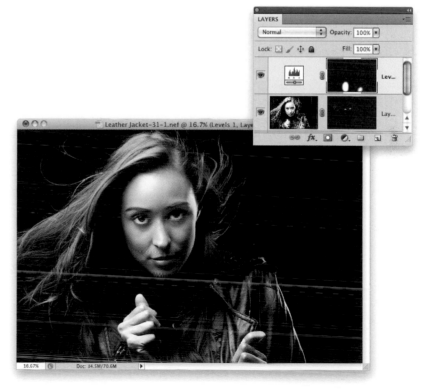

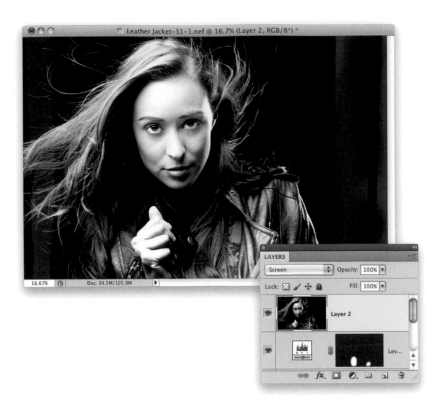

STEP NINE:

Looking at the image in the previous step, her face could still be a little brighter, so start by making a merged layer by pressing **Command-Option-Shift-E (PC: Ctrl-Alt-Shift-E)**, which basically creates a new layer on top of the layer stack that looks like a flattened version of your image. Now, to brighten her face, change the layer's blend mode to **Screen**. This makes the entire image much brighter, and it also makes the background stand a little bit visible again, but we'll deal with that in a minute.

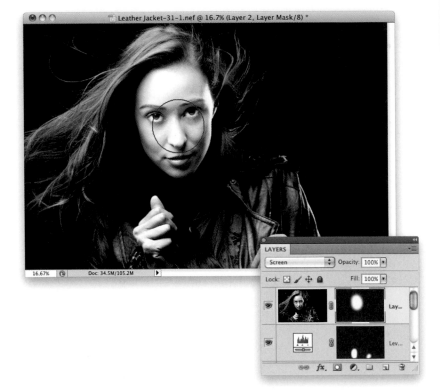

STEP 10:

Press-and-hold the Option (PC: Alt) key and click on the Add Layer Mask icon to put a black mask over that Screen layer. Now, choose a large, soft-edged brush, set your Foreground color to white, and click a few times right over her face to brighten just that area (remember, the rest of the brightening is hidden behind that black mask). Of course, it's too bright, but we'll fix that in the next step.

STEP 11:

Go to the Layers panel and lower the Opacity of this Screen layer until it looks about right to you (here, I lowered it to 40%).

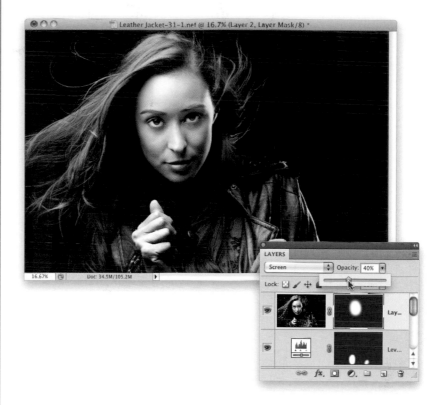

STEP 12:

The background stands are still a little visible, so let's go ahead and fix that. Creat a new merged layer then set your Foreground color to black, get the Brush tool, and just paint right over that stuff. You'll have to paint a little on the left, too.

STEP 13:

Now let's enhance the lighting in her hair. Create another merged layer, and change its blend mode to Screen, too. Hide this Screen layer behind a black layer mask (like we did before), then take the Brush tool and paint over the highlights in her hair in white to make them brighter. Finally, lower the layer's Opacity to around 50% (as shown here).

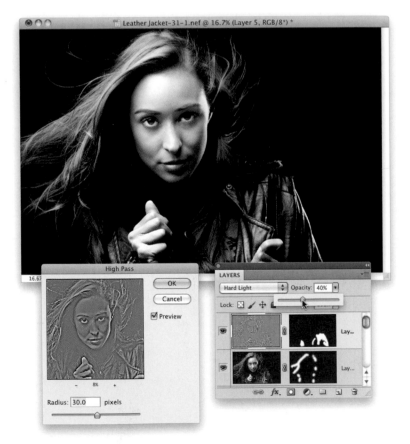

STEP 14:

Our last step is to bring out the detail in her jacket by adding a High Pass filter to the entire image, and then hiding that behind a black mask and just painting over the jacket. Start by creating a new merged layer, then go under the Filter menu, under Other, and choose **High Pass**. When the High Pass dialog appears, increase the Radius to 30 pixels, and click OK. Now change the layer's blend mode to **Hard Light**. This should look pretty awful on everything but the leather jacket. So, Option-click (PC: Alt-click) on the Add Layer Mask icon to hide this super-sharpened layer behind a black mask, then get the Brush tool again, and paint over her jacket with white. Lastly, lower the Opacity of this sharpening layer to around 40% to complete the image.

You can see this finished image at full-page size at the beginning of the chapter.

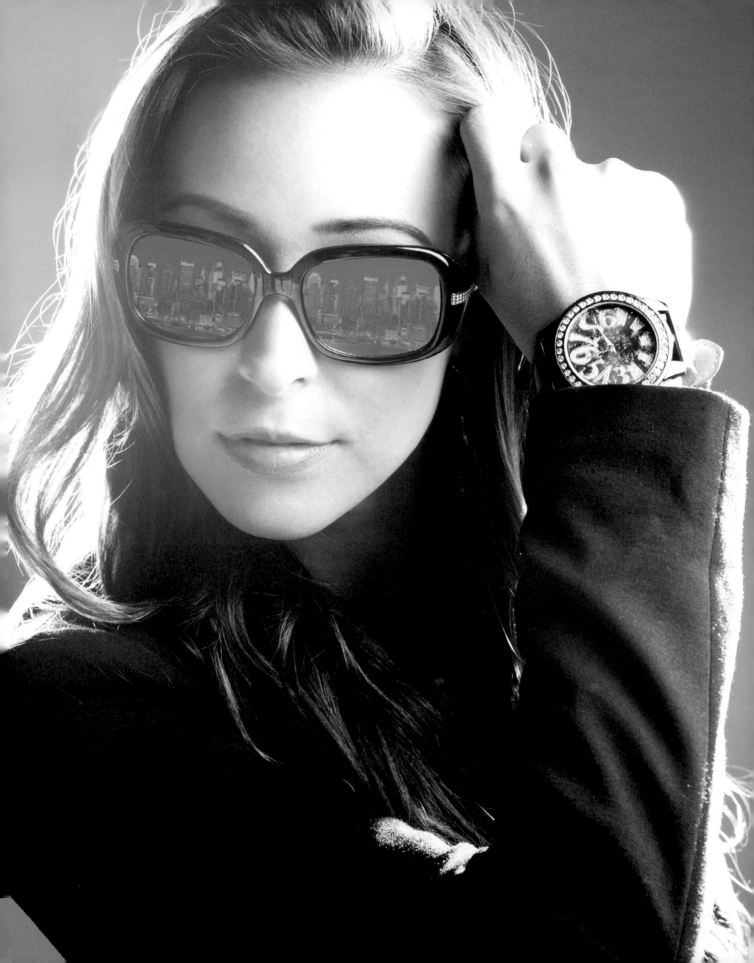

3-LIGHT LENS FLARE SETUP

Lens-Flare Lighting

UNEDITED PROOFS

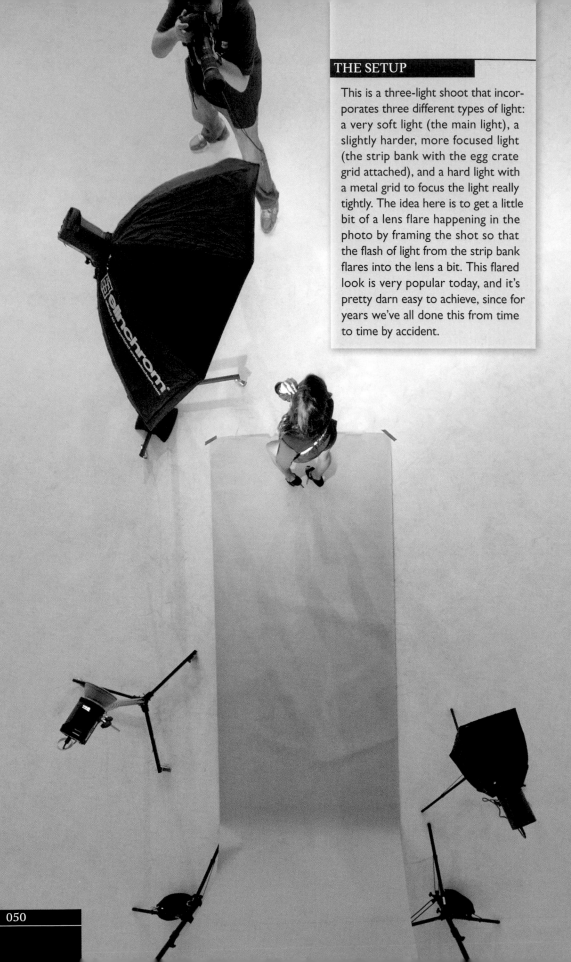

This is a three-light shoot that incorporates three different types of light: a very soft light (the main light), a slightly harder, more focused light (the strip bank with the egg crate grid attached), and a hard light with a metal grid to focus the light really tightly. The idea here is to get a little bit of a lens flare happening in the photo by framing the shot so that the flash of light from the strip bank flares into the lens a bit. This flared look is very popular today, and it's pretty darn easy to achieve, since for years we've all done this from time to time by accident.

GEAR GUIDE

FRONT STROBE:
500-watt unit with
53" octabank softbox

LEFT REAR STROBE:
500-watt unit with
12x36" strip bank
with 40° egg crate grid

RIGHT REAR STROBE:
500-watt unit with
7" reflector with
20°grid spot

**FRONT STROBE'S POWER
SETTING:** 3.6

**LEFT REAR STROBE'S
POWER SETTINGS:** 5.0

**RIGHT REAR STROBE'S
POWER SETTINGS:** 6.3

CAMERA SETTINGS

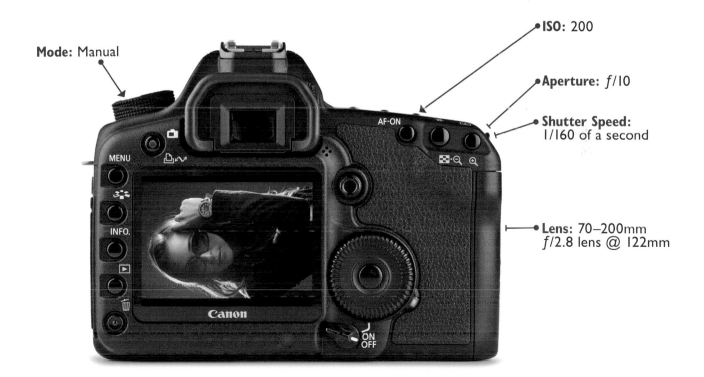

Mode: Manual

ISO: 200

Aperture: *f*/10

Shutter Speed:
1/160 of a second

Lens: 70–200mm
f/2.8 lens @ 122mm

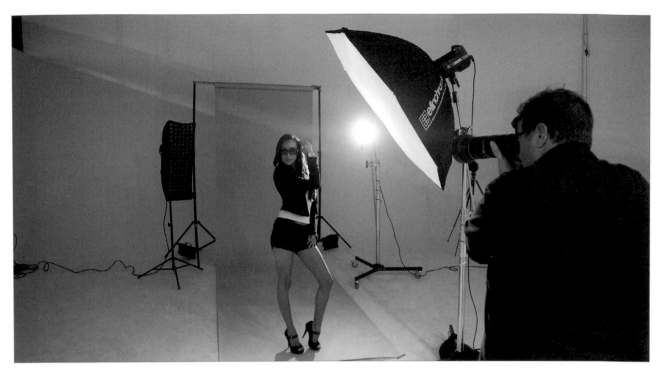

FRONT VIEW: Here you can see all three lights: the main light in front, the hard light behind her on the right, and the softer, but still focused, light with the strip bank on the left. Although the strip bank sends out a thinner column of light than a standard large softbox, by putting an egg crate grid in front of that, it narrows the beam even further and makes it more directional. Perfect for hair or rim light.

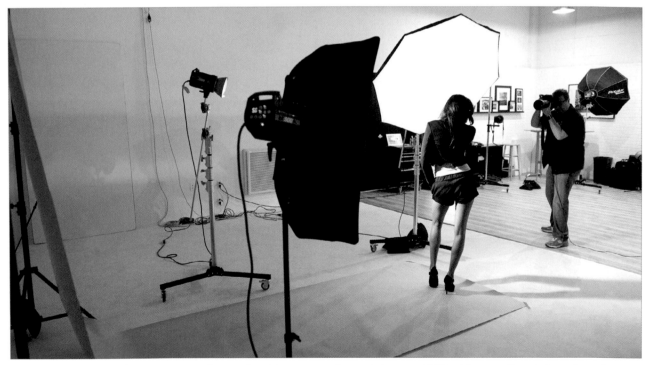

LEFT SIDE: In this shot, you can really see the right rear strobe, and the metal 20° grid snaps directly into the reflector (well, at least the one I use does. Depending on your reflector, you might have to use black gaffer's tape to hold the grid over the reflector).

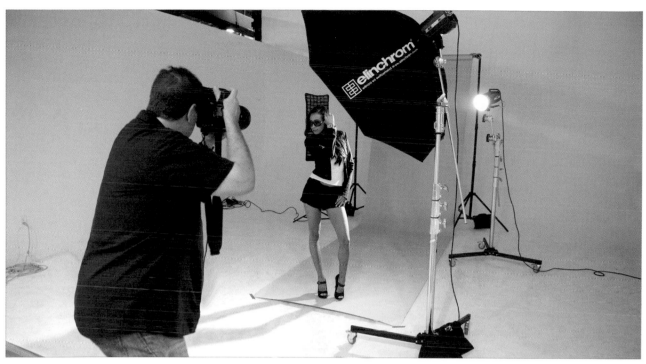

RIGHT SIDE: In this image, you can see that I'm not standing directly in front of the subject—I'm standing a few feet off center, aiming almost directly into the strip bank on the left side (the one with the egg crate grid)—and that's what's creating the "lens-flare" look.

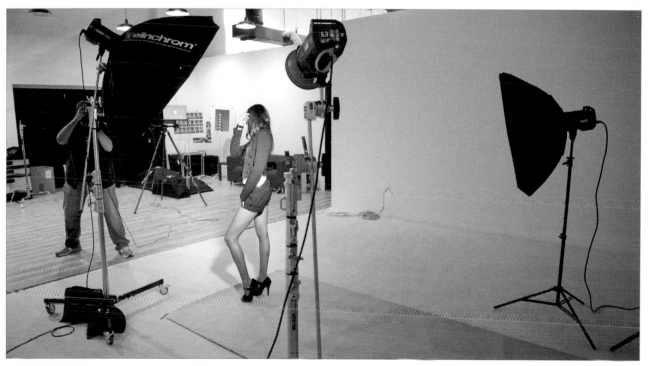

BACK VIEW: Again, we're using a 20° metal grid on the right rear strobe, and the degree determines how narrow the beam created by the grid will be. A 30° grid would create a wider beam, and a 10° grid would create a very thin beam, like a really powerful flashlight.

THE POST-PROCESSING

This shot makes use of the blown-out, lens-flare look to some extent, but we're going to enhance that effect quite a bit in Photoshop. We're also going to add a cool blue tint to the image, and then composite in a reflection of New York City's skyline in her sunglasses (adding a reflected image in the sunglasses that wasn't really there is pretty popular these days). Although this might seem like a pretty simple retouch at first, I think you'll be surprised at how many things we have to deal with along the way to get to the final image.

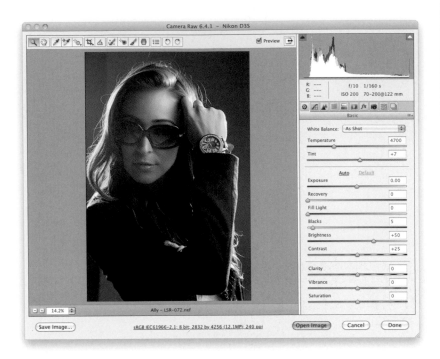

STEP ONE:
Here's the original RAW photo out of the camera open in Camera Raw. While the hair on both sides is pretty well lit, and there's a nice rim light going down her arm and shoulder, her face is a little dark, and it doesn't look as "blown out" as we'd like. So, we'll start working on that in the next step (I just wanted us to take a look at our original starting image first).

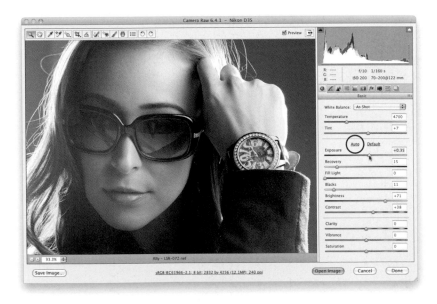

STEP TWO:
If an image looks underexposed, you can often get to a pretty good starting place by simply clicking on the Auto link (shown circled here in red) and seeing what it does. If it looks okay (like it does in this case, where her face, and the entire image for that matter, is brighter and more balanced), then you can tweak things from there. If you click on the link and it doesn't look good, no biggie—just press **Command-Z (PC: Ctrl-Z)** to Undo it. Even after applying Auto, we'll still want to bump up the highlights here a little more (even if it clips a tiny bit), so drag the Exposure slider to the right to +0.35.

STEP THREE:

To add a cool blue tint to the image, click on the Split Toning icon at the top of the Panel area (it's the fifth icon from the left). We're not going to actually add a split tone effect here (where you have one color applied to the highlights and a different color applied to the shadows), we're just going to adjust the shadows, so it's more like a duotone effect instead. First, increase the Shadows Saturation to around 43 (so you can see the color appear in the image), then drag the Shadows Hue slider to the right to 240 to give you the nice bluish tint you see here. It's just applied to the shadow areas, so you can still see some of the original color and skin tones.

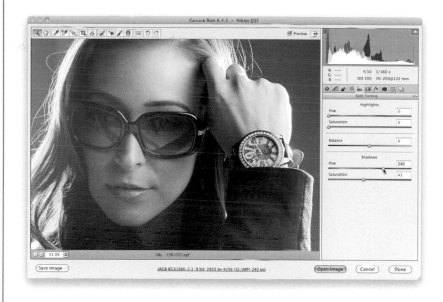

STEP FOUR:

Go ahead and click the Open Image button at the bottom right of the window to open the photo in Photoshop. Here, you can see the full image and how the blue tint looks overall. Now, there are two things we need to do to enhance the contrast and the blown-out effect (two totally different things that actually work together).

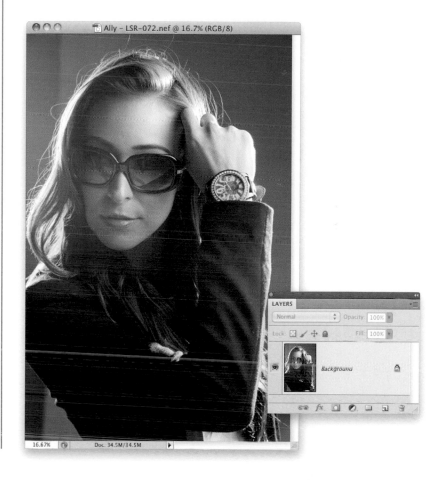

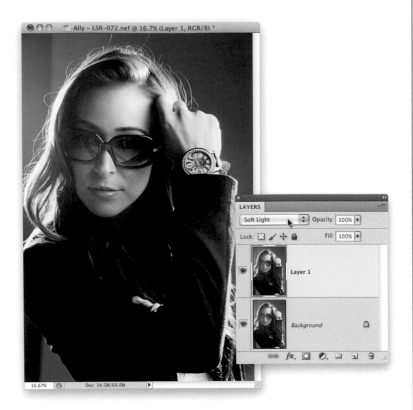

STEP FIVE:

To bring some contrast back into the image, press **Command-J (PC: Ctrl-J)** to duplicate the Background layer, then change the layer's blend mode from Normal to **Soft Light** (as shown here). This adds more contrast and snap to the image, but it also made some of the areas in her coat a little dark, as well.

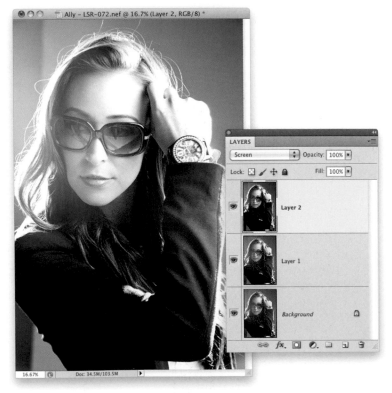

STEP SIX:

Now, to help us get that blown-out look, first we're going to create a merged layer (a layer on top of the layer stack that looks like a flattened version of our image) by pressing **Command-Option-Shift-E (PC: Ctrl-Alt-Shift-E)**. Once the merged layer appears at the top of the layer stack, change its blend mode to **Screen**. This makes our contrasty image look much brighter, and really gives us that blown-out look. But, because we did the Soft Light move first, the image still has nice contrast, even though it's very bright.

STEP SEVEN:

The large wristwatch our subject is wearing is one of the focal points in our image, so we don't want the face of it to look all blown out. We'll do a quick 30-second trick to fix it. Create another merged layer on top of your layer stack and change its blend mode to **Multiply** to make the entire image much darker.

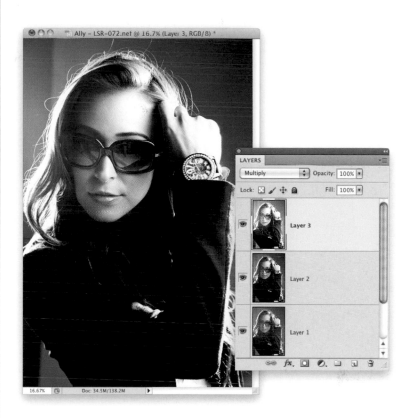

STEP EIGHT:

Of course, we don't want the entire image to be darker and more contrasty—just the watch. So, press-and-hold the Option (PC: Alt) key and click on the Add Layer Mask icon at the bottom of the Layers panel. This puts a black mask over your Multiply layer (as seen here) and now that dark layer is hidden from view. So, get the Brush tool **(B)**, choose a small, soft-edged brush, set your Foreground color to white, and then begin painting over the face of the watch, and the diamonds around it, to reveal the darker version of the wristwatch (as seen here).

STEP NINE:

One of the problems we have to deal with next is that you can see the edge of the seamless paper behind her on the left side. Now, you could try to clone away that edge, but I tried it, and it's trickier than you might think (and definitely more time consuming than what I'm going to show you). Start by creating another merged layer at the top of the layer stack, and then click on the Create a New Layer icon at the bottom of the Layers panel to create a new blank layer above that (that's where we're going to do our painting). We'll work on the seam on the top left first, so get the Eye-dropper tool (**I**), and click it once just to the left of her hair (as shown here) to make that light blue color your new Foreground color.

STEP 10:

Now, switch back to the Brush tool, choose a small, soft-edged brush, and paint over that entire area where the seam is—all the way over to the left corner. There's going to be an area, though, almost right above her hair, where the lighter blue color you've been painting with collides with the darker blue found up there. If you don't do something to blend the two together, you're going to see a new seam up there where they clash. The trick to making these blend is to go up to the Options Bar and lower the brush Opacity to 50%. Then, paint over that area, and the lighter blue color will blend nicely with the darker blue, and you won't see a hard seam where the two overlap.

STEP 11:

Next, let's work on the bottom-left corner. First, click on the merged layer near the top of the layer stack, then get the Quick Selection tool **(W)** and paint over that area in the bottom left to put a selection around it (as shown here. It takes all of five seconds). Now, switch back to the Brush tool. You're going to have to sample the light blue color that's down there, but luckily you can do that without switching tools in the Toolbox. Just press-and-hold the **Option (PC: Alt) key** and your Brush tool temporarily changes into the Eyedropper tool (for as long as you have the Option key held down). Then, click it on that lighter blue color, let go of the Option key, and you're back to the Brush tool.

STEP 12:

Create another new blank layer, drag it to the top of the layer stack, and then start painting over that darker blue area with your light blue color, until the seam is gone (as shown here). Now, you can Deselect by pressing **Command-D (PC: Ctrl-D)**, but we're not quite done yet.

STEP 13:

While you're cleaning up the background, get the Clone Stamp tool (**S**), increase the Hardness setting in the Brush Picker to around 70%, and start cleaning up any stray hairs (as shown here). Option-click (PC: Alt-click) to sample a nearby area and focus on the stuff that sticks way out from her head. Also, while you're near the face, get the Healing Brush tool (press **Shift-J** until you have it) and remove any obvious facial blemishes by making your brush size a little larger than the blemish you want to remove, then Option-clicking on a nearby area of clean skin. Make sure **All Layers** is selected from the Sample pop-up menu in the Options Bar, then move your cursor over the blemish, and click once to remove it.

STEP 14:

Now, we'll put an image into the lenses of her sunglasses (after all, you can see my legs, and the studio floor, and well…it looks kinda lame). So, create another merged layer at the top of the layer stack, and then make a selection around one of the lenses with the selection tool of your choice. Here, I used the Magnetic Lasso tool (press **Shift-L** until you have it). To use it, click once on the edge of one of the lenses, and just move your cursor all the way around the lens, clicking to drop selection points—it senses where the edge is and snaps your selection to it (it's one of the most underrated selection tools). Once you have a lens fully selected, go under the Select menu, under Modify, and choose **Contract**. Enter 2 pixels (as shown here) and click OK to shrink the selection in a bit. We do this so that a little area of black shadow remains around the edge of the lens, so when we paste our image in, it looks like it's inside the frame, rather than stuck on top of the lens.

STEP 15:

Open the image you want to put inside the sunglasses (in this case, an image of the Manhattan skyline at dusk, courtesy of iStockphoto.com), press **Command-A (PC: Ctrl-A)** to select the entire image, then press **Command-C (PC: Ctrl-C)** to Copy it.

STEP 16:

Now, go back to your portrait image, where your lens selection should still be in place. Go under the Edit menu, under Paste Special, and choose **Paste Into** to paste your copied skyline image into the frame. Once it's pasted, you'll see that it's much more contrasty, it doesn't have the blue tint, and it's way too large. So, what do you say we scale it down, tint it blue, and make its contrast match the rest of the image? (Note: If your selection wasn't entirely perfect, you can switch to the Brush tool and paint with white to add to the selection, or paint with black to remove areas from it.)

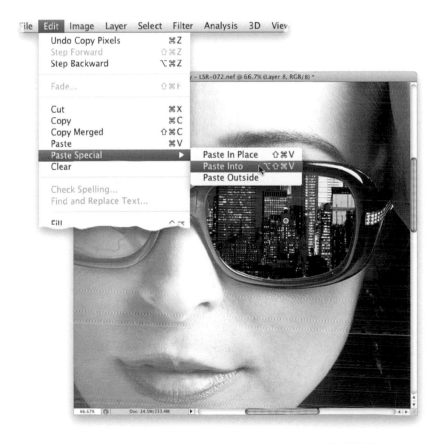

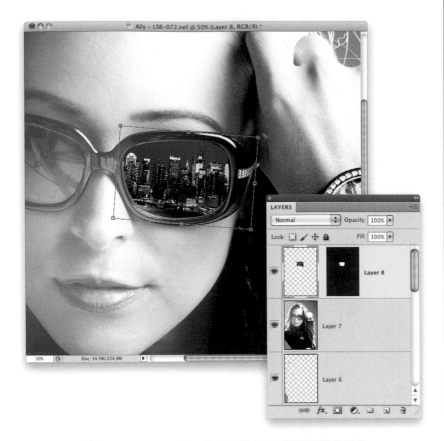

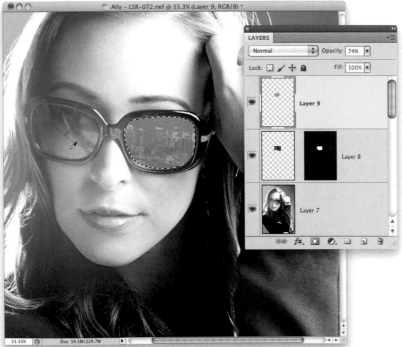

STEP 17:
Press **Command-T (PC: Ctrl-T)** to bring up Free Transform around your pasted image. Then, press-and-hold the Shift key, click on one of the corner points (press **Command-0** [zero; **PC: Ctrl-0**] to see the corner points), and drag inward to scale the image down so it fits within the frame. Move your cursor outside the bounding box, and you'll see it changes into a two-headed arrow cursor. Click-and-drag slightly downward to rotate the skyline to fit the angle of the sunglasses (as shown here). Now, press **Return (PC: Enter)** to lock in your transformation. Okay, that takes care of the size problem.

STEP 18:
We're going to tackle the other two problems at once (lowering the contrast and adding a blue tint) and we'll start by bringing back the selection around the lens. So, press-and-hold the Command (PC: Ctrl) key and, in the Layers panel, click directly on the black layer mask attached to your skyline layer. This loads the lens selection. Now, add a new blank layer, then switch to the Eyedropper tool, and click once on the other lens, down near the bottom where the blue tint is, to make that your Foreground color. Press **Option-Delete (PC: Alt-Backspace)** to fill the blank layer with that blue color and then just lower the Opacity of this layer to around 70%. This puts the blue tint over the city and makes it less contrasty (killing two birds with one stone). Now, you can deselect.

STEP 19:

Before we go on, create another merged layer at the top of your layer stack, because we'll need to make a selection from a flattened version of the image. Now, you're going to do the same thing to the other lens in the sunglasses: Make a selection around the inside of frame, then contract the selection by 2 pixels. Select and copy the skyline image, then go under the Edit menu, under Paste Special, and choose Paste Into. Then, use Free Transform to scale the pasted image down to size, and rotate it a bit to match the angle of the sunglasses.

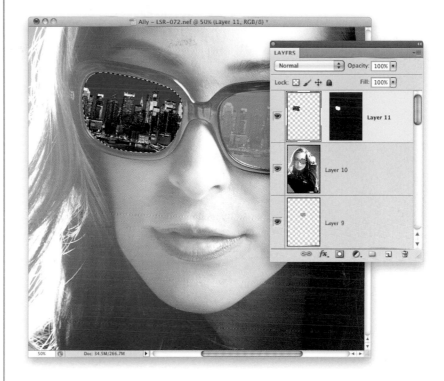

STEP 20:

Finally, we'll lower the contrast and add the blue tint the same way we did in Step 18: Load the lens selection, and then add a new blank layer. Your Foreground color should still be the blue tint you used in the first lens, so press Option-Delete to fill the layer, lower the layer's Opacity, and then deselect.

STEP 21:

Now, we're pretty much done, but when I zoomed out on the image, I noticed something we should've fixed earlier—there are three folds in her jacket on the underside of her arm. But, we'll easily use the Liquify filter to get rid of them (this filter lets you move the image like it was a thick liquid.) First, though, create a new merged layer one more time and then, from the Filter menu, choose **Liquify**.

STEP 22:

Choose the top tool in the toolbar on the left (**W**; the Forward Warp tool) and then set your Brush Size just a tiny bit bigger than the folds you want to remove. Now, just click-and-push them in, so they line up with the rest of the jacket, and push out any areas that dip in. Click OK when you're done.

You can see the finished image shown full-page size at the beginning of this chapter.

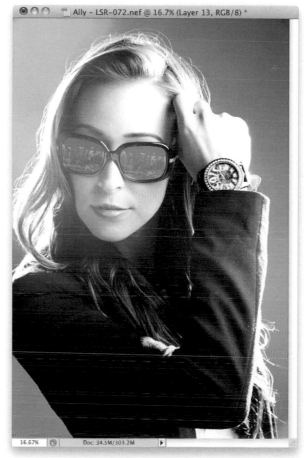

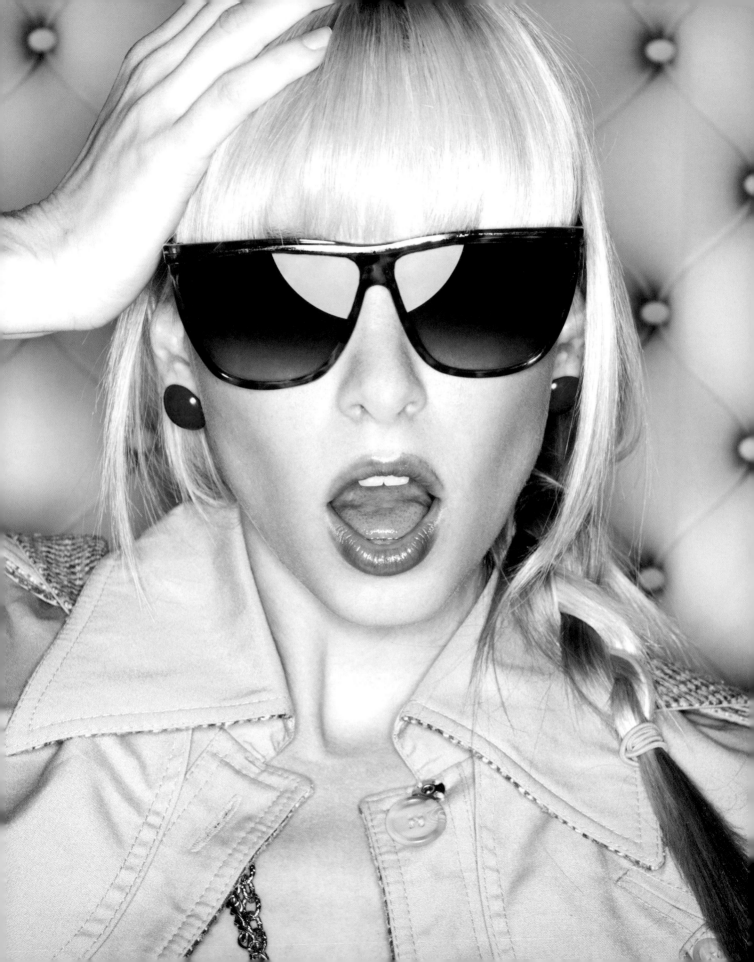

I-LIGHT RING FLASH SETUP

Using Ring Flash for Fashion Lighting

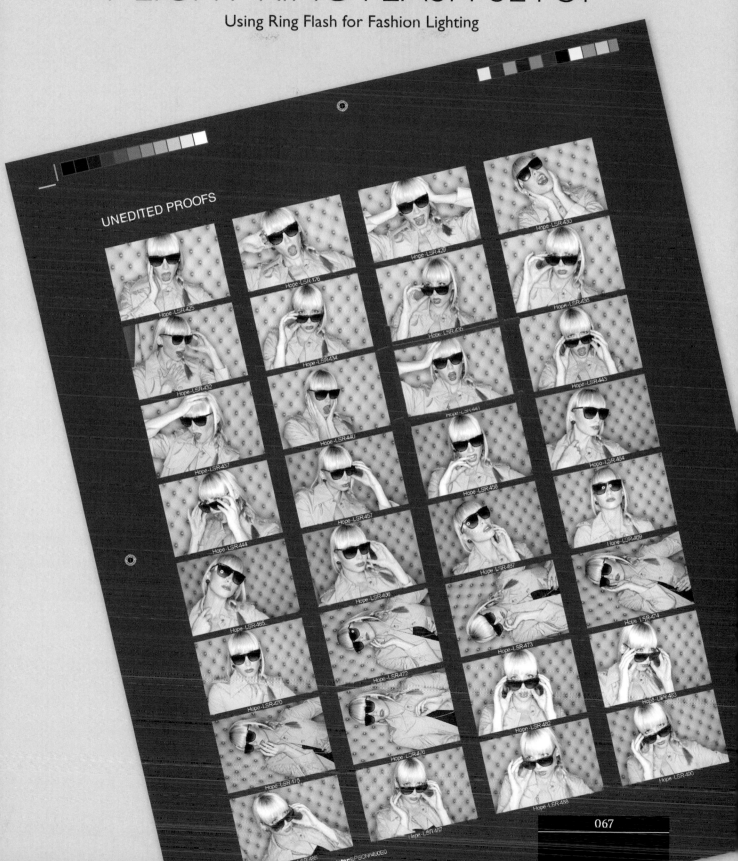

UNEDITED PROOFS

This is just a one-light setup, using a ring flash connected to a battery pack (perfect for location work). Ring flashes have become really popular with fashion photographers, because they produce a very punchy, shadowless look on your subject's face (however, part of the trademark look is the shadow they create behind your subject). The ring flash fits right around the camera lens and sends out a wide angle of light. The key is to put your subject very close to the background (in our case, a fabric background with a printed pattern), so the ring flash casts a very visible shadow onto the background (the shadow kind of looks like a dark halo around your subject).

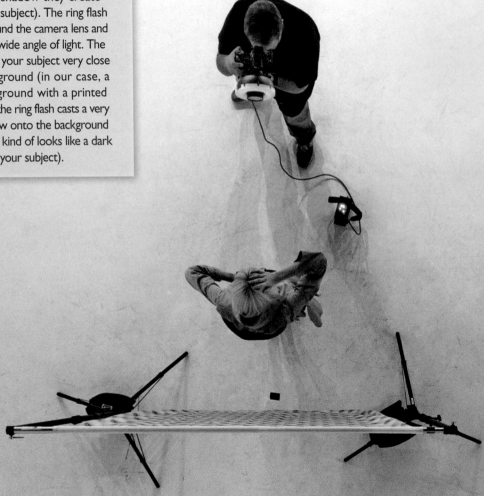

GEAR GUIDE

STROBE: Ring flash
with battery pack

**BATTERY POWER
SETTING:** 2.3

CAMERA SETTINGS

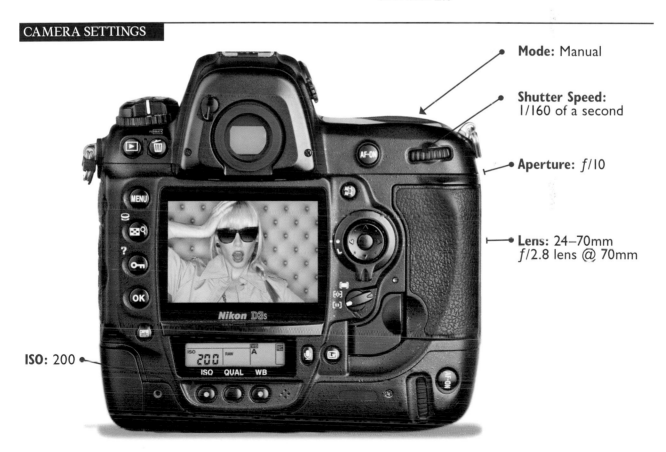

Mode: Manual

Shutter Speed:
1/160 of a second

Aperture: f/10

Lens: 24–70mm
f/2.8 lens @ 70mm

ISO: 200

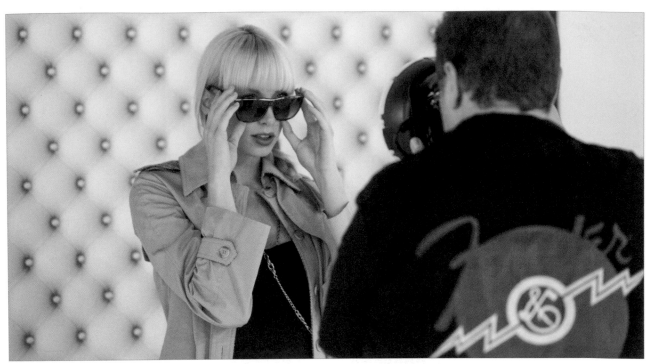

FRONT VIEW: I'm standing directly in front of our subject with the ring flash positioned around my lens (there's a hole in the center of the ring flash that your lens extends through). Because we're using a 24–70mm lens, we have to get in pretty close to our subject (as seen in the over-the-shoulder view here).

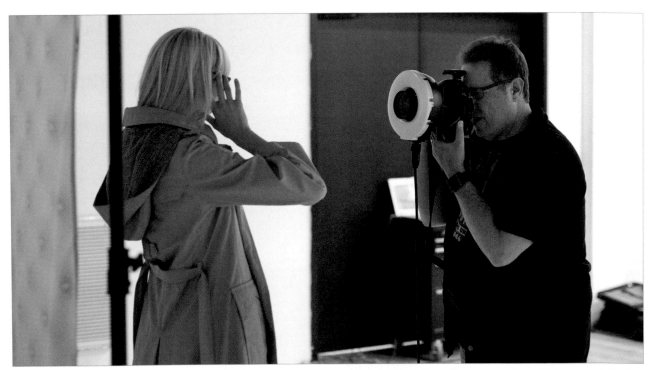

LEFT SIDE: You get a good view of the ring flash itself from this angle. The flash itself puts out a lot of light, especially this close to the subject, but it doesn't really create shadows on your subject—the shadows appear behind them.

RIGHT SIDE: Here you can see that the subject is just a few feet in front of the background. We usually position the subject 8 to 10 feet in front of the background, so they don't cast a shadow on it, but when you're using a ring flash, it's all about casting the shadow on the background, so be sure to keep your subject near it.

BACK VIEW: Another thing photographers love about using a ring flash is the round shape of the catch lights that appear in your subject's eyes. Here's the view from the back right side (the actual "back" view would just be of the background).

THE POST-PROCESSING

In this image, we're not going to focus so much on the portrait retouching, since the most important aspect of a portrait retouch, the eyes, are covered with sunglasses. But, as you'll see in just a moment, the sunglasses also create the biggest problem.

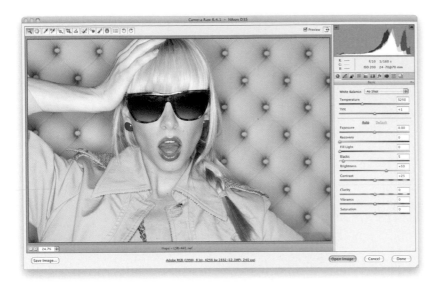

STEP ONE:
There's not much to do in Camera Raw for this image, as the exposure and white balance are pretty good right out of the camera, so go ahead and click Open Image to open it in Photoshop.

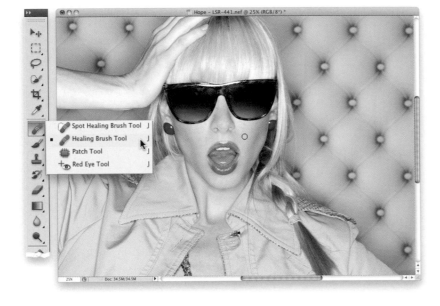

STEP TWO:
We'll start by removing any obvious facial blemishes using the Healing Brush tool. We covered removing blemishes pretty extensively in Chapter 1, so in short: get the Healing Brush (press **Shift-J** until you have it), make your brush size slightly larger than the blemish you want to remove, Option-click (PC: Alt-click) in a clean area right near the blemish, then move your cursor over the blemish and just click once to remove it. Repeat this for any other blemishes in the image (as shown here, where I'm using the Healing Brush to remove a blemish from her face).

STEP THREE:

The real problem with this image is something that, had I noticed, I could have fixed very easily during the shoot—her sunglasses have lots of fingerprints. Seems like an easy fix—just clone or heal them away. But unfortunately, because those smudges extend over her eyes, it's just not that easy. In fact, it's kind of a nightmare (meaning it will be a very long, tedious fix), so we're going to look at two other solutions for cleaning up the sunglasses, which are both quick and easy.

STEP FOUR:

The first solution is literally to put a gradient over the lenses using the exact same colors that are already in the existing lenses. This actually works fairly well. Start by going to the Layers panel and clicking on the Create a New Layer icon to create a new blank layer. Then, get whichever selection tool you're most comfortable with (the Lasso tool, Pen tool, etc.) and make a selection just inside the opening on the lens on the left (as seen here). Don't select right on the edge—leave a tiny bit of black around the edges.

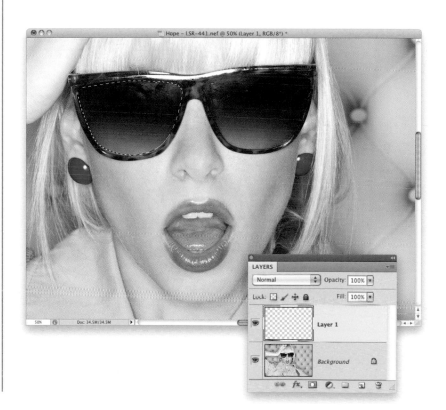

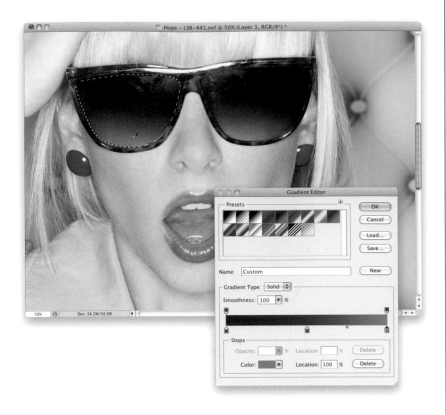

STEP FIVE:

Switch to the Gradient tool **(G)**, then up in the Options Bar, click directly on the gradient thumbnail to bring up the Gradient Editor (shown here). Choose one of the gradient Presets that has three different colors (the sixth gradient from the left, in the top row of the Default set of gradients, is blue, red, and yellow, so I chose that one as the starting place for my custom gradient). There are three stops under the gradient ramp in the middle of the dialog (they look like little houses). Click on the one on the far left, then move your cursor over your image, and it turns into an Eyedropper tool. Click it once at the top of the lens on the left to sample that color for the left side of your gradient. Then click on the center stop, and use the Eyedropper to sample a color from the middle of the lens. Lastly, click on the stop on the far right, then click the Eyedropper near the bottom of the lens (as shown here) to sample that color. Now click OK.

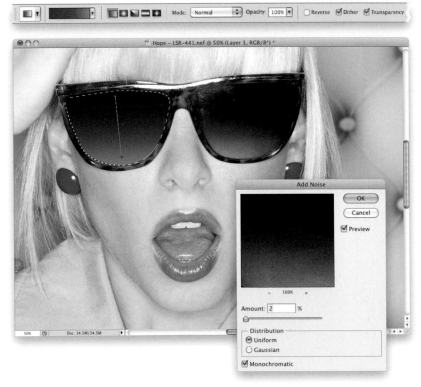

STEP SIX:

In the Layers panel, make sure your blank layer is still active, then take the Gradient tool and click-and-drag it from the top of your selected lens to near the bottom (as shown here) to fill that lens with the gradient colors you just created. At this point, it does look a little fakey, but that's because there's no texture—it's too smooth. So, go under the Filter menu, under Noise, and choose **Add Noise**. When the dialog appears, enter 2%, choose Uniform for Distribution, turn on the Monochromatic checkbox, and click OK to apply a noise texture to the gradient, which helps quite a bit toward making it realistic.

STEP SEVEN:

Deselect by pressing **Command-D (PC: Ctrl-D)**. You can now lower the opacity of this gradient layer a bit, so you can see some of the eye, but it will also bring back a little of the smudging, too, so don't lower it very much. If you want to see a little of her eye, as if the lens was really translucent, then in the Layers panel, click on the Add Layer Mask icon to add a layer mask, get the Brush tool **(B)**, choose a medium-sized, soft-edged brush, set your Foreground color to black, then in the Options Bar, lower the brush's Opacity to around 10%. Now, paint a little bit over where the eye would be (it helps if you lower the Opacity of the gradient layer a bit—just so you can see where the original eye is on the layer below it), and a little bit of it will start to show through (as seen here).

STEP EIGHT:

Now, repeat the same process with the other eye, but at least you don't have to resample the colors for your gradient—it will still have the ones in place from when you did it earlier. Here's what it looks like when you click-and drag a gradient on the other lens (don't forget to add some noise!). Just lower the Opacity of this layer down to around 75% (so the eye peeks through) or keep it at 100% and try the trick where you reveal just 10% of the original eye, like we did in the previous step.

STEP NINE:

Our second solution (in case you don't like the fake gradient technique) is to cheat and cover our smudged areas with a very large reflection in the sunglasses, as if from a very close light source. Start by deleting the fake gradient layers we just added, then start this second technique by adding a new layer. Now, get the Elliptical Marquee tool (press **Shift-M** until you have it), press-and-hold the Shift key, and drag out a perfect circle, positioning it over the sunglasses so it covers where the smudgy areas are (you see those smudges because there was a reflection there in the first place, but we're going to make it much more pronounced—so much so, that it pretty much hides the smudges). Make white your Foreground color, then fill this circle with white by pressing **Option-Delete (PC: Alt-Backspace)**.

STEP 10:

Go ahead and deselect. Now, go to the Layers panel and click on the Add Layer Mask icon at the bottom to add a layer mask to this white circle layer. Lower the opacity of this layer, so you can see the frame of the glasses clearly. Then, get the Brush tool, choose a small-ish, soft-edged brush, and set your Foreground color to black. Set the brush's opacity back to 100%, then click on the brush thumbnail up in the Options Bar to open the Brush Picker, and increase the Hardness amount to 75%. Start painting over any areas that are outside the sunglasses' lenses (as seen here, where I'm erasing the part of the circle that extends over on the top of the rims, and onto her hair).

STEP 11:

Keep painting away any areas outside the lenses of the sunglasses. Also, leave a tiny bit of black showing around the inside edge of each lens, so it looks like the reflection is actually inside the glasses (and not over it).

STEP 12:

Now you can raise the Opacity of that white circle area back up to around 75%, and the look is pretty darn realistic.

STEP 13:
Now, let's add some nice contrast to the image by first creating a merged layer (a layer that appears at the top of all your layers and looks like a flattened version of your image). To create it, press **Command-Option-Shift-E (PC: Ctrl-Alt-Shift-E)**. Then, change the blend mode of this layer from Normal to **Soft Light** (as shown here), and you get a much punchier, more contrasty image.

STEP 14:
Next, let's darken the edges by creating our own custom vignette. Create another merged layer, and change the blend mode of this layer to **Multiply**, which makes everything much darker (as seen here).

STEP 15:

Click on the Add Layer Mask icon at the bottom of the Layers panel to add a layer mask to this new darker layer. Now, with the Brush tool still active, get a huge, 2,500-pixel, soft-edged brush (just keep pressing the **Right Bracket key** on your keyboard until it reaches 2500 pixels), then set your Foreground color to black, and click directly over the area you want to remain bright. In this case, click directly on her face (as shown here). You can add a few more clicks near and surrounding her face, and it gives kind of a spotlight look.

STEP 16:

Create another new merged layer, then switch to the Healing Brush tool, make sure the Sample pop-up menu is set to **Current Layer**, and zoom in tight. See if there are any visible smudges that appear over your white reflection (there probably will be) and just heal those away.

STEP 17:

A quick Levels adjustment will help to make the image a little brighter and punchier, too, so press **Command-L (PC: Ctrl-L)** to bring up Levels, and when the dialog appears, just click the Auto button to perform an Auto Levels. This usually looks pretty decent, but if on a different image, it doesn't, don't hit OK—just hit Cancel and move on to the next step (for now, it looks okay, so click OK). Our final step is optional, and that is to desaturate the colors in the image.

STEP 18:

This desaturated look is very popular right now, and there are two ways to do it: (1) press **Command-U (PC: Ctrl-U)** to bring up the Hue/Saturation dialog, then just lower the Saturation amount, which desaturates the entire image (as I've done here, where I lowered it to –20). Or, (2) add a Hue/Saturation adjustment layer in the Adjustments panel (or from the Create New Adjustment Layer icon's pop-up menu at the bottom of the Layers panel), and do the same thing: lower the Saturation amount to –20, but then press **Command-I (PC: Ctrl-I)** to Invert the adjustment layer's layer mask, so the desaturated look is hidden behind a black mask. Then, get the Brush tool, choose a soft-edged brush, and paint over just the subject's skin, so the clothing and hair stay the same, and only her skin gets desaturated. Which one is right? It's your call.

The final image appears on the first page of this chapter (this wide shot is cropped to fit the tall page size).

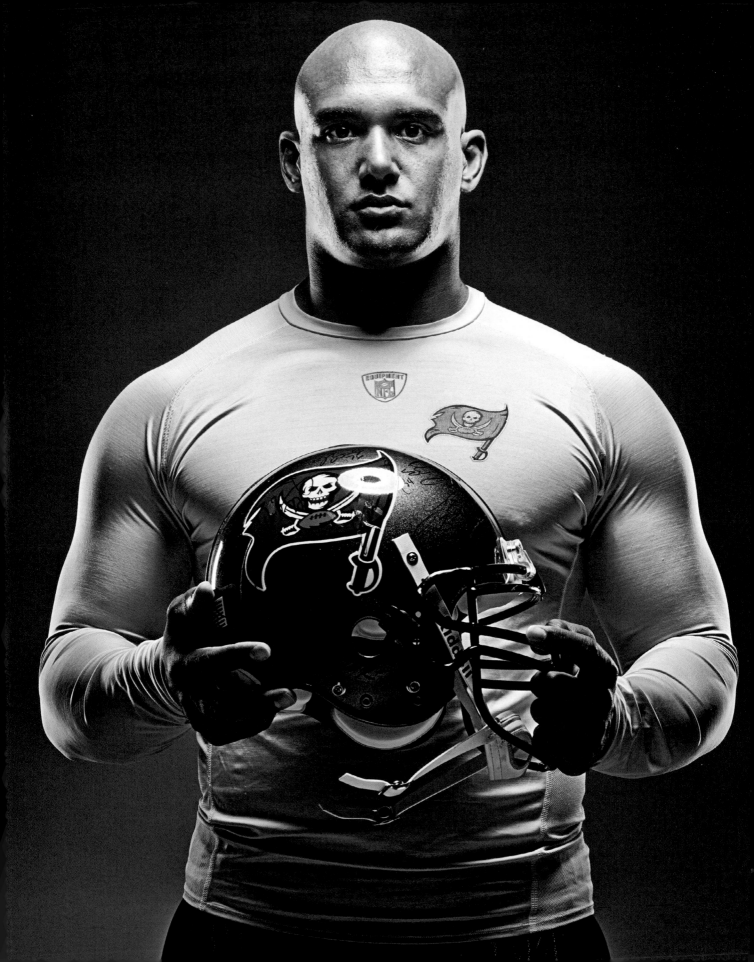

3-LIGHT SPORTS SETUP

Edgy Lighting

Sharpening: Off • Profile: (Managed by printer) • Printer: HP Color LaserJet 4700 124 Printer Room

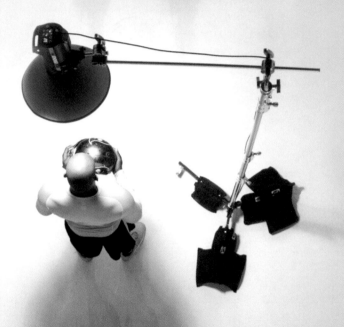

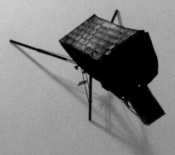

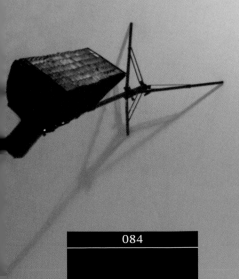

The idea here is for a very edgy, dramatic-looking lighting setup, and it's a perfect one to use for shooting athletes. The main lights are actually the two strip banks in the back—they provide the main lighting for your subject. The beauty dish in front (without a diffusion sock over it, so the light is punchier) is being used just as a fill light, so we power that light down real low.

GEAR GUIDE

FRONT STROBE: 500-watt unit with 17" beauty dish with silver deflector

REAR STROBES: Two 500-watt units with 12x36" strip banks and 40° egg crate grids

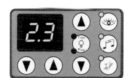

FRONT STROBE'S POWER SETTINGS: 3.2

REAR STROBES' POWER SETTINGS: 4.5

CAMERA SETTINGS

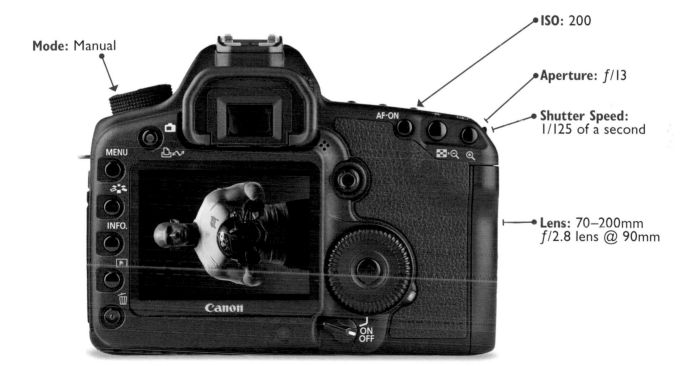

Mode: Manual

ISO: 200

Aperture: *f*/13

Shutter Speed: 1/125 of a second

Lens: 70–200mm *f*/2.8 lens @ 90mm

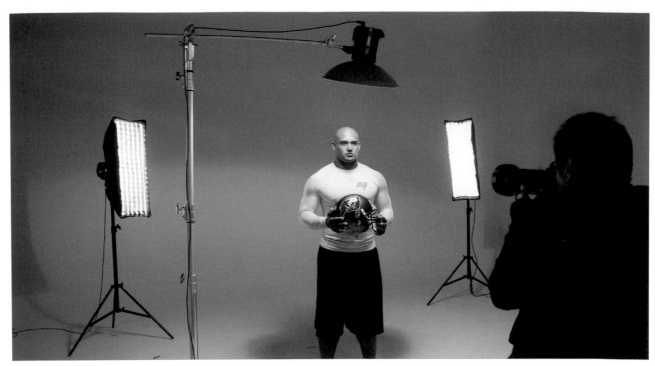

FRONT VIEW: The key to this lighting setup is those two strip banks behind our subject—those are actually the main lights. The beauty dish up front (without the diffusion sock) is strictly to fill in the shadows in front. Since that front light, with the beauty dish, is just a fill light, you'll want to turn the power output down lower than the main lights.

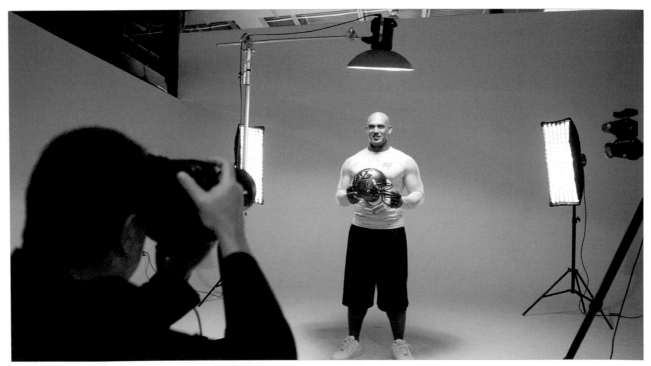

FRONT VIEW: If you want the light from the two strip banks to appear harder, move them farther away from your subject. Also, to make our subject, NFL linebacker Adam Hayward, look bigger than life, I'm shooting from a very low angle, to accentuate the perspective. If you want the background white, aim a light on it at a high power setting.

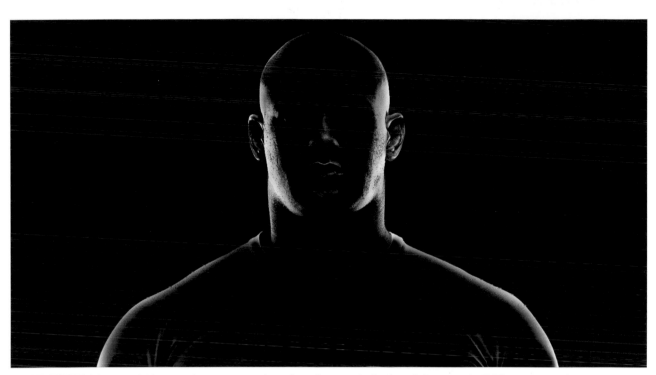

TEST SHOT: It's a good idea to take some test shots first. Start with the front light turned off. Then, turn on just one strip bank in the back, and position it so it lights the subject's head, the side of his face, and his shoulders and arm. Now, turn on the other strip bank, behind the subject on the other side, and then position it so it lights their other side the same way.

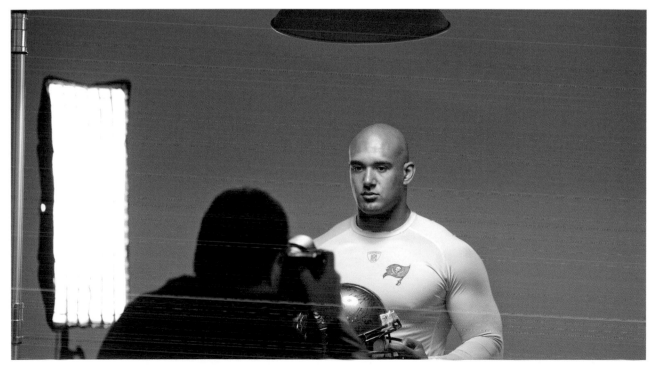

CLOSE-UP VIEW: Here, I switched to a shorter lens (a 24–70mm f/2.8), but to vary the look without moving the lighting, I moved from standing right in front of Adam, to shooting from a 45° angle back at him. Each time you move even one foot in either direction, the lighting looks different, and sometimes the best-looking light isn't from straight in front of your subject.

THE POST-PROCESSING

We're going to do a high-contrast post-processing effect to this image, along with some desaturation. But, once we leave Camera Raw, you have an option to: (a) use the high-contrast technique we learned in Chapter 2; (b) apply the effect with one click, using Nik Software's Color Efex Pro 3—the preset you would use is called "Tonal Contrast" and it works wonders—which I'm mentioning, because it's what I use most of the time; or (c) try the processing I'm going to teach you here, because it's pretty cool. Hey, at least you have some options.

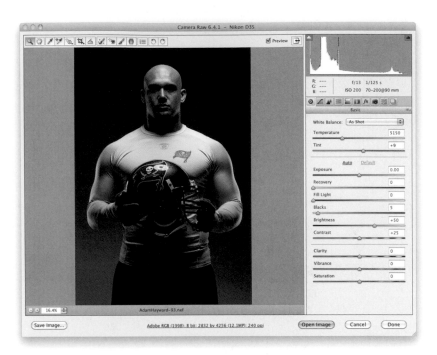

STEP ONE:
Here's the RAW image, as shot, opened in Camera Raw. Just looking at it as it is now, it's a good starting place, but I can already see some things we need to do before we apply the high-contrast stuff. First, the lighting on his chest looks too bright (your eye is drawn to the brightest thing in the image), so we'll need to tone that down a bit. Also, his face is actually a little darker than I'd like (I should have turned up the power on the beauty dish above his head), and his eye sockets are very dark, which was expected because of the angle of the beauty dish. Okay, let's get to work.

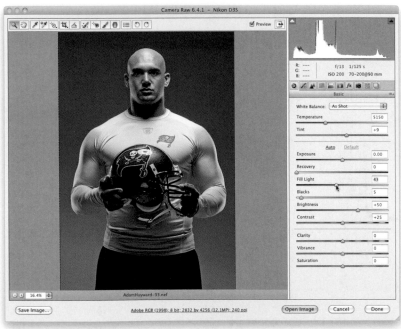

STEP TWO:
Let's start by opening up the shadows in the image. Camera Raw's Fill Light slider is great for this, and if you push it as far as we're going to, it starts to take on its own look, which is good for this type of high-contrast stuff. So, drag the Fill Light slider over to around 45 (as shown here) to open up those shadow areas on Adam, and on the background behind him.

STEP THREE:

Now, we're going to add some Clarity to the photo, which basically adds midtone contrast. Adding a lot of Clarity is partially what gives the image a punchy, high-contrast look (it even looks a bit like you've sharpened the image), and we're going to add a lot of it (you can get away with this on guys, but it's pretty rough on women's skin, so I avoid using it there). Let's go ahead and drag the Clarity slider way over to around +65, and while you're at it, increase the Contrast amount to around +50.

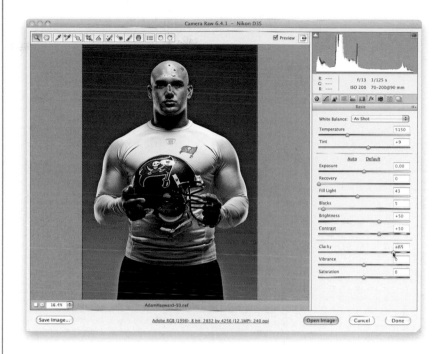

STEP FOUR:

Increasing the Clarity and Contrast amounts adds a lot of contrast and punch to the image, but unfortunately, it also added some clipping on his face. It's only in the Red channel (you can tell by looking at the histogram in the image in the previous step—the red triangle in the top right tells you it's the Red channel clipping. You can also see clipping warning areas in red on his nose, the top of his head, and his ears). Luckily, it's easy enough to fix while we're here. Just drag the Recovery slider to the right until the red warnings on his nose, head, and ears go away (as seen here).

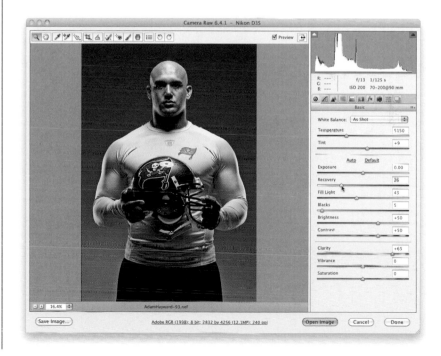

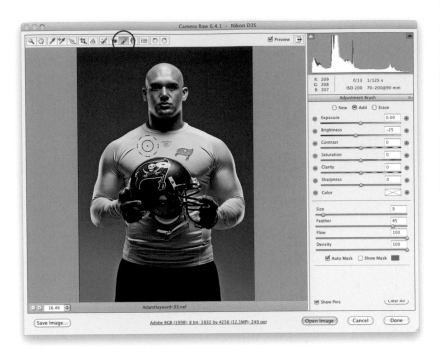

STEP FIVE:
Now, let's work on darkening the front of his shirt, and then lightening his face. Get the Adjustment Brush **(K)** from the toolbar up top (it's shown circled here in red), and then in the Adjustment Brush panel on the right, click once on the – (minus sign) button to the left of the Brightness slider. This zeros all the other sliders out, and sets the brush so it paints darker. Now, make sure the Auto Mask checkbox is turned on (so you don't accidentally paint outside the lines), then paint over his chest to darken that area just a bit (as seen here).

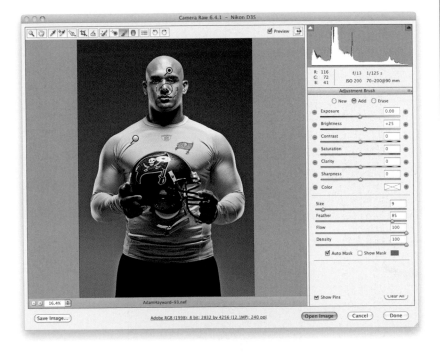

STEP SIX:
Next, let's lighten his face up a bit (and get some more light into his eyes). Click the New radio button at the top of the Adjustment Brush panel (this tells the brush you want to work on a different area), then click the + (plus sign) button to the right of the Brightness slider. This zeros everything out and makes the brush paint a bit brighter. Paint over just the front of his face to brighten that whole area. Once you've painted on his face, if you think it needs to be brighter or darker, just drag the Brightness slider where you'd like it. Next, we're going to cheat, and make our side lighting look stronger than it really was.

STEP SEVEN:

Click the New radio button again, then click the + button to the right of the Adjustment Brush's Exposure slider twice, so it reads +1.00. Now, with Auto Mask still turned on, you're going to paint over the white highlights on the sides of his face created by the back lights, and it really makes them a lot more intense (as seen here). Auto Mask will pretty much keep you just on that area, but if you stray off and make a mistake, press-and-hold the **Option (PC: Alt) key** and your brush switches to Erase mode, so you can paint away your mistakes. Once those are fixed, just release the Option key, and you're back to painting a brighter exposure on the sides of his face. When you're done, you'll see three different "pins" on the image, each representing a different area you adjusted. The pins appear where you first start painting. To edit the area represented by any individual pin, just click on it.

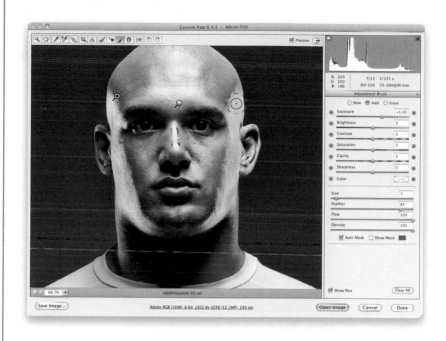

STEP EIGHT:

That's it for what we'll do in Camera Raw, but it's already looking pretty decent (we've greatly improved our starting point anyway). Now, click the Open Image button and your image will open in Photoshop. Once there, duplicate the Background layer twice by pressing **Command-J (PC: Ctrl-J)** twice. Then, click on the middle layer, because we're going to remove the color from it. Go under the Image menu, under Adjustments, and choose **Desaturate**. This removes the color from that layer, but because you have a color layer on top of it, you won't see the image change, but the layer thumbnail for that middle layer will turn black and white (as shown here).

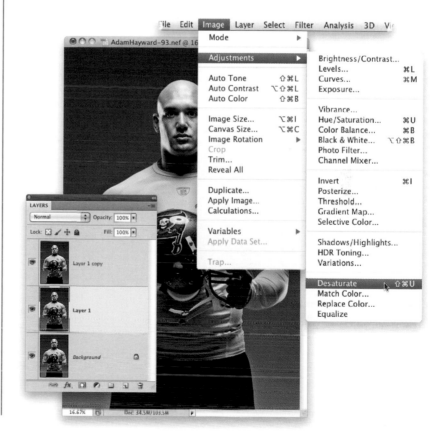

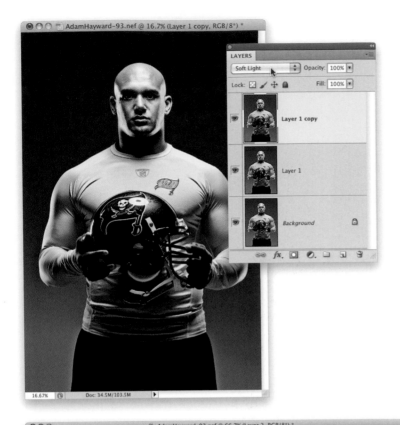

STEP NINE:

While you're still on that layer, lower its Opacity to 80%, so a little of the color from the color image on the Background layer shows through (again, you can't see this, because the middle layer is covered up, but if you want, you can toggle the top layer on/off by clicking on the Eye icon to the left of its image thumbnail). Now, click on the top layer and change the blend mode of this layer from Normal to **Soft Light**, and you get a contrasty, desaturated look (as seen here).

STEP 10:

Next, let's create a merged layer at the top of the layer stack (which is a new layer that looks like a flattened version of your image) by pressing **Command-Option-Shift-E (PC: Ctrl-Alt-Shift-E)**. In a couple of steps from now, we're going to add some pretty intense sharpening, and that sharpening tends to over-exaggerate any facial blemishes. So, switch to the Healing Brush tool (press **Shift-J** until you have it) and choose a brush size that's a little bit bigger than the blemishes you want to remove. Option-click (PC: Alt-click) in an area right near a blemish, then move your cursor over it, and just click once to remove it. Continue this process for getting rid of most of the really obvious blemishes, but don't go so far that he looks like a fashion model.

STEP 11:

Now, we're going to cheat by adding some additional lighting effects. Create another merged layer at the top of the layer stack (you just learned the keyboard shortcut for this), and then change its blend mode to **Multiply**. This makes the image look twice as dark (as seen here). We did this to make the background dark, but next, we're going to reveal the light just where we want it for a dramatic look. So, start by clicking on the Add Layer Mask icon, at the bottom of the Layers panel, to add a white layer mask to this layer.

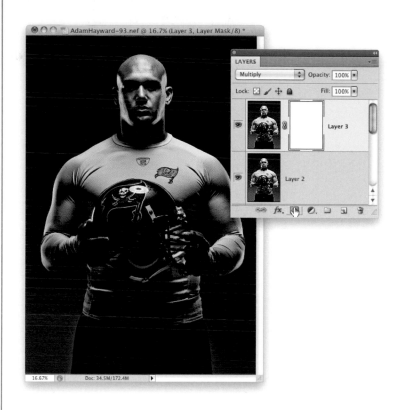

STEP 12:

Switch to the Brush tool **(B)** and then click on the brush thumbnail in the Options Bar to open the Brush Picker. Choose a soft-edged brush and increase its Size to 2500 px (that's as big as it will get). Make sure your Foreground color is set to black, and then click that brush right over his face (as shown here). This cuts a very soft-edged hole in your dark Multiply layer, revealing the brighter layer below it, which gives you the dramatic lighting look. Go ahead and click a couple more times, down to the top of his helmet to lighten those areas (I'd let the areas below his helmet just fall off to shadows like it does here).

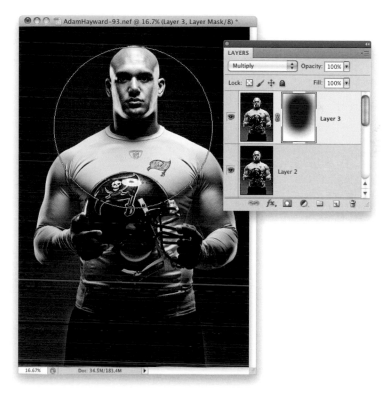

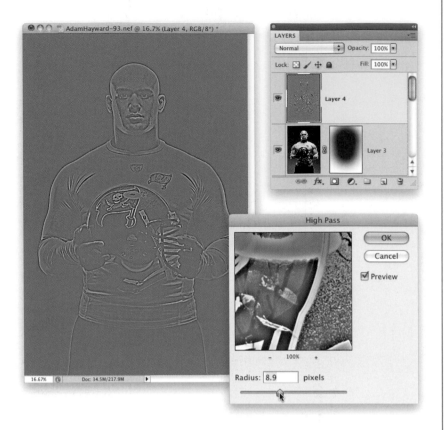

STEP 13:

Let's add some really punchy sharpening to give everything some snap and shine. We do this using the High Pass filter, so start by creating another merged layer, then go under the Filter menu, under Other, and choose **High Pass**. When the dialog appears, drag the slider all the way to the left, so the preview turns solid gray, then drag it to the right, until you start to see lots of edge detail (like you do here, when I got to almost 9). The higher you drag, the more dramatic the sharpening, so be careful not to go crazy with this. Once it looks similar to what you see here, click OK.

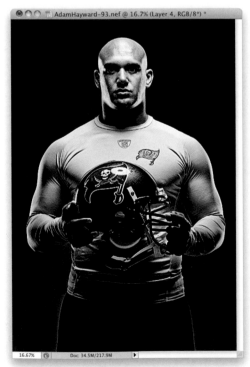

STEP 14:

Now, to bring this sharpening into the image, go to the Layers panel and change the blend mode of this layer to **Hard Light** (as shown here), and the sharpening is applied. If you think it's too much sharpening, you can lower the Opacity of this layer, or you can try a more subtle style of High Pass sharpening by changing the layer's blend mode to Soft Light, rather than Hard Light. For this image, I like the Hard Light sharpening, but it's totally your call (thankfully, there is no International Bureau of Sharpening that issues standards on how much sharpening is the right amount). Now, as I step back and look at the image at this point, I still think his eye sockets are a bit too dark, but that's an easy fix that we'll tackle next.

STEP 15:

Create another merged layer, and change its blend mode to **Screen** to make the entire image much brighter. Now, Option-click (PC: Alt-click) on the Add Layer Mask icon at the bottom of the Layers panel to hide the brighter version of your image behind a black layer mask. Get the Brush tool, choose a small, soft-edged brush, and paint over his eye sockets in white to add more light there. If you think it's too much, lower the Opacity of the layer. One more little tweak: To bring back the original red color in the flag logo on his chest, create another merged layer, then hide every other layer in the Layers panel, except the Background layer (so only two layers are visible—the top merged layer and the Background layer). Add a white layer mask to the top layer, and paint over the flag in black to reveal the original color (you can see this in the next step).

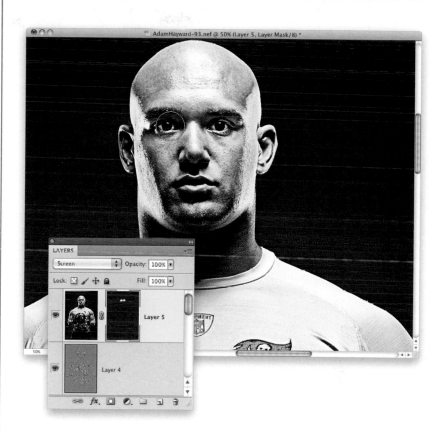

STEP 16:

The final step is simple, but it has a huge impact on how the final image looks. Create another merged layer and hide the layer below it (the one where you painted back in the red flag logo), so the only layers that are visible are the top merged layer you just created and the Background layer. Now, basically, you have a before/after by turning this top layer on/off, but you also have something more than that—you have a "master effect controller." That's right, by lowering the Opacity of this top merged layer, you control how much of the high-contrast effect appears on the image. Here, I've lowered the Opacity to 60%, so it blends with the original image and brings back a hint of his original skin tone, to create the final image you see here (and at the beginning of this chapter).

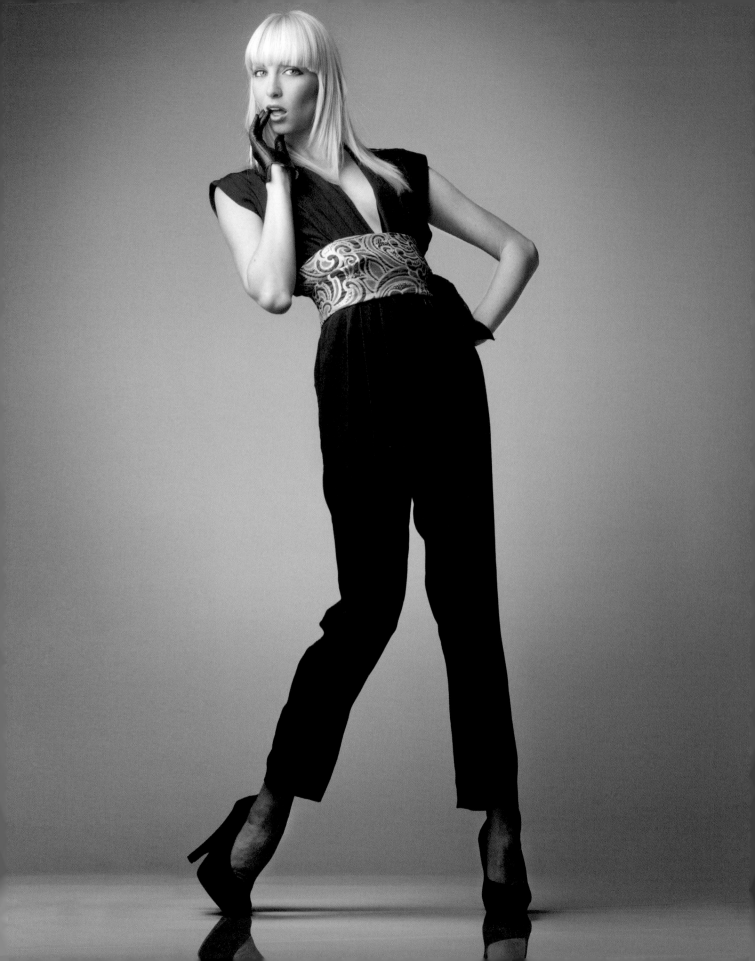

1-LIGHT FULL-LENGTH SETUP

Full-Length Fashion Lighting

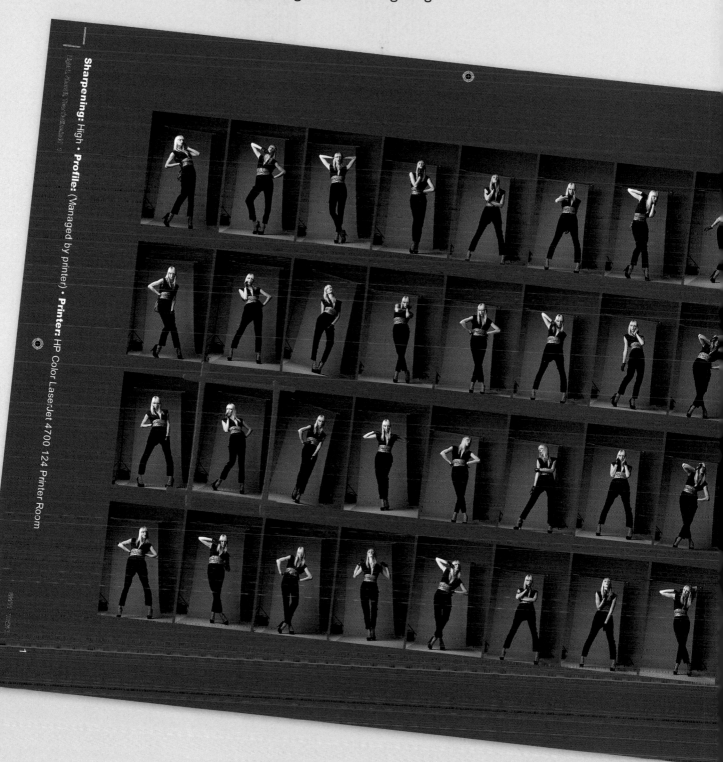

Sharpening: High • **Profile:** (Managed by printer) • **Printer:** HP Color LaserJet 4700 124 Printer Room

THE SETUP

When shooting fashion, lighting the clothing is almost as important as lighting the subject, so I use a really large (53") softbox. Because of its large size, it not only helps to light the clothing, but it also creates some of the most soft, beautiful light out there. Also, because of its large size, I can usually get away with using just this one light (and if I need to light the background, I just move the light and the subject closer to it). The softbox here is just a little bit in front and to the side of our subject. It's positioned up high and aiming down at her. We're shooting full-length photos here, and the trick is to get down low when shooting full-length. So, here I'm down on one knee, but I'm also often sitting cross-legged on the floor, or even lying down, to get that great perspective for full-length.

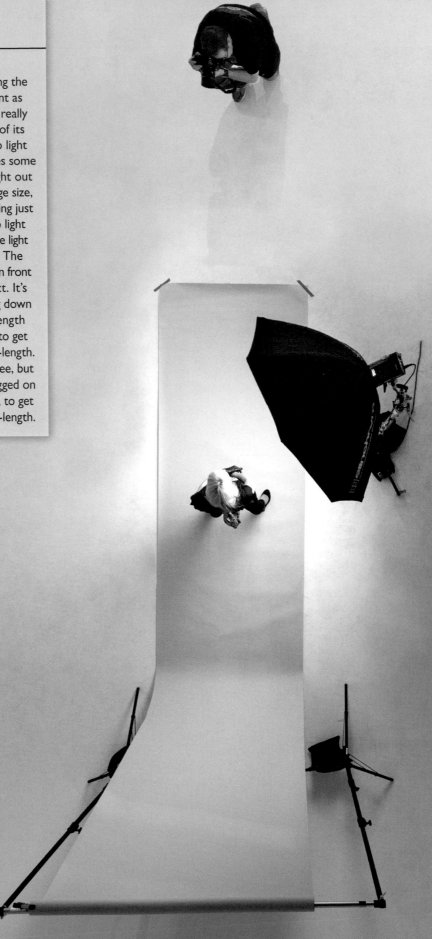

GEAR GUIDE

STROBE: 500-watt unit with 53" octabank softbox

STROBE'S POWER SETTING: 4.1

CAMERA SETTINGS

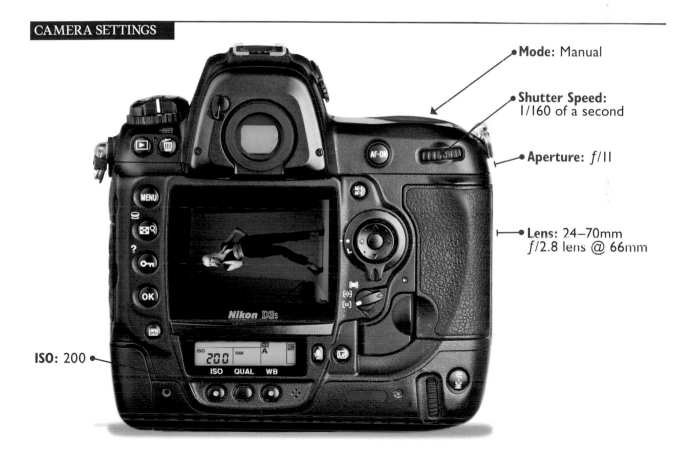

Mode: Manual

Shutter Speed: 1/160 of a second

Aperture: f/11

Lens: 24–70mm f/2.8 lens @ 66mm

ISO: 200

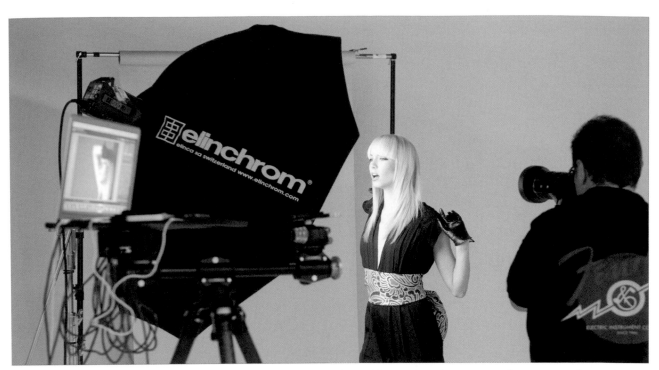

LEFT SIDE: Here's a view of my warm-up shoot of just headshots. Notice that the gray seamless paper isn't very high, which is fine for headshots. But later, when I was down on one knee, shooting full-length, the top of the paper wound up below the top of her head, and I didn't realize that until about 20 frames into the shoot.

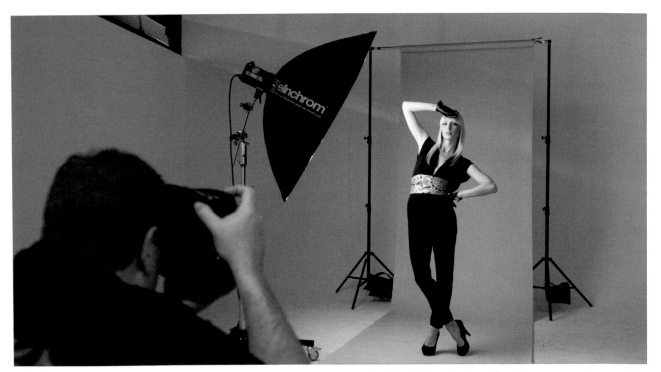

FRONT VIEW: Here, we've raised the height of the gray seamless for the full-length shots. I'm down on one knee, and I switched to a 24–70mm lens for shooting full-length. I have the subject closer to the background than my usual 10 feet, because I'm using the main light to do double-duty and light the gray seamless, as well.

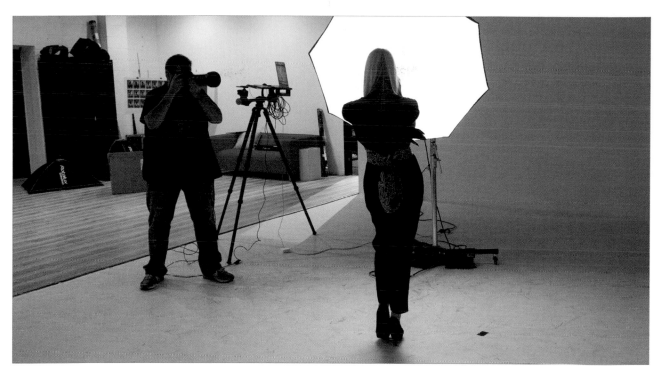

RIGHT SIDE: Here, I am shooting some of the tighter headshots with my 70–200mm lens. The position of the light doesn't change at all (and in this shot, you can see my laptop, as I'm shooting tethered directly from my camera into Lightroom). Since I'm shooting headshots, I'm in a standing position.

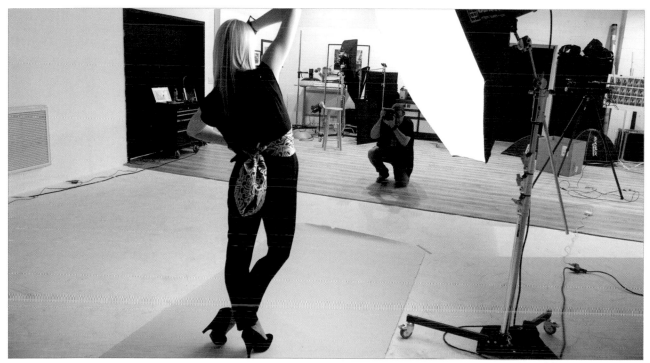

BACK VIEW: This shows you how close the subject is to the softbox, and you can see me down on one knee getting the full-length shots. If you don't have enough room to shoot as far back as I am, you can use a 50mm lens for your full-length shots (the 50mm f/1.8 lenses are surprisingly inexpensive, but the 50mm f/1.4 lenses jump up big time in price).

THE POST-PROCESSING

As for the portrait retouching, it's pretty easy—the standard "remove the blemishes, whiten the eyes" variety. And, since it's a full-length shot, the detail in the face won't be nearly as visible, so the retouching isn't always as critical. However, there are a number of other things in this shot that will keep us really busy. You're going to cover a lot of ground in this retouch—some of these fall under special effects, some fall under modifying light, and some fall under hiding or fixing stuff—but in the end, there's a lot of handy stuff here to learn, so it's worth it.

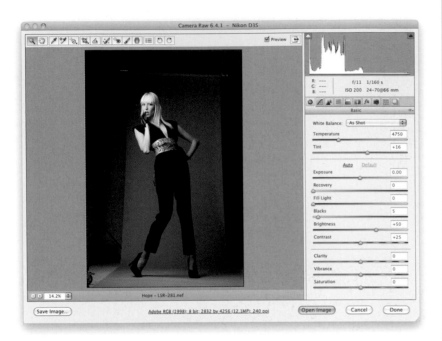

STEP ONE:
Here's the original RAW photo open in Camera Raw, and you can really see how the low shooting angle works in this shot. My plan was to have the main light close enough to light the background, and it did light it a bit—you can see the gray seamless paper fairly well (remember, any light you see on that gray background is from that one softbox in front. Otherwise, that gray would fall to solid black). However, for fashion, it's a little dark. So, we'll need to fix that, along with fixing the fact that we can see the edges of the seamless, the light stands, sandbags, and other distracting stuff.

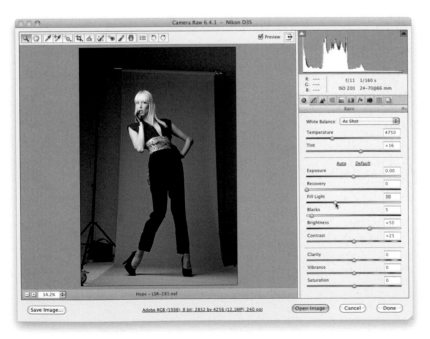

STEP TWO:
Another issue we have is that she's wearing a black outfit, because with a fashion shoot, you need to see detail in the fashion. So, let's open up the shadow areas in her outfit and brighten the gray background at the same time. Just drag the Fill Light slider to the right (here, I've dragged it over to 30), and look how much brighter the background and her outfit look (you can see detail just below the wrap around her waist). The Fill Light slider really doesn't do much to her face or hair, which already look pretty good (those highlight areas would have been affected by dragging the Exposure slider, or even the Brightness [midtones] slider, somewhat).

STEP THREE:

The image needs a little cropping, too (okay, more than just a little). There's too much room above the subject's head, and too much room on the sides. So, get the Crop tool **(C)** from the toolbar at the top, and drag it out, so it covers the entire image. Now, we want to make sure we keep the same proportions as the original image as we crop, so press-and-hold the Shift key first, then click-and-drag the top-right corner point inward. Do the same with the top-left corner point, until it looks like the crop you see here. When you change to any other tool, or press **Return (PC: Enter)**, you'll see the cropped version of your image. Here, the crop looks good, so click the Open Image button to open it in Photoshop.

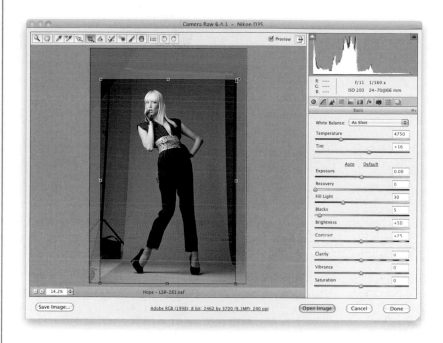

STEP FOUR:

The first thing we'll do is expand the gray background, so we don't see all the other junk. Get the Rectangular Marquee tool **(M)** and draw out a tall, thin rectangle on the right side of the image, like the one you see here. Just avoid touching the edge of the seamless or the subject's elbow.

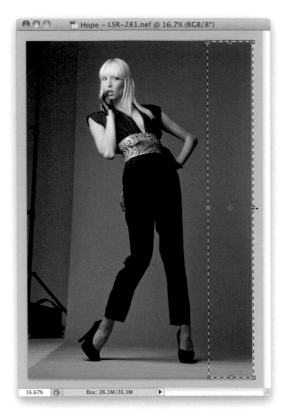

STEP FIVE:
Press **Command-T (PC: Ctrl-T)** to bring up Free Transform around your selected area. Grab the right-center transform handle and simply drag it to the right, until it fills that gap on the right side. Once you're there, press **Return (PC: Enter)** to lock in your transformation, then press **Command-D (PC: Ctrl-D)** to Deselect.

STEP SIX:
Now, let's do something similar on the other side. There's not as much empty gray area on the left side of her, so you'll have to make a very thin rectangular selection (like the one shown here). You probably also noticed that my selection here goes right through part of her heel. It's easier to fix this later than it is to try to work around this, so I'm not too worried about it right now. However, to make our fix a bit easier, once your selection is in place, go ahead and press **Command-J (PC: Ctrl-J)** to put that selected thin rectangular area up on its own layer.

STEP SEVEN:

Bring up Free Transform around your new layer, then grab the left-center point and drag it to the left, until it fills that gap on the left side. Then, press Return to lock in your transformation, and deselect. Now, see her stretched heel (stop giggling)? We're going to have to fix that in the next step.

STEP EIGHT:

Click on the Add Layer Mask icon at the bottom of the Layers panel. The mask is white, so you'll need to paint in black. Set your Foreground color to black, get the Brush tool (B), and choose a small, soft-edged brush. Now, start painting over the stretched part of her heel, and as you paint, it hides the stretched heel on the top layer and reveals the original one on the Background layer. It won't do the entire job—we'll still have a little to clean up with the Clone Stamp tool or Healing Brush on the far left— but that's okay, because the hard part to repair would have been right at her heel. But because of our layer mask, it was easy. That leaves us with the super-easy manual cloning on the far left of the image. No sweat.

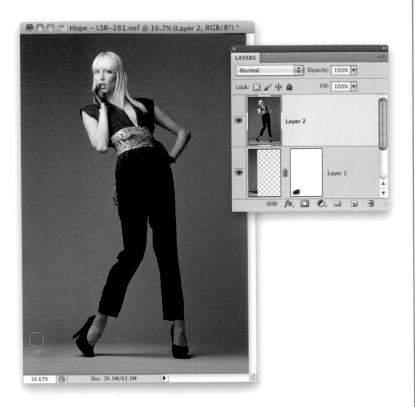

STEP NINE:

Start by creating a merged layer, which is basically a new layer at the top of your layer stack that looks like a flattened version of your image, by pressing **Command-Option-Shift-E (PC: Ctrl-Alt-Shift-E)**. Then, get the Clone Stamp tool **(S)**, Option-click (PC: Alt-click) in a clean area right beside the messy leftovers, and clone right over them. Here's a great tip for accurately cloning along a visual seam where the lighter floor meets the darker background: The trick is to Option-click directly on the seam—with the little line in your sampling cursor being right on that seam (I sampled right on the seam between her feet, toward the foot on the right). Then, move over to the junk you need to remove, and you'll see a preview right inside your brush cursor that shows the seam where you sampled. Line that up where the seam should be, clone horizontally in a straight line, and, voilà, the seam continues right on the money.

STEP 10:

Looking at the image, I still think the gray background should be much, much lighter (although you'll see fashion on dark gray, it's more commonly on a very light gray). So, our plan is to select our subject, put her up on her own layer, then brighten the background a lot. Because she'll be on her own layer, she won't be affected—just the background will. Also, your selection doesn't have to be dead-on, because there will be a version of her still on the Background layer. So, get the Quick Selection tool **(W)** and start painting over the subject, and as you do, it starts to select her automatically. If it accidentally selects an area you don't want selected, press-and-hold the **Option (PC: Alt) key**, and paint that area away.

STEP 11:

Once you've got a basic selection, it's time to refine it a bit by clicking on the Refine Edge button up in the Options Bar. This brings up the Refine Edge dialog you see here. First, at the top, the View pop-up menu offers all sorts of ways to view how your selection looks. My favorite is to view it as Black & White (like a layer mask), because then you can really see how the edges of your selection look. In this case, they look pretty harsh (pretty much like they would if I had used the Magic Wand tool instead). Once you see how ratty your selection looks, you instantly realize why you need to refine the edges using Refine Edge.

STEP 12:

The problem with selections like these (of people) is that parts of the selection need to be hard (like around her arms, clothing, shoes, and so on), and parts need to be softer and more complex (like around her hair). To make it do both (creating a smarter edge all the way around), in the Edge Detection section, turn on the Smart Radius checkbox. Then, drag the Radius slider to the right until you see the edges start to smooth out a bit (here, I dragged the Radius to 17.5). Also, with tricky areas like her hair, you can help Photoshop out by getting the Refine Radius tool (found directly to the left of the Smart Radius checkbox) and painting over the edges of her hair (as shown here). This lets Photoshop know that this is an area where it really needs to identify the edges more closely.

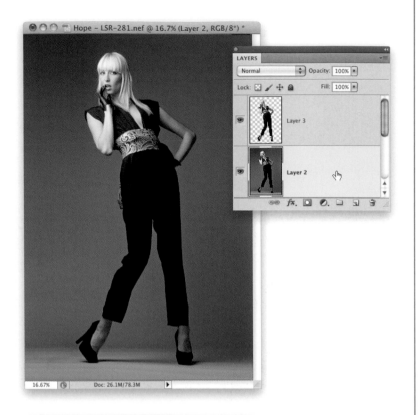

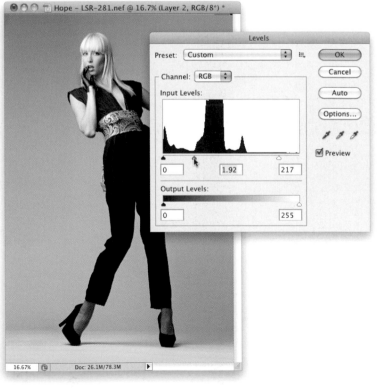

STEP 13:

When you're done, make sure **Selection** is chosen from the Output To pop-up menu at the bottom, click OK, and it puts a selection around your subject (if the selection doesn't look like it captured all the hair, don't sweat it. There's no way for a "marching ants" selection alone to display everything that's selected. Chances are, it got it all). Next, press Command-J to put her up on her own separate layer. Now, a copy of just our subject is on the top layer, and the merged layer, with the regular gray background, is directly below it. Go ahead and click on that merged layer to target it (as shown here).

STEP 14:

Go under the Image menu, under Adjustments, and choose **Levels** (or just press **Command-L [PC: Ctrl-L]**). When the Levels dialog appears, drag the white Input Levels highlights slider (it's under the far-right side of the histogram) to the left to brighten the background quite a bit. Also, drag the gray Input Levels midtones slider to the left, until the background behind the subject looks nice and bright, and then click OK. Notice that she didn't get brighter at all? That's because what you're seeing is that selected copy of her on the top layer and the adjustment is only affecting the merged layer beneath her. This is a pretty darn handy trick for re-lighting the background behind your subject after the fact (although we made it brighter here, we could just have easily made it much darker by dragging the shadows and midtones slider to the right, instead). Oh, while you're here, will you clone away that little leftover black area in the top-right corner of the image? Thanks.

STEP 15:

When you zoom in tight to make sure the edges of your selection look good after brightening the background, you might find an area here or there that needs a little touch-up, like the slightly darker gray area that appears to the left of her waist here. Just click on your selected subject layer and add a layer mask. Then, get the Brush tool, choose a very small, hard-edged brush, set your Foreground color to black, and just paint that stuff away (as shown here). It's a 15-second fix, but totally worth doing.

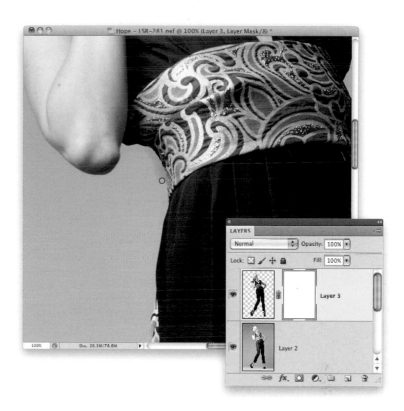

STEP 16:

Now, if there were an art director on this shoot, this next retouch would totally be their call, but here's how I see it: From a distance, that little bit of sash that is peeking out from behind her looks like a mistake in the image (if a lot of the sash were visible, it would be fine, but a little looks kinda weird). I would remove it, so it's not distracting to the viewer. So, start by creating another merged layer at the top of the layer stack, then get the Lasso tool (L) and draw a selection right down the edge of her pants and around the sash we want to remove (as shown here).

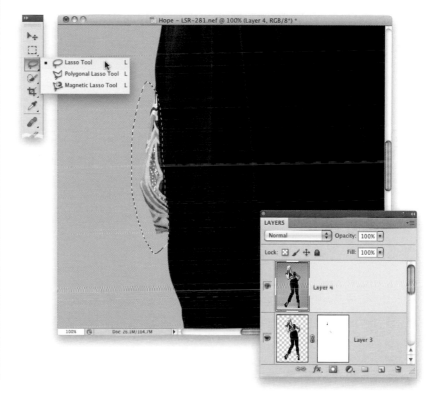

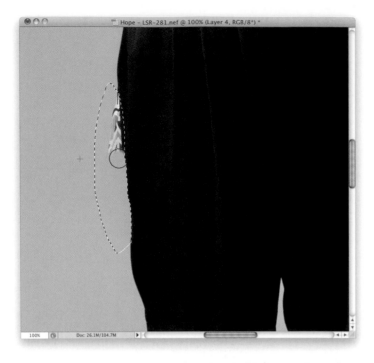

STEP 17:

Switch to the Clone Stamp tool, then Option-click in a clear area of the background, directly to the left of the sash, but outside the selected area (it's important to sample from an area that has the same tone and color, or your retouch will look lighter or darker. That's why you can't sample from above or below the selected area—it has to be right beside it). Now, just clone over the sash, and the gray background covers it. Okay, why the selection first? That way you don't accidentally erase any of the clothing. By making that selection first, you basically put up a security fence around that area, and nothing can get outside that fence (try painting on her pants while the selection is in place—you can't do it. You can only paint inside the selected area). Once the sash is gone, you can deselect.

STEP 18:

Now, we're going to create a reflection below our subject, as if she was standing on a shiny, reflective floor. So, get the Rectangular Marquee tool and make a selection from the bottom of her shoes, all the way to the top of the image (as shown here).

STEP 19:

Put your selected area up on its own separate layer, and then bring up Free Transform. Now, Right-click anywhere inside the Free Transform bounding box and a menu of possible transformations pops up. Choose **Flip Vertical** (as shown here) to flip your top layer upside down, and then press Return to lock in your transformation.

STEP 20:

To create the reflection effect, get the Move tool **(V)**, press-and-hold the Shift key (so everything stays perfectly straight as you drag it), and then click-and-drag this upside down layer straight down, until the bottom of her shoes matches up with…the bottom of her shoes! At this point, it looks like a perfect mirror effect, rather than a reflection. So, to get that reflection effect, just lower the Opacity of this flipped layer to around 50% (like I did here) or less. What's the right amount of opacity? That's totally your call.

STEP 21:

Now, let's zoom in to 200% for a little retouching (because we're zoomed in tighter than 100%, the image will look a little pixelated, but we'll still be able to easily see what needs to be done). Create another new merged layer. Then, get the Healing Brush tool (press **Shift-J** until you have it), and get rid of any really obvious blemishes (here, I'm getting rid of one on her neck) by Option-clicking (PC: Alt-clicking) on a nearby area of clean skin, then moving your cursor right over the blemish, clicking once, and it's gone (as seen here).

STEP 22:

Another distracting thing I'd remove while we're here are the folds of skin on her neck. It's perfectly natural to have these in real life, but they look exaggerated and distracting in a photograph, so I usually remove nearly all of them (sometimes I'll leave at least one, down low, so it doesn't look freaky). Just take the Healing Brush, sample a nearby area, and start painting over those skin folds until they're gone (as seen here).

STEP 23:

Press **Command-J (PC: Ctrl-J)** to duplicate the top merged layer, so if we need to lower the amount of our next retouch, we can just lower the layer's opacity. Our retouch this time around is to remove the small wrinkles under her eyes. Again, use the Healing Brush to sample an area right under a wrinkle, then paint right over it to remove it. If it looks weird with them completely gone (depends on the person), then lower the opacity of this layer until just a little hint of the wrinkles comes back.

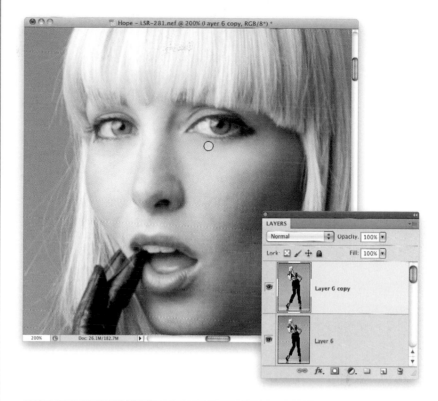

STEP 24:

Next, let's work on the eyes. Create another merged layer, and then change its blend mode to **Screen** to make everything much brighter. Now, let's hide that bright layer behind a black mask by Option-clicking (PC: Alt-clicking) on the Add Layer Mask icon. Get the Brush tool, choose a very small, soft-edged brush, set your Foreground color to white, and then paint over the whites of her eyes and her irises (being careful not to brighten the dark rings around the outside of the irises—you want them to stay dark). Now, zoom out a bit and let's decide how much to lower the layer's opacity, so the eyes look great (100% is way too bright, almost always). Start at 50% (as shown here), and see how that looks (I actually like it at 50%, but depending on the photo, you might need to take it down as low as 30%).

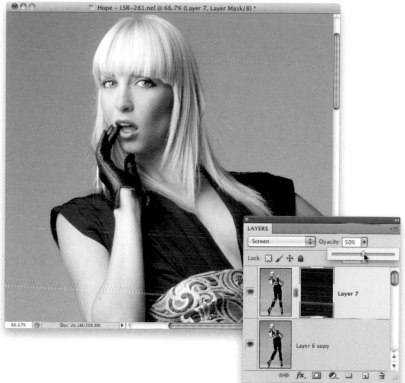

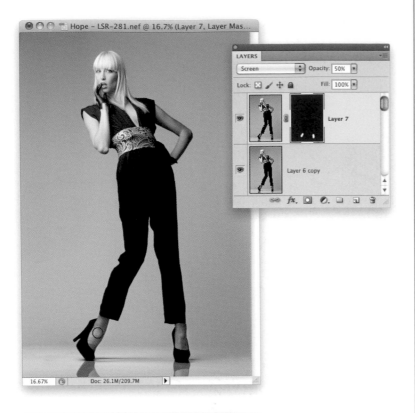

STEP 25:

Now, let's zoom all the way back out and look at how things are shaping up. To me, her ankles and the tops of her feet look a little dark. Since we already have a 50% Screen layer in place with a black layer mask, why don't we just brighten those up a bit by painting over them with our white, soft-edged brush (you'll have to make the brush size a little larger)? If that looks too bright, you can just Undo that paint stroke **(Command-Z [PC: Ctrl-Z])**, then lower the opacity of the brush up in the Options Bar. I didn't have to do that, in this instance, but I thought at least you'd like to know what to do in case it was too bright.

This is pretty much it, but I do have an optional effect you might want to consider, which lets you add a light on the background, so you get a glow around your subject.

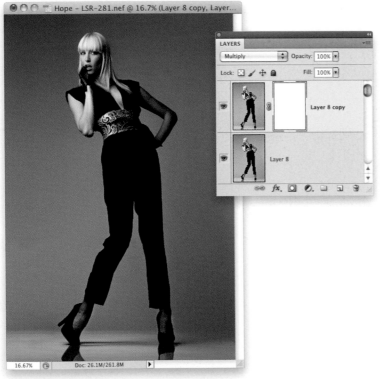

STEP 26:

Create another merged layer, press Command-J to make a copy of it, and then change the copy's blend mode to **Multiply**. This makes the entire image much darker (as seen here). Now, click on the Add Layer Mask icon to add a layer mask to this layer.

STEP 27:

Set your Foreground color to black, then with the Brush tool still active, choose a huge, 2500-pixel, soft-edged brush (just press the **Right Bracket key** on your keyboard until you see 2500 pixels in the brush thumbnail up in the Options Bar. By the way, the Bracket keys are to the right of the letter P on your keyboard). Now, take this giant brush, move it over your subject, and just click a few times. This knocks a huge, soft hole out of the dark Multiply layer, revealing part of the brighter layer right below it, which gives the impression that you lit the background with a separate strobe. It's a pretty convincing effect, but again, it's a totally optional look. I just thought I'd show it to you, so you can choose the look you like best.

STEP 28:

Here's a side-by-side comparison, so you can see the two different versions next to each other. When I saw them side by side, though, something leaped out at me—her arm on the right side of the image seemed too dark (you can see what I mean in the image in Step 25). Luckily, the fix is pretty easy: Create another merged layer, duplicate it, and change the blend mode to Screen. Next, duplicate that layer, so it's now twice as bright, and press **Command-E (PC: Ctrl-E)** to merge the two bright layers into one really bright layer. Then, Option-click on the Add Layer Mask icon to hide this super-bright layer behind a black mask. Choose a small, soft-edged brush and paint in white over her arm on the right. It'll probably be too bright, so lower the Opacity until it's just a little darker than the arm on the left side of the image (here, I lowered it to 60%).

You can see the finished image at full-page size at the beginning of this chapter.

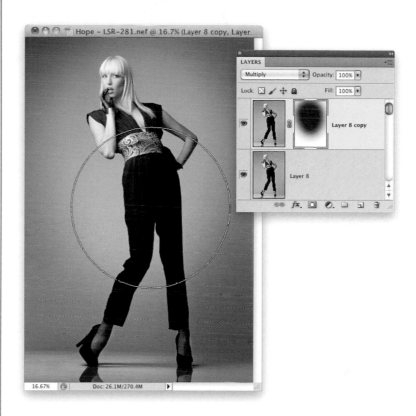

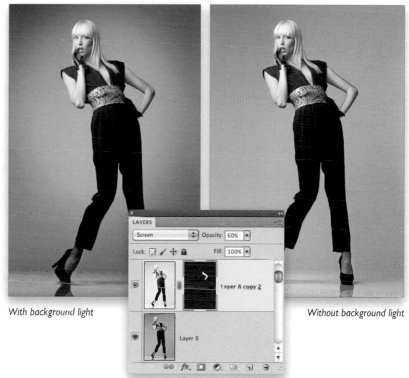

With background light

Without background light

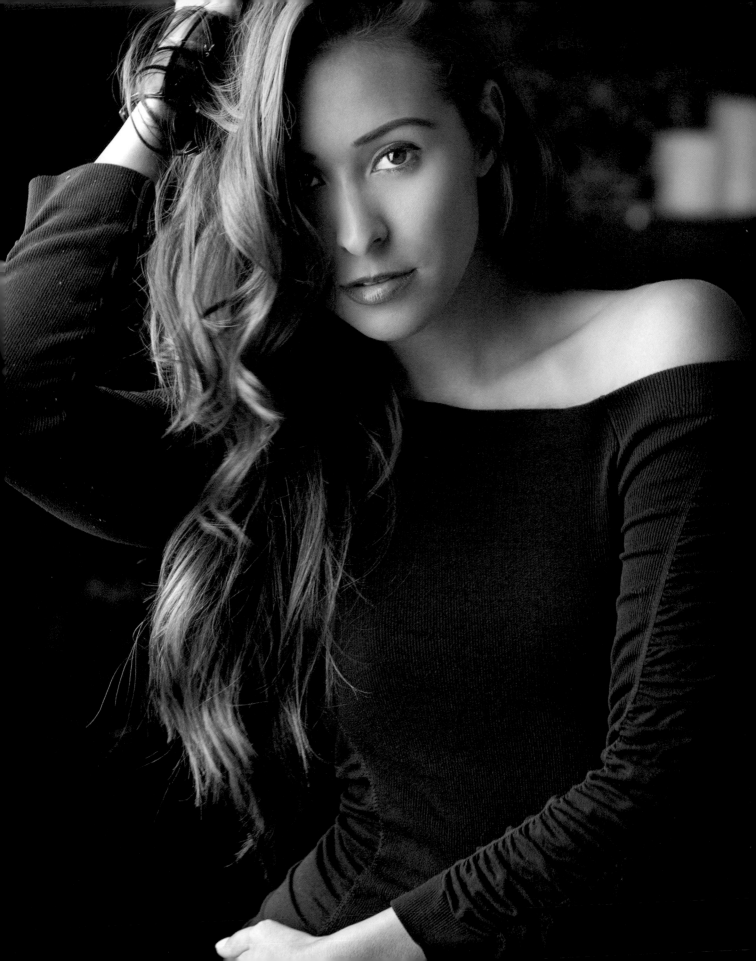

1-LIGHT HOME INTERIOR SETUP
Soft Glamour Lighting

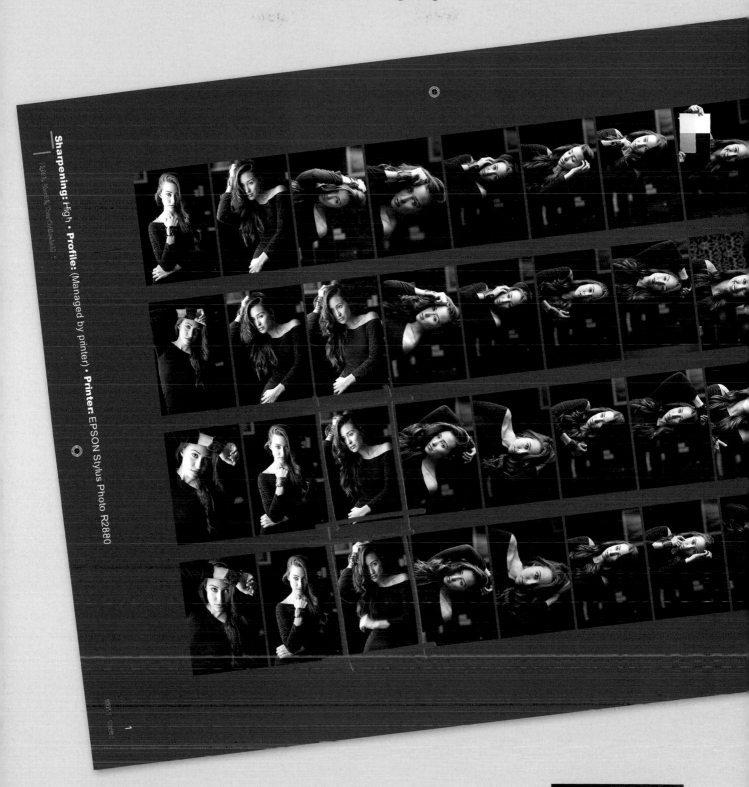

Sharpening: High • Profile: (Managed by printer) • Printer: EPSON Stylus Photo R2880

When I want to get super-soft, glamorous light, I use the biggest softbox I can find. This one, which is literally 6 feet tall and placed directly beside the subject, creates amazingly beautiful wrapping light and lots of dramatic shadows on the other side of her face. Couple that with the already soft light from the continuous fluorescent bulbs, and you've got a perfect setup for shooting glamour portraits. In the background, we created a set to look like a home interior. The backdrop is from F.J. Westcott, and it's called their Pasha Modern Vintage Background. It's supported with two background stands. I borrowed a framed print of one of my travel images off my assistant's wall, and hung it from a regular light stand. Lastly, we borrowed some shelves, candles, and a plant from a co-worker's office.

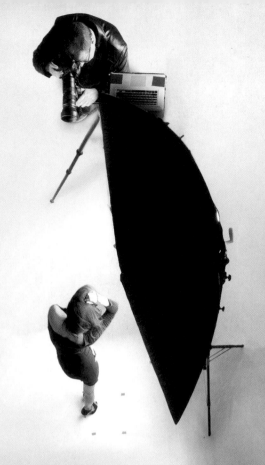

GEAR GUIDE

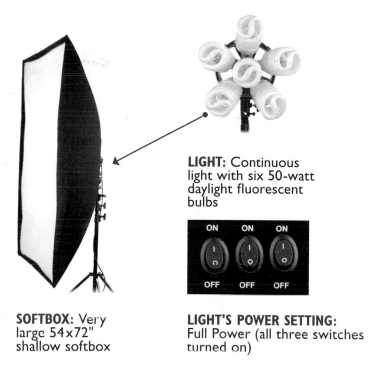

LIGHT: Continuous light with six 50-watt daylight fluorescent bulbs

SOFTBOX: Very large 54x72" shallow softbox

LIGHT'S POWER SETTING: Full Power (all three switches turned on)

CAMERA SETTINGS

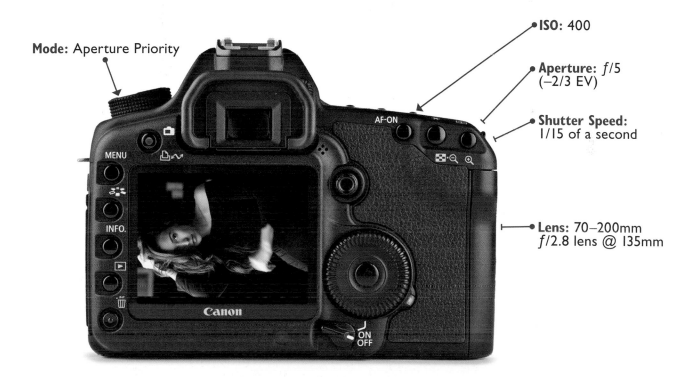

Mode: Aperture Priority

ISO: 400

Aperture: f/5 (−2/3 EV)

Shutter Speed: 1/15 of a second

Lens: 70–200mm f/2.8 lens @ 135mm

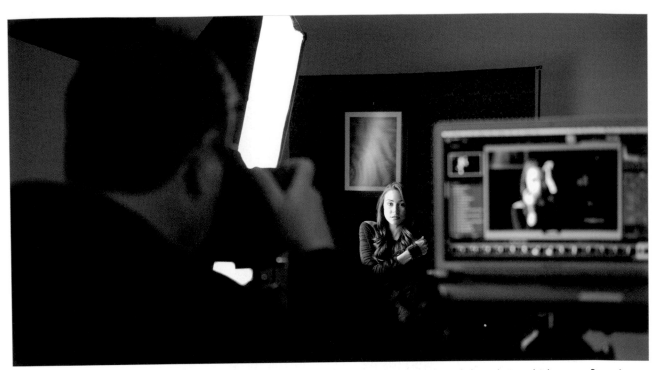

FRONT VIEW: Here's an over-the-shoulder view of the shoot. I'm shooting tethered directly into Lightroom 3, so I can see the images larger as soon as they're taken. You can see a reflection in the hanging picture behind her, so I had to compose the shot so you just saw the edge of the photo in the frame.

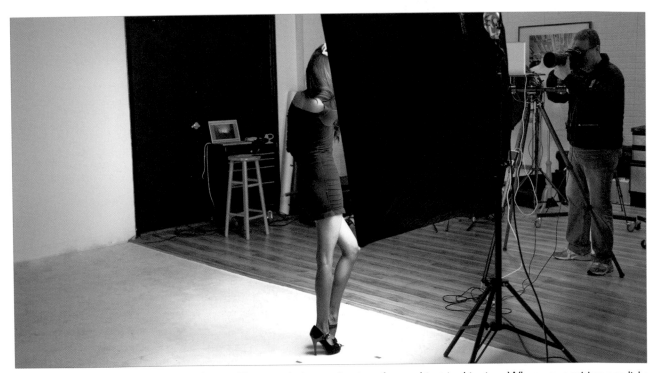

LEFT SIDE: You can see the size of the softbox in relation to the size of our subject in this view. When you position one light on the side of your subject like this, it helps to ask them to angle their body somewhat toward the light, and for them to "play" a bit toward it. If they turn their head away from the light, it'll be pretty dark.

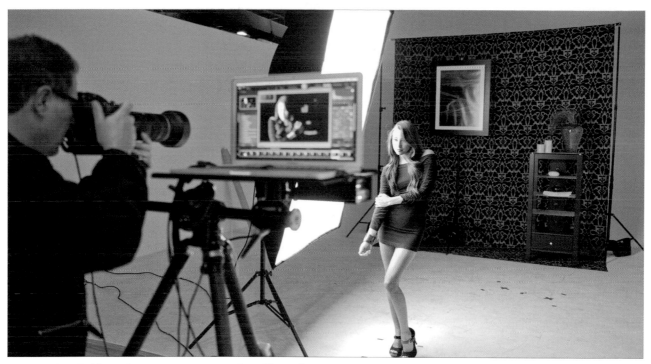

RIGHT SIDE: This side view gives you an idea of how close our subject is to the softbox (and just how large that softbox really is—when it comes to softboxes, the bigger the softbox, the softer the light). Also, you can see that she's far enough from the background that the light doesn't engulf it—it just kind of spills a little onto it.

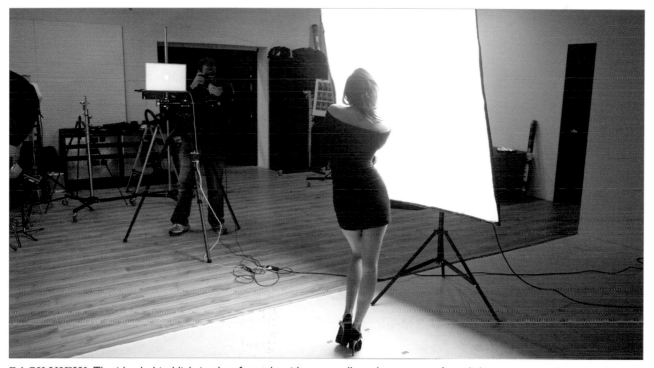

BACK VIEW: The idea behind lighting her from the side was really to keep most of our light concentrated on the side of her face closest to the light, but with a light this big, we get the benefit of it wrapping around her and keeping the shadows on the other side of her face lighter.

THE POST-PROCESSING

Okay, there's a lot to do in this one, starting with doing a "part swap," because one of her hands is blurry in the image we're retouching here. So, we're going to replace it with her hand and arm from a similar photo, taken seconds before. We've got to do everything from fixing the white balance, to retouching her dress, to skin softening, to adding highlights to her hair, to, well…there's a lot of post here. Don't worry, you'll be able to easily do every single step, so don't let the number of steps throw you off—it's easy. Plus, when you're done, you'll have learned lots of important techniques.

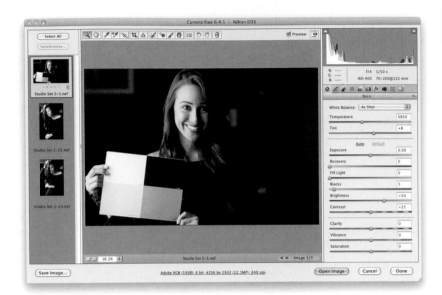

STEP ONE:
If there's a white balance problem (like there is with these photos), I like to fix that first, because my rule has always been: "Fix the most distracting thing first." Then, you can focus on everything else. On this shoot, I remembered to have our subject hold a gray card, which makes setting the white balance simple (the card she's holding is included in my book *The Adobe Photoshop CS5 Book for Digital Photographers*, so if you have that book, turn to the last page and you'll find this perforated card). Have your subject hold the card up clearly in the photo (as seen here).

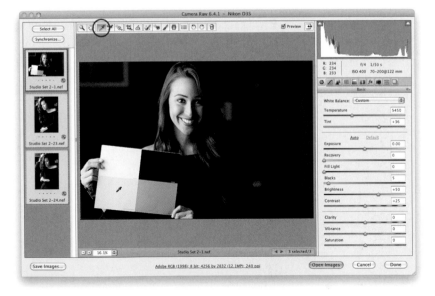

STEP TWO:
I opened three images in Camera Raw (as seen in the filmstrip here, on the left side of the window): the gray card photo, the photo where her hand isn't blurry, and at the bottom, the one we're going to retouch. Start by clicking the Select All button at the top of the filmstrip (so any changes made to the selected photo are applied to the other photos automatically). Then, get the White Balance tool (**I**) from the toolbar up top (it's shown circled here in red), click it once on the light gray swatch on the card (as shown here), and the white balance is fixed. That card makes it really easy.

STEP THREE:

Now, press **Command-D (PC: Ctrl-D)** to Deselect the three images. We don't need the gray card image any longer, we just need the bottom two, so click on the bottom image, then Command-click (PC: Ctrl-click) on the center image to select them both. We're going to lighten up the shadow areas in her dress and, more importantly, in the background by increasing the Fill Light amount. Drag the Fill Light slider to the right to 15 (as shown here) to lighten the shadow areas in both selected images.

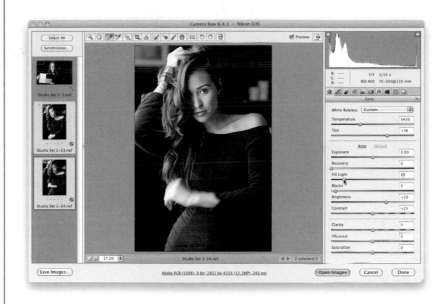

STEP FOUR:

It did a great job on the dress, but a so-so job on the background, so we'll lighten it manually, using the Adjustment Brush (changes you make with this tool don't get applied automatically to the other selected image, so deselect both and just click on the bottom image). Get the Adjustment Brush (from up in the toolbar—it's shown circled here in red), then click the + (plus sign) button to the right of the Brightness slider two times to reset all the other sliders to 0, and increase the Brightness to +50. Now, take the brush and paint over the background areas behind her (except for the picture frame on the left— it's bright enough), and as you do, it opens up those areas a bit and makes them more visible (as seen here). When you're done, select the bottom and center images again, then click the Open Images button at the bottom of the window.

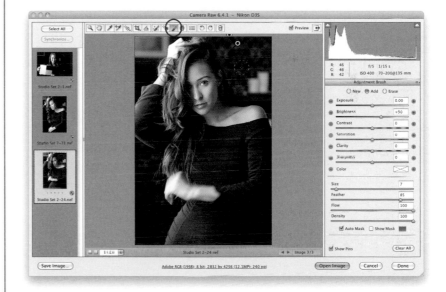

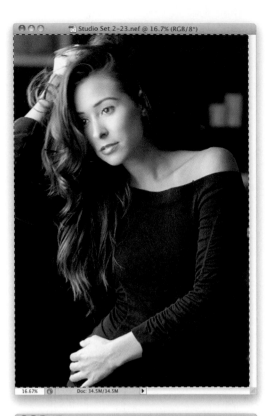

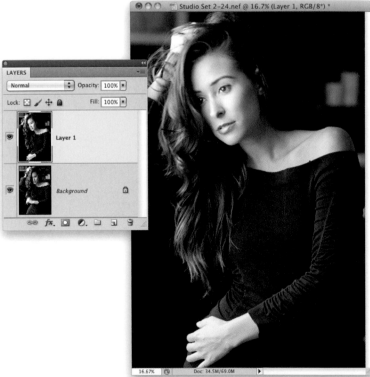

STEP FIVE:

Here's one of our two images open in Photoshop. This is the one we're going to borrow her arm from, since it's not moving. (*Note:* The blurring in her arm in the other photo came from me using too slow a shutter speed. I should have either opened up the f-stop [I shot this at f/5, but I should have gone to f/2.8, which would have increased my shutter speed quite a bit] or increased my ISO from 400 to 800 or higher. So, why didn't I do either of these? I wasn't paying attention to the shutter speed, so basically I messed up. It happens.) We need these two images stacked on top of each other as layers, so you can either use the Move tool **(V)** to drag-and-drop the image from this document over onto the other one (in which case, press-and-hold the Shift key as you drag, so they line up), or just Select All **(Command-A [PC: Ctrl-A])**, as shown here, then copy it into memory **(Command-C [PC: Ctrl-C])**. Now, you can close this image.

STEP SIX:

Go to the other image and Paste **(Command-V [PC: Ctrl-V])** the copied image (without the blurry hand) on top of the blurry hand image. It will appear as its own layer (as seen here). By the way, the two images we're using were taken seconds apart, so our subject hasn't moved much, but if she had, we'd need to have Photoshop auto-align these images first. If that were the case, what you'd do is select both layers in the Layers panel, then go under the Edit menu and choose Auto-Align Layers, and then when the dialog appears, just leave the Auto option checked, and click OK. That would do the trick. In this case, we can skip that step, but now at least you know.

STEP SEVEN:

Next, we need to hide the top layer (the non-blurry arm shot) behind a black mask. So, press-and-hold the Option (PC: Alt) key and click on the Add Layer Mask icon at the bottom of the Layers panel (it's shown circled here in red). This adds a black layer mask to your layer, and hides your image behind it.

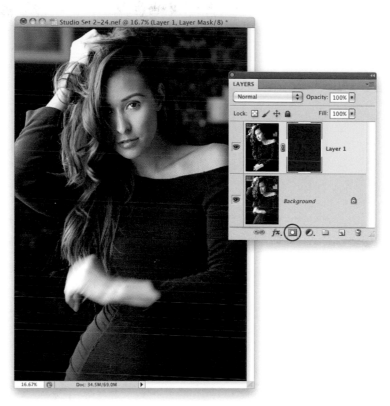

STEP EIGHT:

Press **D** to set your Foreground color to white (the default Foreground and Background colors are reversed on a layer mask), get the Brush tool **(B)**, choose a medium-sized, soft-edged brush, and start painting away her blurry hand, revealing the non-blurry hand on the top layer. You can see an in-process view here, as I'm starting to paint in white, and you can see where it's erasing the blurry hand and using the arm from the other image. It's certainly not done yet, but it's a start.

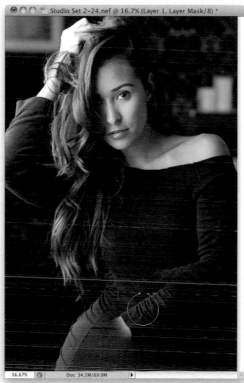

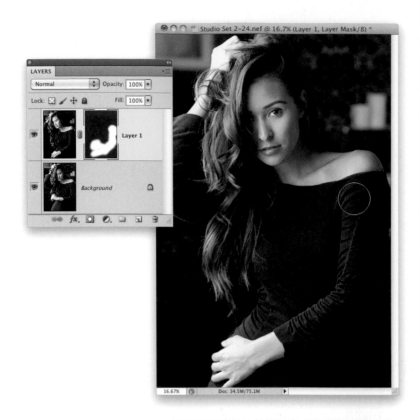

STEP NINE:

As you continue up the arm, it replaces it entirely, and it does a pretty good job. If you start to see a part you're painting over that doesn't line up too well, just press X to switch your Foreground color to black, and paint over the bad area to return it to what it looked like before. In this case, I stopped before I got to her shoulder, but you could probably get away with replacing most of her shoulder, as well. With a repair like this, you might have to do a little Clone Stamp tool fix at some point, but it should be pretty minor (and you probably won't notice it until you zoom in).

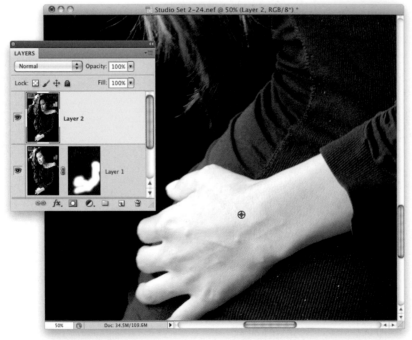

STEP 10:

Time for some skin retouching, and we need a new layer to work on without a layer mask on it. So, start by creating a merged layer (a new layer that's a flattened version of your image) on top of your layer stack by pressing **Command-Option-Shift-E (PC: Ctrl-Alt-Shift-E)**. Now, let's work on her bottom hand. I usually get rid of any large veins or blemishes on the back of the hands, so get the Healing Brush tool (press **Shift-J** until you have it), make sure the Sample pop-up menu in the Options Bar is set to **Current Layer**, and then Option-click (PC: Alt-click) on a clean area on her hand that's near the veins you want to remove (as shown here).

STEP 11:

Then, paint over the veins with the Healing Brush, and they're gone! Go ahead and continue cleaning up this area with the Healing Brush, and while you're there, you may as well use the same tool to remove any specks or spots on her dress (a black dress picks up lots of little specks and stuff). Just remember: the dress has a vertical texture, so when you need to remove a speck, make sure you sample directly above the speck, and then keep an eye on your brush cursor—it shows you a preview of what it's about to paint, and you want to keep those straight texture lines straight (you'll see what I mean when you try it).

STEP 12:

As I was moving around the image, removing specks, I found this area at the top of her dress where the masking I did earlier wasn't right on the money, so it's going to take a little bit of cloning to fix that up. Pretty easy stuff, but it has to be done, right? So, switch to the Clone Stamp tool **(S)**, and choose a small, soft-edged brush.

STEP 13:

Option-click (PC: Alt-click) your cursor right along the top edge of her dress, then move your cursor over the messed-up area and paint it away. That fixed part of it, but you'll have to basically clone a little of her skin down to cover that spot. So, click on the brush thumbnail in the Options Bar to open the Brush Picker, and when it pops down, drag the Hardness setting over to 61%, so the brush isn't quite so soft. Now, you can paint the skin along the top of the dress (as shown here) to smooth things out.

STEP 14:

While I was working on that part of the dress, I noticed a ripped area on the top right of her dress, so let's fix that, too. This is a fairly large area to fix. So, for stuff like this, I switch to the Healing Brush's companion tool, the Patch tool (click-and-hold on the Healing Brush tool and it's on the menu that pops out). Choose the Patch tool, and use it to draw a selection around the ripped area (it works just like the Lasso tool).

STEP 15:

Now, take the Patch tool and click directly inside the selected area, then drag it straight upward to a clean area above it (you're basically telling the Patch tool which area to use as its patch). Release your mouse button, and it snaps back to the original position and fixes the rip. If it picks up any tiny little leftovers from her skin, just use the Clone Stamp tool to get rid of them. I need to get away from this shoulder area, because I keep finding new stuff here—in this case, it's that little bump in her shoulder, straight up from where we patched her dress. It's just poking out a tiny bit, but we can fix that really easily, too.

STEP 16:

Go under the Filter menu and choose **Liquify** (it's right near the top), and when the Liquify dialog opens, choose the top tool in the toolbar on the left (the Forward Warp tool **[W]**), make your Brush Size a little larger than the area you want to adjust, then just literally push that little area that's poking up down with the brush. It will move kind of like a thick liquid (like molasses), and you'll have this fixed in 10 seconds (or less). When it looks good, click OK, and let's get away from this shoulder before I find something else.

STEP 17:

Now, let's zoom in on the face and see what needs to be done. Just a few things here: we need to (1) remove any obvious blemishes using the Healing Brush; (2) brighten the whites of her eyes and her irises; (3) trim up her eyebrow on the right; and (4) soften her skin a tiny bit. That should do it. Let's get to work!

STEP 18:

We always remove the blemishes first, so start by getting rid of those (and a couple stray hairs on her forehead) with the Healing Brush (as shown here).

STEP 19:

Now, create a new merged layer at the top of the layer stack, and change its blend mode to **Screen** to make the entire image much brighter. Then, Option-click (PC: Alt-click) on the Add Layer Mask icon to hide this brighter layer behind a black layer mask. Switch to the Brush tool, choose a small, soft-edged brush (make sure your Hardness is set back to 0% in the Brush Picker, so the brush is fully soft), set your Foreground color to white, and paint over the whites of her eyes (as shown here). It'll be hard to get that thin white area under the iris, so just paint right over it, so it spills out onto her lower eyelashes. Then, switch your Foreground color to black and paint over the spillover area to remove it (this is much easier than trying to use a super-tiny brush to get that little area). Lower the Opacity of this layer to 50%, so the whites aren't too white.

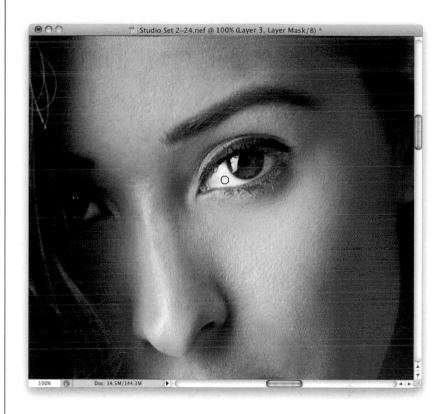

STEP 20:

Create another merged layer, and now let's work on trimming the eyebrow. Get the Lasso tool **(L)** and draw a lasso selection in a clean area right above her eyebrow (as shown here) that's kind of in the shape of an eyebrow. We need to slightly soften the edges of this selection (so you won't see a hard edge when we move it), so go under the Select menu, under Modify, and choose **Feather**. When the Feather Selection dialog appears, enter 3 pixels and click OK.

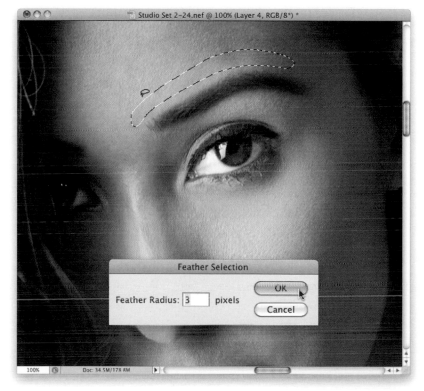

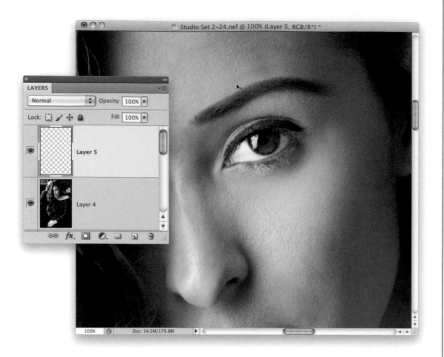

STEP 21:

Press **Command-J (PC: Ctrl-J)** to put that selected area up on its own layer, then switch to the Move tool **(V)**. Now, drag that eyebrow-shaped layer straight down toward the top of the eyebrow and, as you move close to it, the bottom of your layer perfectly trims the top of her eyebrow (this works surprisingly well, and I do this retouch to most of my images where the subject's face will appear large in the image).

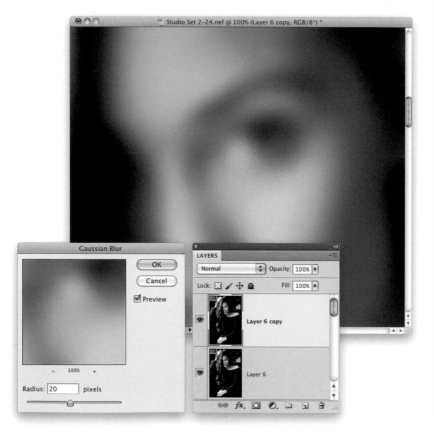

STEP 22:

Time for another merged layer, so go ahead and create that now, because we're going to do some simple, quick skin softening. We are going to use a tiny bit of blurring on the skin, but don't worry—we're not going to obliterate the skin texture or do any of that over-the-top softening that makes people look plastic. This is going to be very subtle, and we'll retain *lots* of skin texture, so the smoothing will look natural, without us having to spend hours on the skin alone. First, press Command-J to duplicate your merged layer, then go under the Filter menu, under Blur, and choose **Gaussian Blur**. When the dialog appears, enter 20 pixels and click OK to put a large blur over the entire image (as shown here).

STEP 23:

Next, lower the Opacity of this layer to 50% (we need a high Opacity percentage to start, so we can see the softening as we paint it on), then Option-click (PC: Alt-click) on the Add Layer Mask icon to hide this 50% opacity blurry layer behind a black mask. Make sure your Foreground color is set to white, and get the Brush tool with a small, soft-edged brush. Now, paint over just her skin areas, avoiding any areas that should stay sharp, like her lips, eyes, eyelashes, eyebrows, hair, clothing, nostrils, and such. Also, avoid painting over the edges of the skin, because it blurs the edges. In fact, avoid the edges of anything (you can paint almost right up to them, but don't actually paint over the edges themselves).

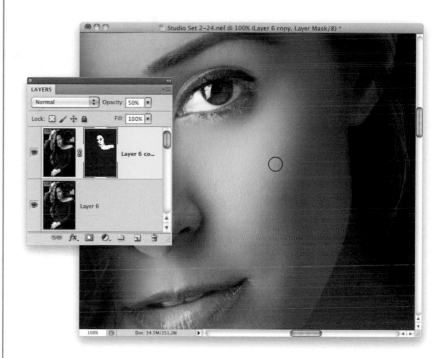

STEP 24:

There's a trick you can use to make sure you didn't miss any areas, and that is to press-and-hold the Option (PC: Alt) key and click directly on the black-and-white layer mask thumbnail over in the Layers panel (the thumbnail directly to the right of your current layer). This displays just the mask in your image window, and now you can easily see all the places you missed (all those little black areas you see here on her cheek, the bridge of her nose, and her jaw are areas I missed painting over). Luckily, you can paint right on this layer in white, so it just takes a few seconds to paint over any areas you missed (as seen here). When you're done, Option-click (PC: Alt-click) on the layer mask thumbnail again to return to the normal view.

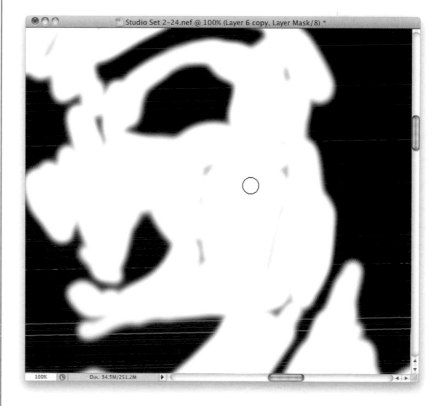

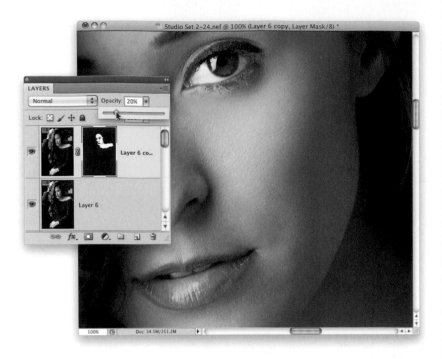

STEP 25:

Here's where we bring the skin texture back in a big way—you're going to lower the Opacity of this blurry layer quite a bit. My usual starting place is 35%, but in this case you can go all the way down to 20%. When you do that, you can see lots of skin texture throughout, but the skin is definitely softened, and the highlights and shadows are smoothed out a bit, as well.

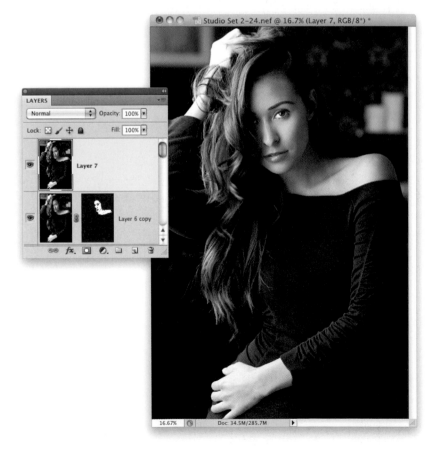

STEP 26:

Now, let's zoom back out and see how things are shaping up (you can zoom right to a fit-in-window view by double-clicking on the magnifying glass (called the Zoom tool) in the Toolbox. Looking at the image at this stage, here's what's bothering me: both of her hands seem too bright (compared with her face and shoulders, anyway). The hand on top is right near the light, so there's not a ton we can do there, but we can fix the other one quite a bit. I think it's more important to fix the lower hand, as the light should fall off down there anyway, so we'll start there. First, create another merged layer (as seen here).

STEP 27:

Then, go to the Adjustments panel and click on the Levels icon (you'll need to use an adjustment layer for this, because we're going to have to change the layer's blend mode after the fact, so the skin doesn't look burned or weird). Now, in the Adjustments panel, drag the center midtones slider (just below the histogram) to the right quite a bit (here, I dragged to 0.39) to really darken up the image a lot. Then, press **Command-I (PC: Ctrl-I)** to Invert the layer mask (so now, the darker image is hidden behind a black mask). Make sure your Foreground color is set to white, and that you have a smallish, soft-edged brush, and then paint over both her hands (as shown here, where I'm painting over her bottom hand). If you make a mistake and accidentally paint over her dress, switch your Foreground color to black and paint over the spillover. Finally, to keep the skin on her hands looking normal, change the layer's blend mode to **Luminosity**.

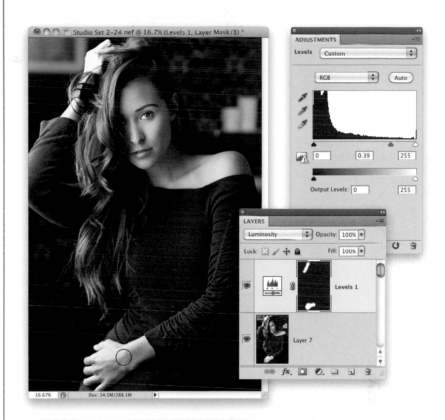

STEP 28:

Now for some hair highlights. Create yet another merged layer, change its blend mode to **Screen**, and then Option-click (PC: Alt-click) on the Add Layer Mask icon to hide this brighter Screen layer behind a black mask. Set your Foreground color to white, then take a medium-sized, soft-edged brush, and paint over the highlight areas of her hair (as seen here). I know it's a bit bright, but we'll fix that in a moment—for now, just paint over those highlight areas, and don't forget the highlights on the side of her hair that's away from the light.

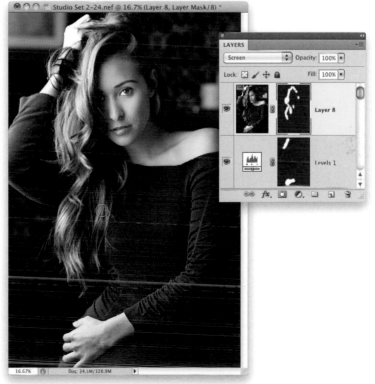

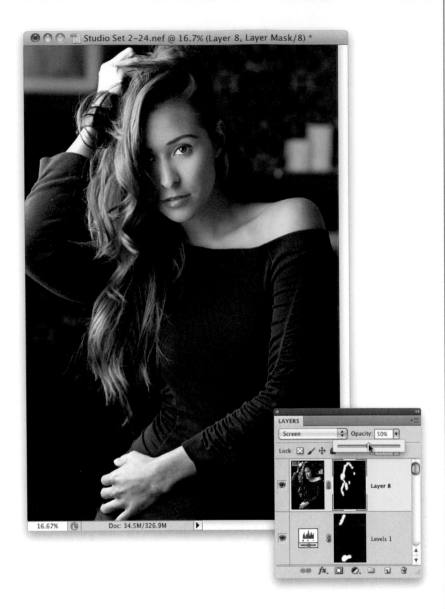

STEP 29:
Go to the Layers panel and lower the Opacity of this layer to around 50% (as shown here), and see how that looks. If you think it's still too bright, you can lower it to wherever you think it looks good. Okay, we're almost there.

STEP 30:

I know we brightened the background behind her earlier in this project, but looking at how the image looks now, I think a tiny bit of darkening in the corners of the image might be just what it needs to finish it off. Create another merged layer, then change its blend mode to **Multiply** to make the entire image darker. Now, Option-click on the Add Layer Mask icon to hide the darker Multiply layer behind a black mask. Set your Foreground color to white, choose a large-sized, soft-edged brush, and paint over the corners a bit to darken them (as shown). If you think it's too dark, just lower the layer's Opacity. You can see the final image on the opening page of this chapter.

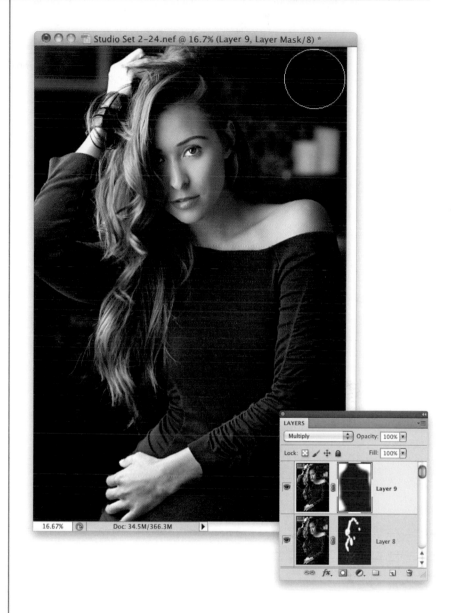

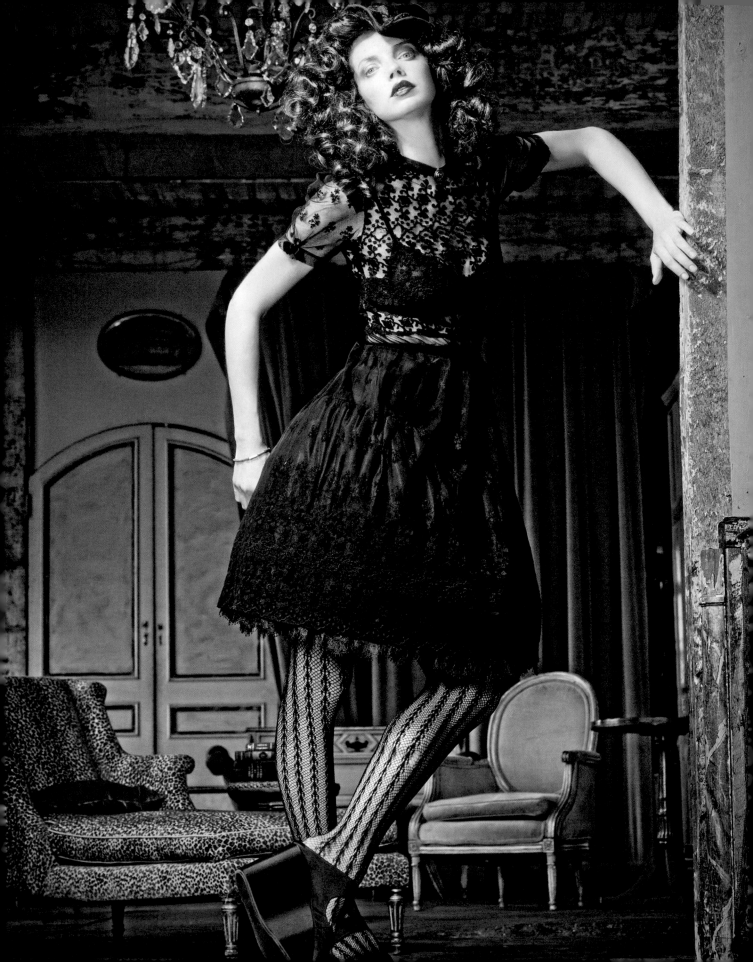

2-LIGHT ON-LOCATION FASHION SETUP

Fashion Side Lighting

UNEDITED PROOFS

Sharpening: High • Profile: (Managed by printer) • Printer: EPSO

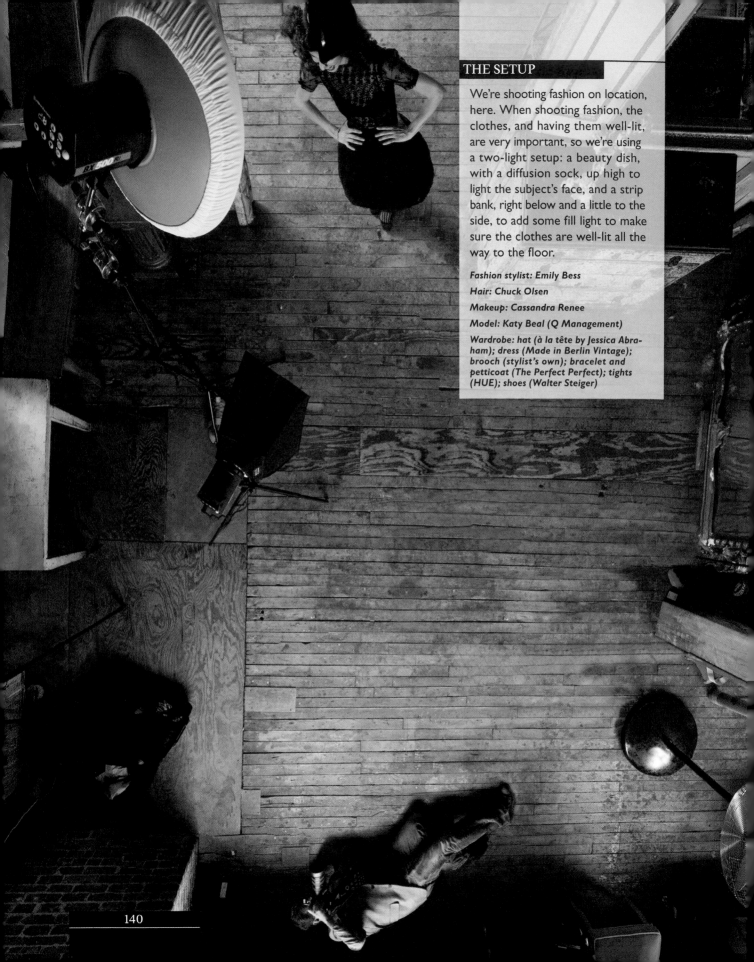

THE SETUP

We're shooting fashion on location, here. When shooting fashion, the clothes, and having them well-lit, are very important, so we're using a two-light setup: a beauty dish, with a diffusion sock, up high to light the subject's face, and a strip bank, right below and a little to the side, to add some fill light to make sure the clothes are well-lit all the way to the floor.

Fashion stylist: Emily Bess
Hair: Chuck Olsen
Makeup: Cassandra Renee
Model: Katy Beal (Q Management)

Wardrobe: hat (à la tête by Jessica Abraham); dress (Made in Berlin Vintage); brooch (stylist's own); bracelet and petticoat (The Perfect Perfect); tights (HUE); shoes (Walter Steiger)

GEAR GUIDE

TOP STROBE: 500-watt unit with 17" beauty dish with diffusion sock

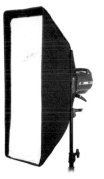

BOTTOM STROBE: 500-watt unit with 12x36" strip bank

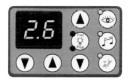

TOP STROBE'S POWER SETTING: 2.6

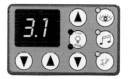

BOTTOM STROBE'S POWER SETTING: 3.1

CAMERA SETTINGS

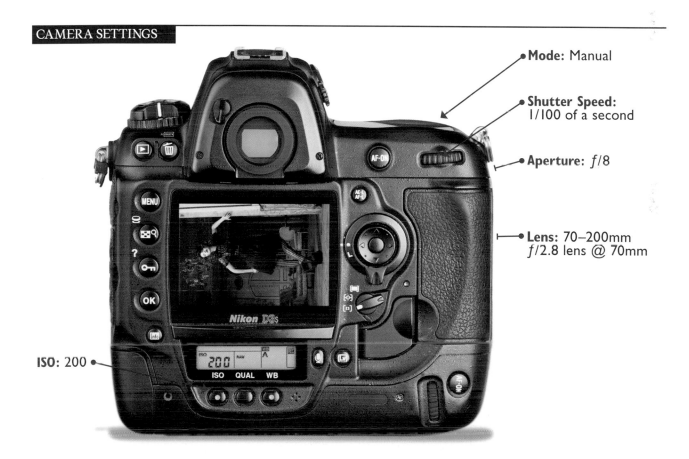

Mode: Manual

Shutter Speed: 1/100 of a second

Aperture: ƒ/8

Lens: 70–200mm ƒ/2.8 lens @ 70mm

ISO: 200

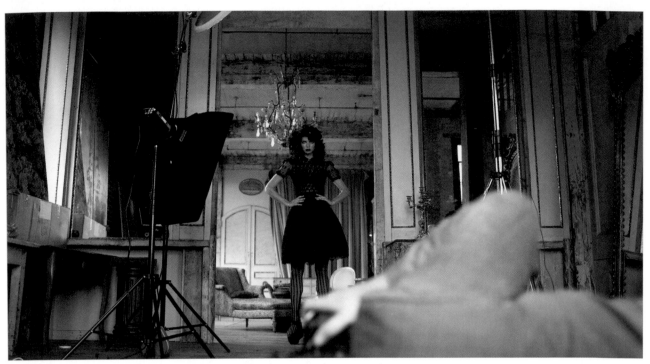

FRONT VIEW: Here, you can see the two lights: The beauty dish is up really high, and has a diffusion sock over the front of it to make the light a little softer. It's aimed so it mostly lights her face. The strip bank below it is simply adding more light to her clothes (we did not use a fabric grid over the strip, so the light would spread out a little wider).

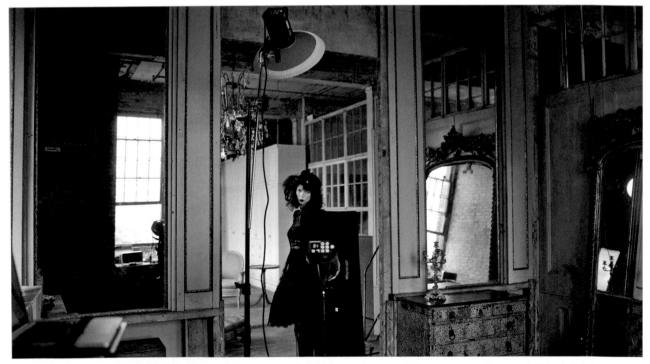

LEFT SIDE: This view really lets you see the steep angle of the top light, and it's easy to see how each light is lighting just part of our subject. I wanted the light to be directional, and all coming from one side, so that's why they're both positioned on the same side (some traditional lighting setups would have had the fill light on the opposite side).

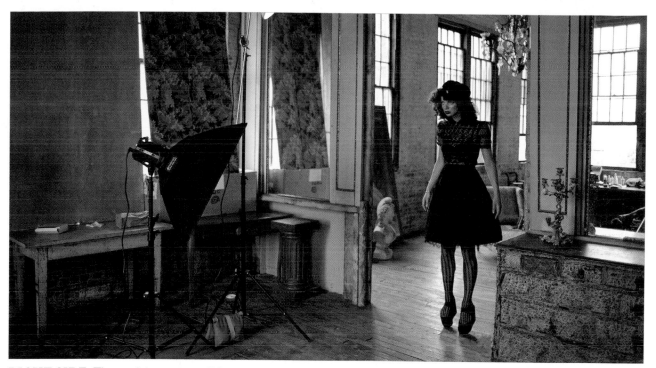

RIGHT SIDE: The model was very tall (one reason why she was such a great model), and she was wearing very, very tall shoes, which were designed to make it look like she was standing en pointe, like a ballerina. So, the beauty dish had to be really high.

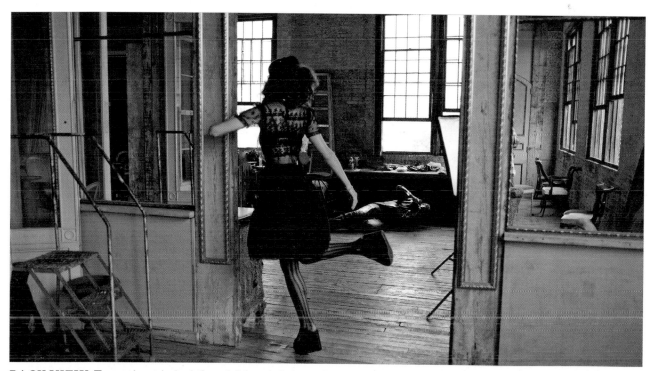

BACK VIEW: To get the right look for a full-length fashion photo, you have to get down really low (as seen here, where I'm lying down on the job). It's harder to hand-hold the camera steady in this position, which is why you'll sometimes see photographers shoot low like this on a tripod with the legs splayed outward, so it holds the camera still for you.

THE POST-PROCESSING

The lighting on our model is pretty even, and since it's a full-length shot, we don't have to be as critical about retouching every little pore, right? But, the set this was shot on (on location) needs a lot of work in balancing out the light and toning down some areas. And, there's even a bit of a perspective problem (the wall on the right is kind of leaning back). Plus, we'll add a color effect to the overall image (very popular for fashion shots these days), so we actually have quite a bit to do.

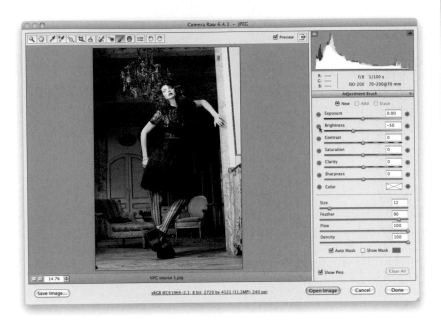

STEP ONE:

We'll start in Camera Raw and, right off the bat, we'll need to fix something very distracting in the image—the wall on the right side is very bright, and is drawing the viewer's attention away from our subject. So, we'll darken just that area by getting the Adjustment Brush **(K)** from the toolbar up top, and then clicking twice on the – (minus sign) button to the left of the Brightness slider in the Adjustment Brush panel (as seen here). This sets all the other sliders to zero, and sets the brush to paint darker midtones.

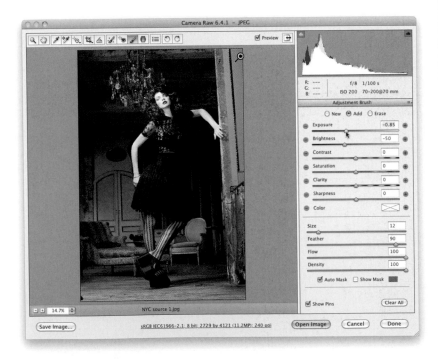

STEP TWO:

Now, take the brush and paint over the wall on the right, being careful not to paint over her hand. In cases like this, most of the time just darkening the midtones (Brightness) like we did in Step One would do the trick, but this area is so bright that we need to bring down the highlights (Exposure), as well. You don't need to use the brush again, though. Just drag the Exposure slider to the left (as shown here, where I dragged it down to –0.85 and that did the trick). Look at how much more balanced the image looks now.

STEP THREE:

While we have the Adjustment Brush, there's one other area I would adjust—the floor. If you look back at Step Two, you can see it's also a little bright, but not nearly as bad as the wall was (but still worth fixing). Start by clicking on the New radio button at the top of the Adjustment Brush panel (because you want to adjust something new [the floor] and you want to be able to control this new area separately from the wall you painted earlier). Then, click once on the − (minus sign) button to the left of the Brightness slider to set all the other sliders to zero, and set the brush to −25. Now, paint over the floor to darken it a bit (as seen here). Notice we now have two "pins" on the photo—the green pin at the bottom is the currently active adjustment and any sliders you move will affect just the area assigned to that pin (in this case, the floor). If you wanted to go back and adjust the wall, you'd click on that pin at the top right, and then the sliders would affect just the wall.

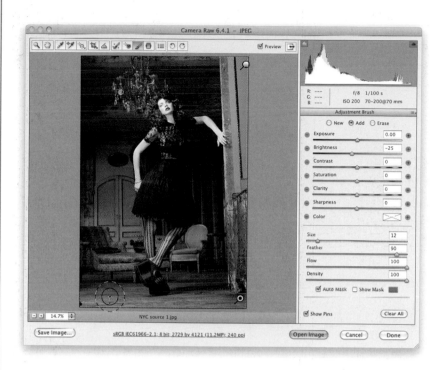

STEP FOUR:

Lastly, the image looks a little crooked (the wall in the back is tilted), so we need to rotate it a bit. You can use the Straighten tool (**A**; to the right of the Crop tool in the toolbar) or just get the Crop tool (**C**), drag it out so it covers the entire image, and then drag in the sides just a little bit. Now, when you move your cursor outside the cropping border, it changes into a two-headed arrow, and you can click-and-drag in a circular motion to rotate the image (as I have here, where I tilted the image a bit to the left to straighten things out). Press **Return (PC: Enter)**, and it crops the image (and in this case, straightens it, too!).

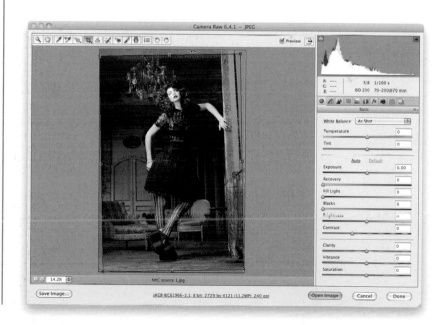

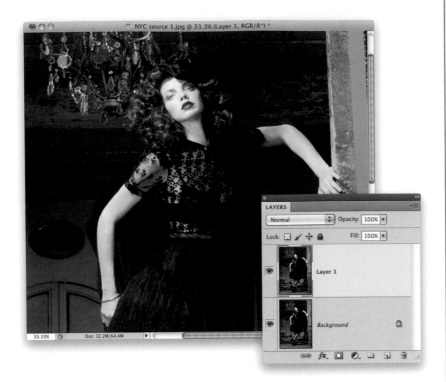

STEP FIVE:
Click the Open Image button at the bottom right to open the image in Photoshop. This image has a lot of texture and depth, and it would probably look great with a high-contrast effect applied to it (well, not to her skin, but to everything else). So, start by zooming in a little, so you'll be able to see the effect, and then duplicate the Background layer by pressing **Command-J (PC: Ctrl-J)**.

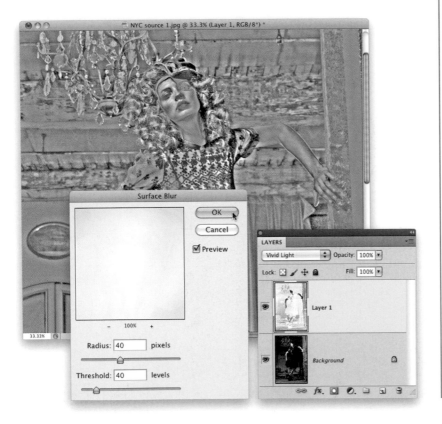

STEP SIX:
Change the blend mode of this duplicate layer to **Vivid Light**, then press **Command-I (PC: Ctrl-I)** to Invert the image. Next, go under the Filter menu, under Blur, and choose **Surface Blur**. When the dialog appears, enter 40 for the Radius, 40 for the Threshold, and click OK. This filter is doing lots of crazy math, so it might take a minute or two (or five) to fully be applied to the image (so, basically, expect to see a Progress bar in most cases).

STEP SEVEN:

Now, press **Command-Option-Shift-E (PC: Ctrl-Alt-Shift-E)** to create a merged layer on top of your layer stack (basically, it's a new layer that looks like a flattened version of your image). Then, go under the Image menu, under Adjustments, and choose **Desaturate** (as shown here). This removes the color from this merged layer.

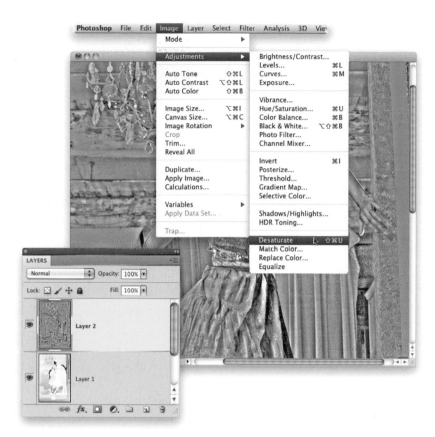

STEP EIGHT:

In the Layers panel, you can delete the middle layer now (Layer 1; the one below your top merged layer). Then, click on the merged (top) layer, change its blend mode to **Overlay**, and the high-contrast effect is applied to your image (as seen here. Click on the Eye icon to the left of the layer to really see the difference). Now, although this effect looks great on her dress, and hair, and the furniture, walls, etc., it's usually too harsh on women's skin, so we need to remove it from just her skin. Click on the Add Layer Mask icon at the bottom of the Layers panel, then get the Brush tool **(B)**, choose a medium-sized, soft-edged brush, set your Foreground color to black, and paint over her arms, hands, neck, and face to remove the high-contrast effect from those areas.

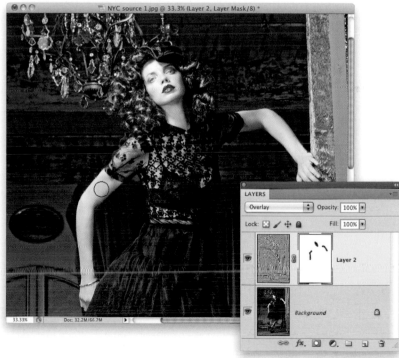

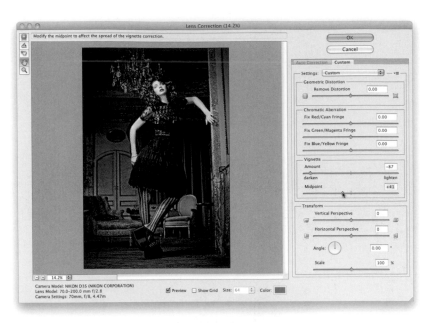

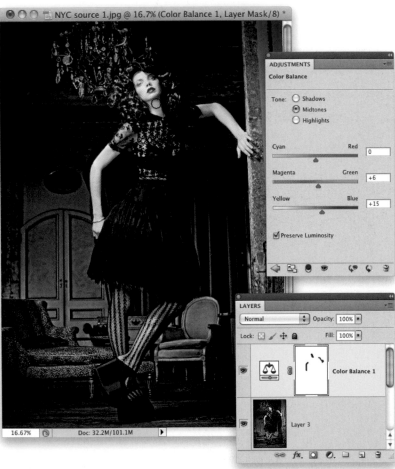

STEP NINE:

To enhance the light, and minimize the attention on the background, we're going to darken the outside edges all the way around the image by adding an edge vignette. So, create another merged layer at the top of the layer stack, then go under the Filter menu and choose **Lens Correction**. When the dialog opens (shown here), click on the Custom tab near the top right, then go down to the Vignette section, and drag the Amount slider almost all the way to the left. The Amount controls how dark the vignetting will be, and we want it pretty dark, so I dragged it over to –87. Then, drag the Midpoint slider a little to the left (as shown here, where I dragged it to +41). This slider controls how far in from the edges this darkening extends. We don't want it to go too far, or our subject will start to get dark. When it looks good to you, click OK.

STEP 10:

A popular effect in fashion photography these days is to add a color tint to the image, so click on the Create New Adjustment Layer icon at the bottom of the Layers panel and choose **Color Balance** (or click on the Color Balance icon in the Adjustments panel). Then, in the Adjustments panel, for Tone, click on the Midtones radio button. Now, you're going to increase the amount of the greens by dragging the middle slider to the right a bit toward Green (here, I dragged it to +6). Then, drag the bottom slider toward Blue (here, I dragged it to +15), and finally, make sure the Preserve Luminosity checkbox is turned on at the bottom. Now, get a small, soft-edged brush, and paint in black over her skin (face, neck, arms, and hands) to return them to a natural color (really, all that's getting the tint is the background and her clothing).

STEP 11:

After all the tweaks we've made, things are starting to get a little dark, so let's brighten them up just a little bit by creating another merged layer and changing its blend mode to **Screen**. Of course, this makes it too bright, so lower the layer's Opacity to around 40% (as shown here).

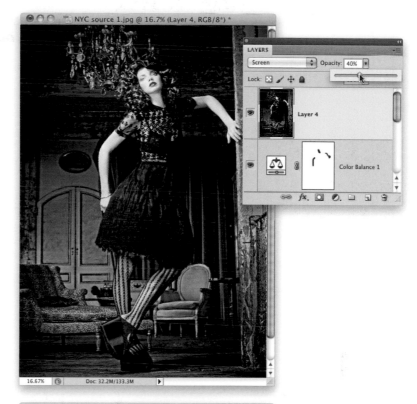

STEP 12:

Now, let's fix the perspective problem (caused mostly be me not being able to get back as far as I'd like for shooting a full-length shot. So, I was kind of shooting up at the subject a bit, which is why you see the wall on the right kind of leaning back a bit). Start by creating another merged layer, then get the Rectangular Marquee tool **(M)** and select the top half of the image (as shown here).

STEP 13:

Press **Command-T (PC: Ctrl-T)** to bring up Free Transform, then press-and-hold **Command-Option-Shift (PC: Ctrl-Alt-Shift)** to turn on the perspective control. Now, drag the top-right corner point straight to the right, and it creates a perspective effect, like the one you see here (if you can't reach the Free Transform handles, press **Command-0** [zero; **PC: Ctrl-0**] and your image window will automatically resize, so you can reach them). Just keep an eye on the wall as you drag (I dragged a little too far here—it doesn't take much), until it looks straight. In case you were wondering, we don't use a feather on the selection here, because then you'd see the edge. If you do it without the feather, in this particular case, you won't see an edge. Don't commit your transformation yet.

STEP 14:

This perspective move tends to make the selected area look a little bit "squatty" (after all, you just stretched the picture out by its sides). So, to fix that, release the keys you were holding down, grab the top-center point, and drag upward (as shown here) to lengthen (stretch upward) the photo a bit and make it look right again. These two moves help the photo look much more balanced. When it looks right, press **Return (PC: Enter)** to lock in your transformation, and then press **Command-D (PC: Ctrl-D)** to Deselect. One last fix: if you look closely, you'll see some gaffer's tape on the floor to the right of her feet, and we should probably get rid of that.

STEP 15:

Here, I've zoomed in so you can really see the tape on the floor. To get rid of it, I'd use the Spot Healing Brush tool **(J)**—it's perfect for stuff like this, because, by default in CS5, it uses the Content-Aware Fill feature to make the best possible patch of the area you just painted on. You don't have to hold down any keys or anything—just make the brush size a little larger than the width of the tape, then paint right over it, and it's gone (as seen in the following step).

STEP 16:

I zoomed back out and you can see the gaffer's tape is gone, the perspective is fixed (with no seams), the photo is tinted, the edges are darkened, and her skin tone still looks good. This is the final image you see at the beginning of the chapter.

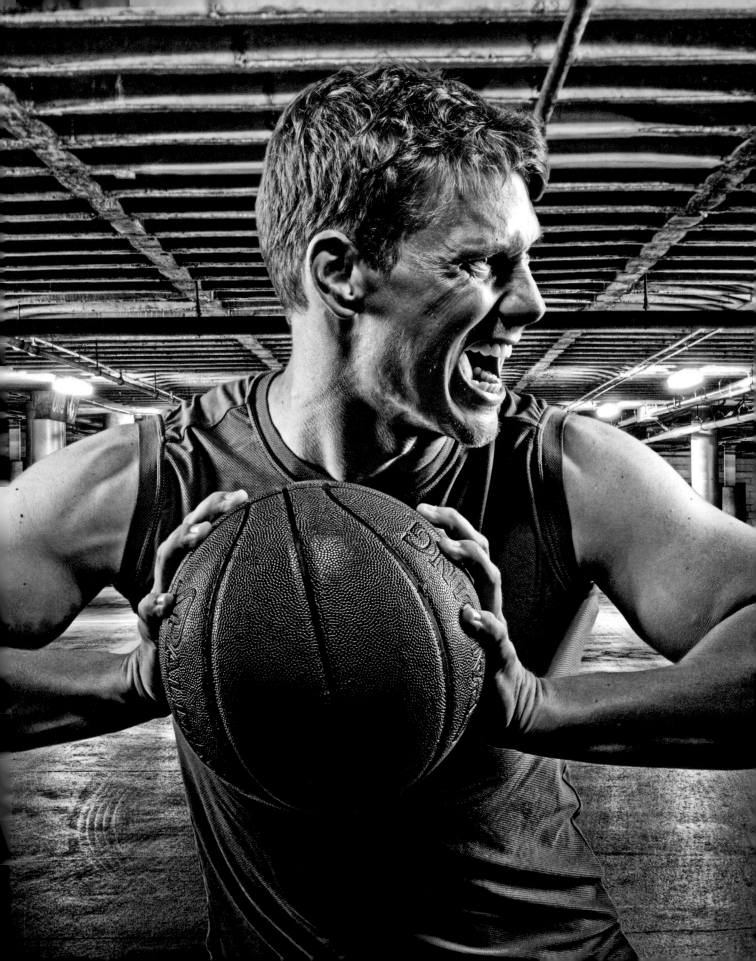

4-LIGHT SPORTS COMPOSITE SETUP

Lighting for Compositing

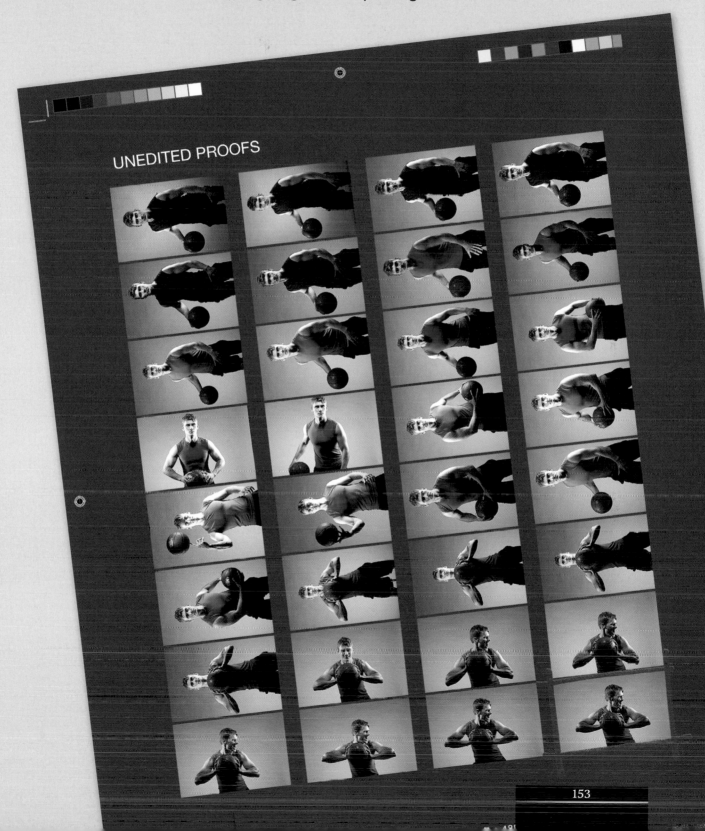

UNEDITED PROOFS

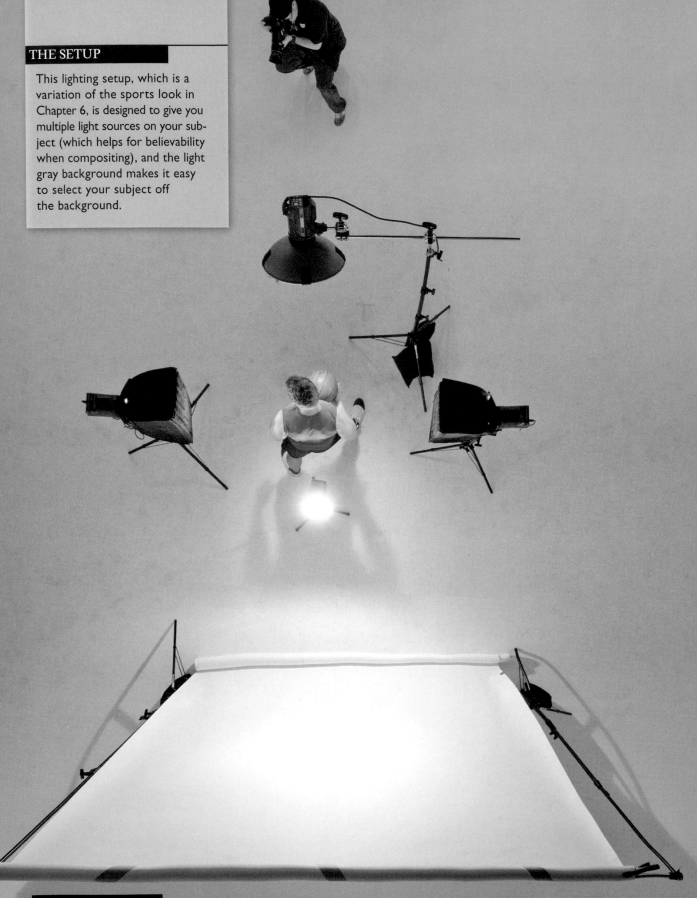

This lighting setup, which is a variation of the sports look in Chapter 6, is designed to give you multiple light sources on your subject (which helps for believability when compositing), and the light gray background makes it easy to select your subject off the background.

GEAR GUIDE

FRONT STROBE: 500-watt unit with 17" beauty dish and 25° honeycomb grid

SIDE STROBES: Two 500-watt units with 12x36" strip banks and 40° egg crate grids

BACKGROUND STROBE: 500-watt unit with 7" reflector

FRONT STROBE'S POWER SETTING: 2.3

SIDE STROBES' POWER SETTINGS: 5.8

BACKGROUND STROBE'S POWER SETTING: 4.3

CAMERA SETTINGS

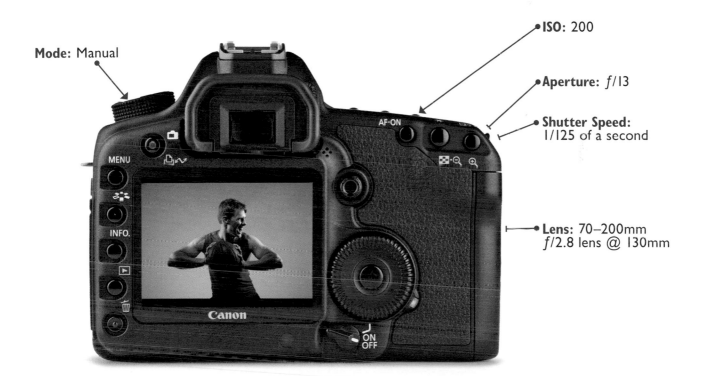

Mode: Manual

ISO: 200

Aperture: f/13

Shutter Speed: 1/125 of a second

Lens: 70–200mm f/2.8 lens @ 130mm

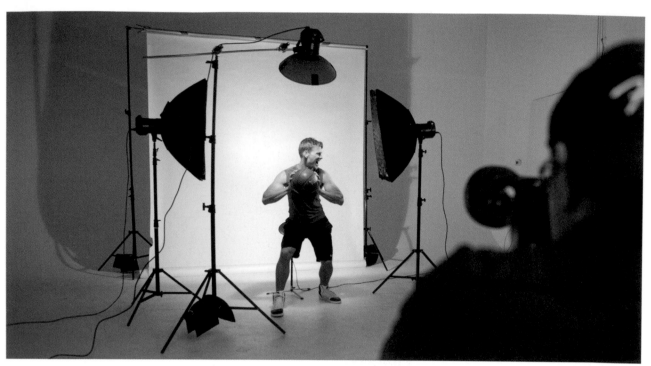

FRONT VIEW: Here's a view of the entire setup, from an over-the-shoulder angle. I'm down low, sitting on an Apple Box (you can buy them from B&H), so my athlete has a bigger-than-life perspective. It also helps to hide the light stand and strobe behind him, lighting the background. The background needs to be a very light gray to make it easier to composite him.

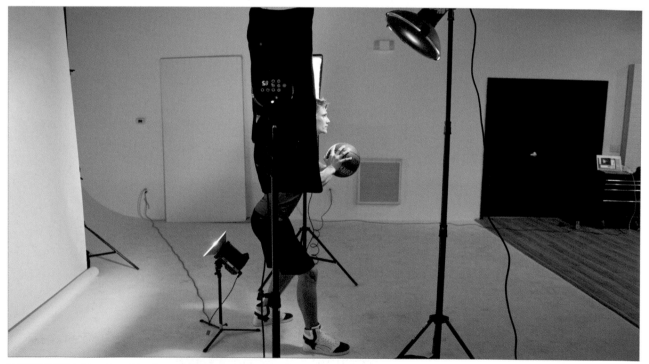

LEFT SIDE: Here's a side view, and you can see the all-important background light. If you can get the background a nice light gray, by lighting it at a low power setting, not only will it be easier to remove your subject from the background, but when you put your subject on a different background, you won't have any spillover from the background color.

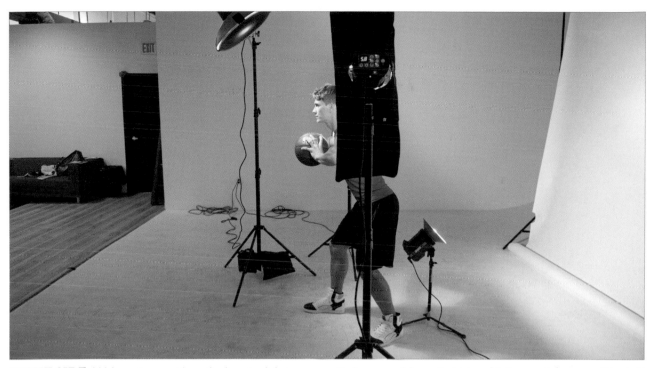

RIGHT SIDE: We're using a grid on the beauty dish to narrow its beam, and focus it right on his face and the top of the ball (it attaches to the outside of the dish with Velcro). Our subject is positioned just about a foot in front of the strip banks on either side of him. If they were directly beside him, the light would spill fully onto his face, not just the edges.

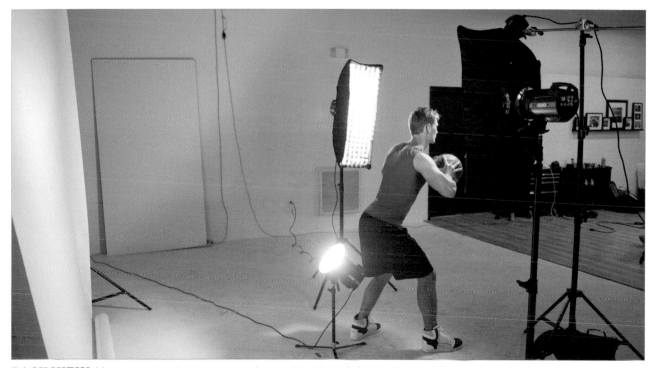

BACK VIEW: Here, once again, you can see his position just slightly in front of the two strip banks. With this setup, make sure your subject doesn't move forward or back a bunch, or they'll move out of the lighting and their face will move into the shadows.

THE POST-PROCESSING

The whole idea of this shoot is based around the post-processing, so we're going to have some fun with this one! Basically, what we're going to do is select our subject off the background (which will be easy, thanks to how we lit it), then we have to make him match the color and tone of the background we're putting him on, so it looks realistic. Then, we add high-contrast effects and sharpening to both parts (background and subject) to unify them, but you'll learn lots of important little compositing tricks along the way.

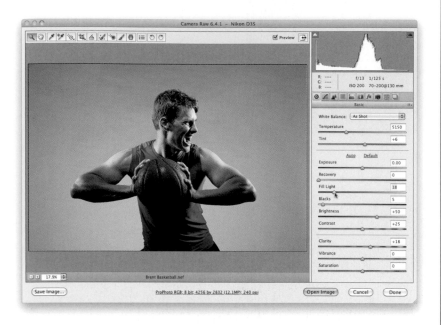

STEP ONE:

Here's the photo in Camera Raw, and luckily there's not a lot that needs to be done here, but I definitely would open up the shadows a bit by dragging the Fill Light slider to the right (here, I dragged it over to 18). This not only opens up the shadows on him, but on the background a bit, too. Also, since we're going to add a high-contrast effect on him (one I learned from my friend, German retoucher Calvin Holly-wood), let's go ahead and increase the Clarity to +18 while we're here to make it a little punchier right off the bat. Now, click the Open Image button to open it in Photoshop.

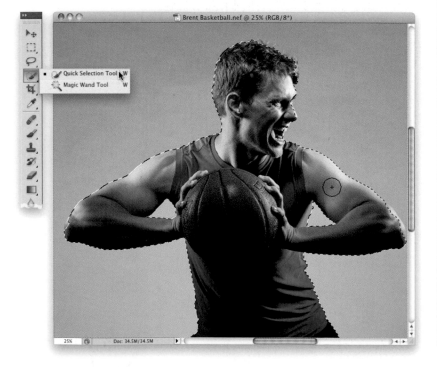

STEP TWO:

We need to make a perfect selection of our subject, including the little bits of hair sticking up on the top of his head, so get the Quick Selection tool **(W)** and start painting over him to select him (you can see me painting the selection here on his arm on the right). It will probably select those gray areas under his arms, so you'll need to deselect them by pressing-and-holding the **Option (PC: Alt) key** and click-ing once in those areas (holding the Option key works the same way as it does with the Lasso tool—it undoes the selection where you paint while it's held down. So, if the Quick Selection tool selects something you don't want it to, use that tip).

STEP THREE:

To make sure the Quick Selection tool did a good job, zoom in tight on his face (as shown here). You can see it missed a few places, which is honestly typical for this tool, but it's what you do next that makes it all come together. So, for now, just make your brush size smaller and pick up those areas it missed. When it comes to the hair, don't sweat it—just get in the ballpark—we'll pick up the fine hair detail in a just a moment. By the way, by default, the brush is in Add mode, so if you have a selection in place and want to add to it, you don't have to hold any special keys or anything—just start painting and it adds those areas to your current selection.

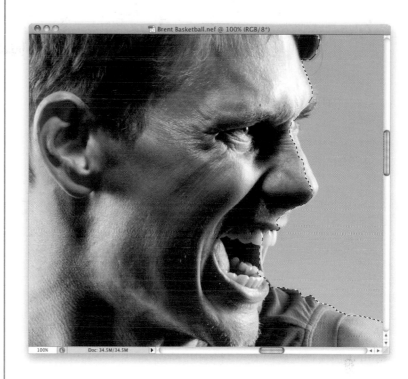

STEP FOUR:

Here's the result after painting with the Quick Selection tool for literally just a few more seconds. Your starting place for your composite will be much better, so it's worth the few extra seconds here. Next, we'll unlock the real power of selections in Photoshop CS5 and it's hidden under the Refine Edge button up in the Options Bar (it's shown circled here in red). Go ahead and click that button, and we'll start refining our edge to pick up the hard-to-select stuff, like his hair. By the way, the Refine Edge button was there in Photoshop CS4, but it didn't have the things—like Smart Radius and the Refine Radius tool, which were added in CS5—that give it all its power.

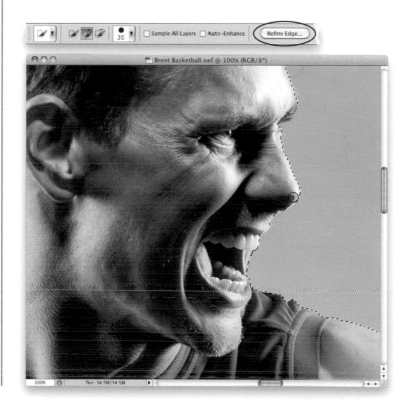

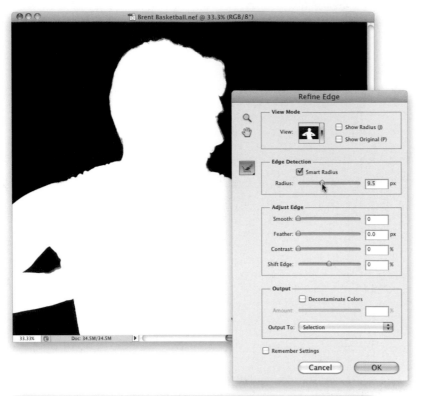

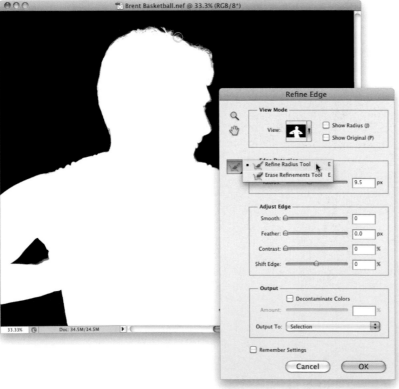

STEP FIVE:

When the Refine Edge dialog appears, at the top is the View Mode section, where you choose how you want to see your selection (on a white background, on a black background, as a red overlay like Quick Mask, etc.). My favorite is the view you see here—Black & White, which essentially shows you the mask itself, which I like, because you can really see the quality of the selection and if it's picking up enough hair. The original selection wasn't, but if you turn on the Smart Radius checkbox and drag the Radius slider to the right (here, I dragged it over to 9.5), you can start to see the strands of hair being selected on the top of his head. It's not perfect yet, but it's a much better starting place. Don't click OK yet.

STEP SIX:

To really pick up the hair, you need to tell Photoshop pretty much which parts you need it to focus on, so grab the Refine Radius tool and, with a small brush size, paint over the edge at the top of his head (as shown here). By doing this, you're telling Photoshop, "There is fine detail here you're missing," and it will re-evaluate that area and give you a much better selection (you can actually see his hair strands are now selected). Now you have a selection mask that has both simple, straight selections and a complex selection for his hair. At the bottom, in the Output section, there's a pop-up menu for what you want to happen when you click OK. For this project, choose **Selection**, click OK, and then you'll return to the normal image view, and your selection will be in place. Press **Command-C (PC: Ctrl-C)** to Copy that selection into memory.

STEP SEVEN:

Now, let's open our background image. In this case, it's a photo of an indoor parking garage that I downloaded courtesy of the folks at iStockPhoto (thanks!). I love all the texture, and the fact that there's obvious lighting from above, which will help with the believability factor when we drop a subject in here who is lit from three sides.

STEP EIGHT:

To get your subject on this background, just press **Command-V (PC: Ctrl-V)** to Paste him in and he'll appear on his own layer (as shown here). It looks pretty darn good, thanks to the Quick Selection tool and our use of Refine Edge (together they make an amazing team). Of course, there are all sorts of issues: his skin tone is very warm in kind of a cold background environment, we need to add some contrast to unify him and the background, and he needs a shadow for realism. But, first, we'll need to zoom in and check to make sure there's no fringe around him that would be a giveaway that he was pasted in from somewhere else.

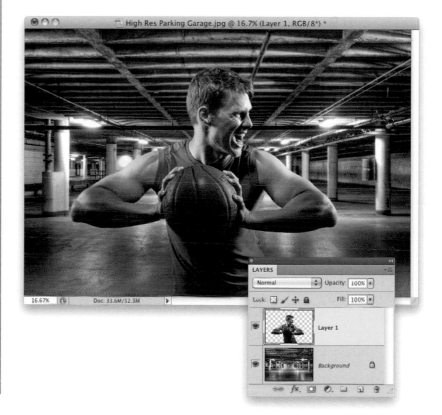

STEP NINE:

When we zoom in tight, you can see a little white edge fringe along his blue shirt, and some along his arms, and this is a dead giveaway that he wasn't really there. Luckily, we can usually hide that fringe really easily. The first thing I would try is to go under the Layer menu up top, then at the bottom of the menu, under Matting, choose **Defringe**. When the Defringe dialog appears (shown here), leave it set at a Width of 1 pixel, and simply click OK.

STEP 10:

Here's the result of using Defringe— the white edge fringe is gone. What Defringe does is it looks at the edge of your image on the layer, then the color of the background it's now upon, and it replaces 1 pixel all the way around your subject with a blend of the two colors, which makes the white fringe go away. If Defringe doesn't work, try this: First, press Command-Z (PC: Ctrl-Z) to undo Defringe. Then, go under the Layer menu again, under Matting, and choose Remove White Matte. That'll usually work if Defringe didn't. If that doesn't work, undo it and try Remove Black Matte. If that still doesn't do it, undo that and then press-and-hold the Command (PC: Ctrl) key and click on your layer's thumbnail in the Layers panel to reload your selection around your subject. Now, go under the Select menu, under Modify, and choose Contract. Enter 1 pixel and click OK to shrink your selection inward by 1 pixel. Then, Inverse this selection by pressing **Command-Shift-I (PC: Ctrl-Shift-I)**, and hit Delete. This removes 1 pixel all the way around your image, and that should remove the fringe.

STEP 11:

My guess is that one of the first two (Defringe or Remove White Matte) will work, so you'll probably never have to use the other two. But, just know that at least you can add them to your compositing bag of tricks. Okay, back to our project: press-and-hold the Command (PC: Ctrl) key and click on your layer's thumbnail in the Layers panel to reload your selection around your subject (as seen here).

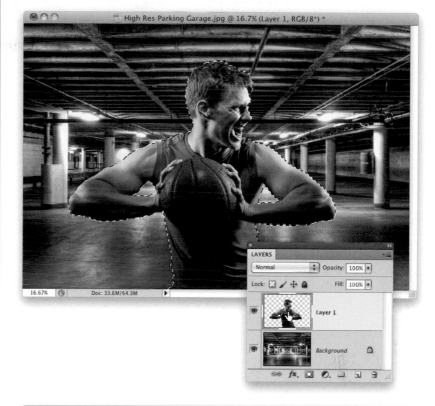

STEP 12:

Hide the top layer from view by clicking on the Eye icon to the left of the layer, then click on the Background layer in the Layers panel. This leaves a perfect selection in the shape of your subject on the Background layer (as seen here). We're going to use this selection to steal the colors of the background and use them on our subject, so the colors match perfectly.

STEP 13:

Press **Command-J (PC: Ctrl-J)** to put a copy of that selected area up on its own separate layer (I hid the other two layers from view temporarily, just so you could see what this looks like. It's for example purposes only—you don't have to do this). Now, go to the Layers panel, and drag this subject-shaped layer up to the top of the stack of layers (as seen here), but of course, make sure all your layers are visible.

STEP 14:

Now, you need to reload this top layer as a selection, so Command-click (PC: Ctrl-click) on your top layer's thumbnail in the Layers panel to reload your selection around your subject. While it's still selected, go under the Filter menu, under Blur, and choose **Average** (as shown here). This totally blurs the selected area, but it does it based on an average of the colors inside that selected area (which, as you remember, came from our Background layer), and what it creates is a solid color that is an average of the colors in your selection. How cool is that? Now, once it's blurred, it just looks like a solid greenish gray color in the shape of a man, but we'll put that to use in the next step. Go ahead and press **Command-D (PC: Ctrl-D)** to Deselect.

STEP 15:

To bring this averaged color of the background onto our subject, go to the Layers panel and change the blend mode of this layer from Normal to **Color**. That ignores the fill and just brings in the color. Now your subject looks totally green, so lower the opacity of this Color layer until some of his original color starts to come back, and keep lowering it until his color matches the color in the background (as shown here, where I lowered the Opacity to around 65%). Now the overall tone of the background and our subject are pretty much the same, which is a key aspect of successful compositing, so it's really worth learning. If you go back to Step 11 and compare how warm his overall tone was to the tone you see here, you can really see how powerful this little trick is.

STEP 16:

Next, let's create a drop shadow. First, let's merge the Color layer on top with our subject layer right below it: make sure the Color (top) layer is selected, then press **Command-E (PC: Ctrl-E)** to merge them into just one layer. Then, duplicate that layer by pressing **Command-J (PC: Ctrl-J)**. Press the letter **D** on your keyboard to set your Foreground color to black, then press **Option-Shift-Delete (PC: Alt-Shift-Backspace)** to fill this duplicate layer with black (as shown here). We're going to turn this black-filled shape into our drop shadow.

STEP 17:
Press **Command-T (PC: Ctrl-T)** to bring up Free Transform around your shadow shape. Then, press-and-hold the **Command (PC: Ctrl) key**, grab the top-center point, and drag down and to the left (as shown here) to flatten out your shadow, so it appears as though it's being cast on the floor. (This is a lot easier to do than it looks—just drag it over and down in kind of a circular motion to the left, like you're going counter-clockwise, while holding down the Command key the entire time. Holding the Command key lets you skew the transformation to the left or right.) When you're done, press **Return (PC: Enter)** to confirm your transformation.

STEP 18:
Now, you're going to blur your shadow to death, so go under the Filter menu, under Blur, and choose **Gaussian Blur**. I add a ton of blur for a very specific reason: Photoshop-added shadows can look very fake if they're not done exactly right, and the biggest giveaway is that the shadows don't look soft enough. However, if you blur the living daylights out of them, it's really hard to say, "Oh yeah, that was added in Photoshop." So, while this may not actually be the most "accurate, real-life shadow he would have cast had he really been in that garage," the upside is, you won't get caught. So, when the Gaussian Blur dialog appears, enter a large amount of blur (I entered 45 pixels), and click OK to blur your shadow big-time. Then, lower the Opacity of this layer quite a bit (I lowered mine here to around 50%, but you can even go lower—it's supposed to be subtle). Since the shadow is supposed to be behind him, drag the shadow layer below his layer.

STEP 19:

Let's add the high-contrast effect (similar to what we've done in two other places in the book, but with one twist coming up in a few steps). First, start by hiding your subject layer and the drop shadow layer from view. Then, click on the Background layer and duplicate it by pressing Command-J (PC: Ctrl-J). Change the new layer's blend mode to **Vivid Light**, then press **Command-I (PC: Ctrl-I)** to Invert the image. Now, go under the Filter menu, under Blur, and choose **Surface Blur**. When the dialog appears, for the Radius, enter 40 pixels, for the Threshold, enter 40 levels, and click OK (this filter takes a while to apply, so this is a great time to grab a cup of coffee).

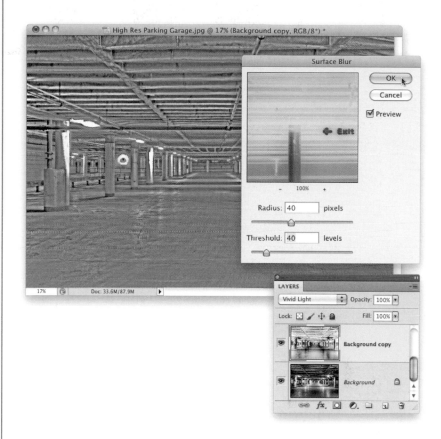

STEP 20:

Create a merged layer (a new layer that is a flattened version of your visible layers) by pressing **Command-Option-Shift-E (PC: Ctrl-Alt-Shift-E)**. Now, hide the layer right below it (the one you just applied the Surface Blur filter to). Next, change the blend mode of this merged layer to **Overlay**, which gives you the high-contrast grungy effect you see here. At this point, you need to remove all the color from this gray layer, so press **Command-Shift-U (PC: Ctrl-Shift-U)** to Desaturate the layer (or, if you're charging by the hour, go under the Image menu, under Adjustments, and choose Desaturate). We're not done yet, but we're well on our way.

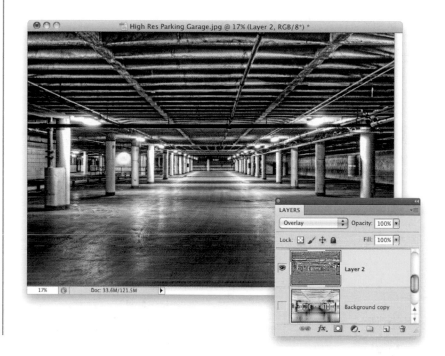

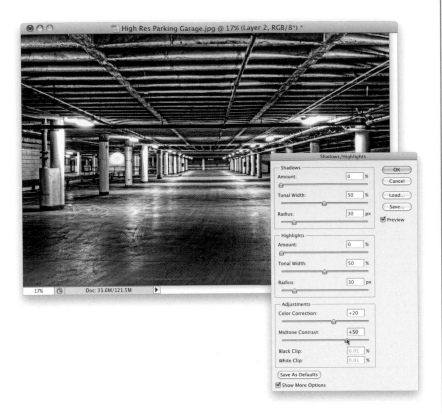

STEP 21:
To crank up the grittiness of this background image, and really make the details pop, go under the Image menu, under Adjustments, and choose **Shadows/Highlights**. When the dialog appears (shown here), lower the Shadows Amount to 0% (by default, it opens up the shadows by 35%, but that's not what we want here, and it's not what we came to Shadows/Highlights for). Then, go down near the bottom of the dialog, in the Adjustments section (if you don't see this section, turn on the Show More Options checkbox), and raise the Midtone Contrast amount. Things get really gritty fast (here, I raised it to +50). Now, you can click OK, and your background has the really high-contrast effect.

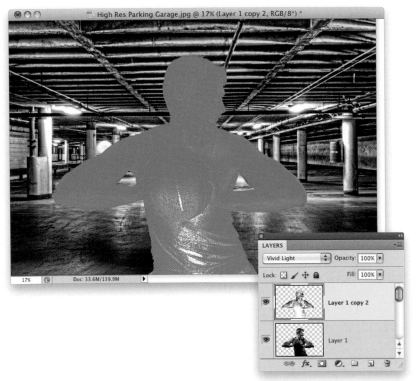

STEP 22:
One of the "tricks of the trade" when it comes to compositing is to apply the same type of effect to your subject as you did to the background, because this kind of visually unifies them. So, now you're going to have to do the same moves on your subject (but we'll skip that last Shadows/Highlights move, because it would be too harsh on his skin). Go ahead and do what you just did to the background, to him: make his layer visible again, click on his layer and duplicate it, then change its blend mode to Vivid light and Invert the layer.

STEP 23:

Apply the Surface Blur filter set to 40 and 40 (just like before, and like you see here).

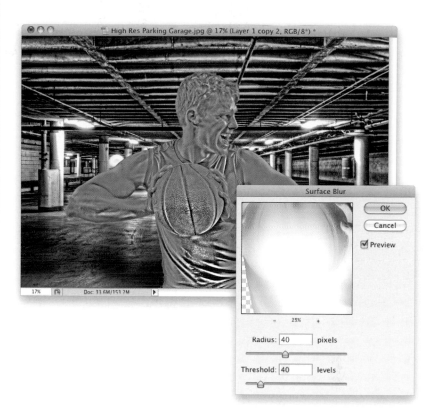

STEP 24:

Now, before you create your merged layer, because our subject is on his own separate layer, creating a merged layer at this point would make the image look totally flattened (background and all), and we just want the layers of him merged. So, start by hiding all the other layers below him, including the shadow layer, from view. Now, create your merged layer by pressing Command-Option-Shift-E (PC: Ctrl-Alt-Shift-E), and you can see it's just him on a transparent background, which is exactly what we want. Desaturate this layer to remove all the color, and we're almost done.

STEP 25:
You'll need to make all the other layers visible again, so go back to the Layers panel and click where the Eye icons used to be next to their thumbnails, except for that second layer from the bottom (as seen here), because we'd turned it off after we merged the background layers. In fact, if you wanted to, you could just delete this layer, because you're not going to need it again (totally your call).

STEP 26:
We also don't need to see the layer directly beneath our top layer, so hide it from view (you can also just delete that layer altogether if you like, but here, I just turned those two layers off). Now, to get the high-contrast grungy effect to appear on our subject, just change the blend mode of this top layer to Overlay (as shown here) and the effect is applied to him, as well. Whew! That was a lot of steps, but you have to admit—it wasn't hard. It was just a lot of simple steps one after another, but it was a bit tedious. Good news is, though, that part is done and now we can finish this off.

STEP 27:

To really make this image pop, we're going to add some High Pass sharpening, so start by creating yet another merged layer (as seen here in the Layers panel), then go under the Filter menu, under Other, and choose **High Pass**. When the filter dialog appears, drag the Radius slider all the way to the left, so the layer looks solid gray. Then, start dragging that slider over to the right until you start to see some nice edge detail appear onscreen (like you see here). The farther you drag, the more intense the sharpening will be, so be careful about dragging too far (here I dragged over to a Radius of 9 pixels). Click OK to apply the filter to this layer (as seen here).

STEP 28:

To get that gray layer to actually create sharpening for us, we have to change its blend mode to **Hard Light**, and—BAM!—welcome to Sharpen City! Toggle the view on/off for this top layer a few times, and you'll really see how much this adds to the image. If you think it's too much (I did), then you can lower the Opacity of this layer until it looks good to you (in this case, I lowered it to 50%).

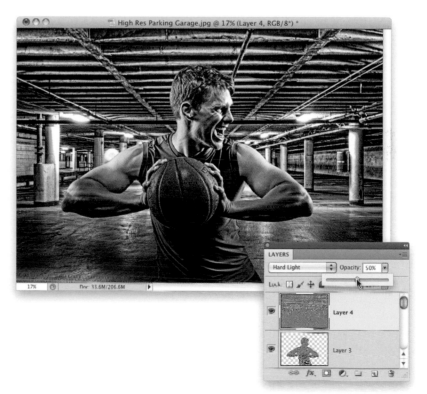

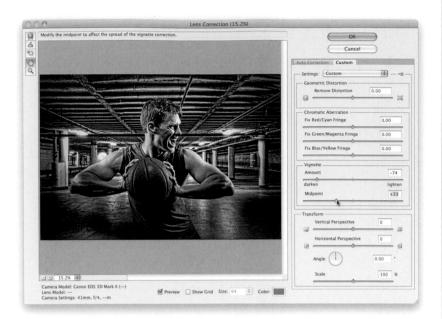

STEP 29:
One last finishing move: For high-contrast looks like this, it looks great to darken the edges a bit, so the light on your subject looks more concentrated. Start by creating another merged layer at the top of your layer stack, then go under the Filter menu and choose **Lens Correction**. When the dialog appears, click on the Custom tab near the top right, and then go down to the Vignette section. Drag the Amount slider about three-quarters of the way over to the left (this controls how dark the edges will be), and then drag the Midpoint slider over to the left about one-third of the way (this controls how far into the image the darkening extends). Click OK to apply this edge darkening.

STEP 30:

Here's the final image that you saw on the first page of this chapter. This particular shot was composed in a wide (landscape) orientation, but of course the pages in this book are tall (portrait) orientation, so although this is the exact image that appears on the first page, it had to be cropped in a bit to fit on the page. One last thing: Do you see that orange ball of light appearing over his biceps on the left? That's a real light in the garage, but when I put the image on the chapter's first page, it looked very distracting. So, I just made a rectangular selection of the same area right above the bicep on the other side, then I pressed Command-J (PC: Ctrl-J) to put that small area up on its own layer. I then used the Move tool to drag it over so it covered the orange ball of light, but of course, it didn't fit because it was from the other side of the garage. Easy fix—I brought up Free Transform, Right-clicked inside the bounding box, and from the menu, chose **Flip Horizontal.** That did the trick.

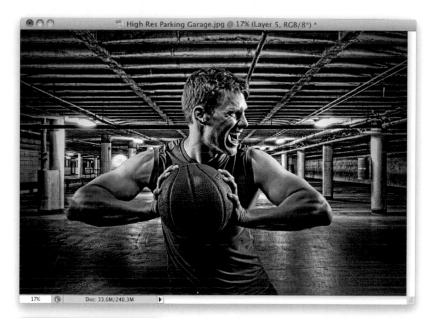

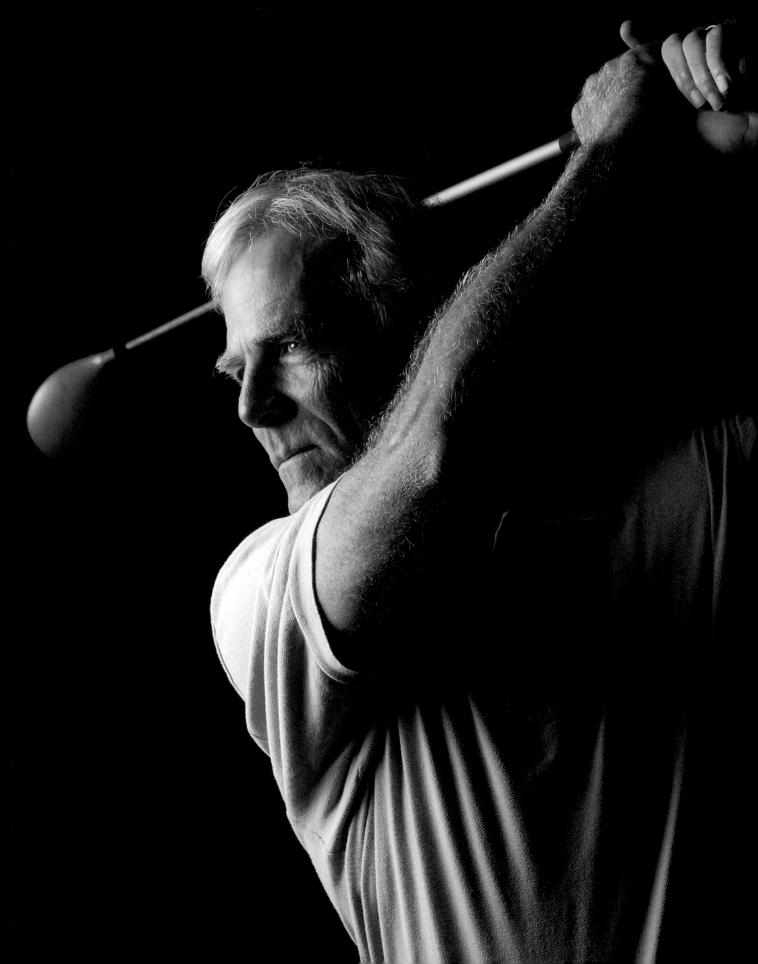

1-LIGHT DRAMATIC SETUP

Dramatic Side Lighting

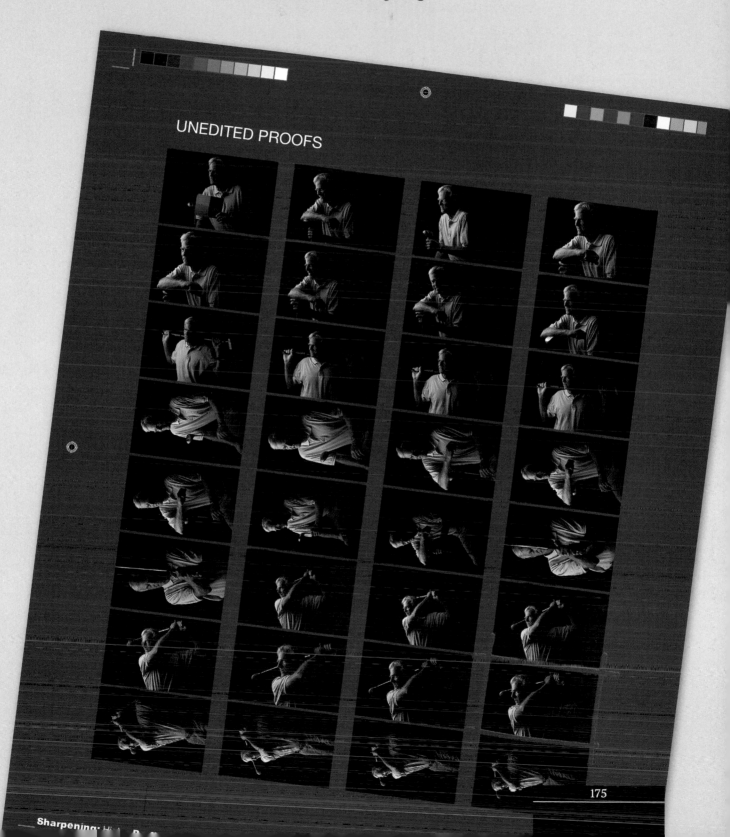

UNEDITED PROOFS

Sharpening:

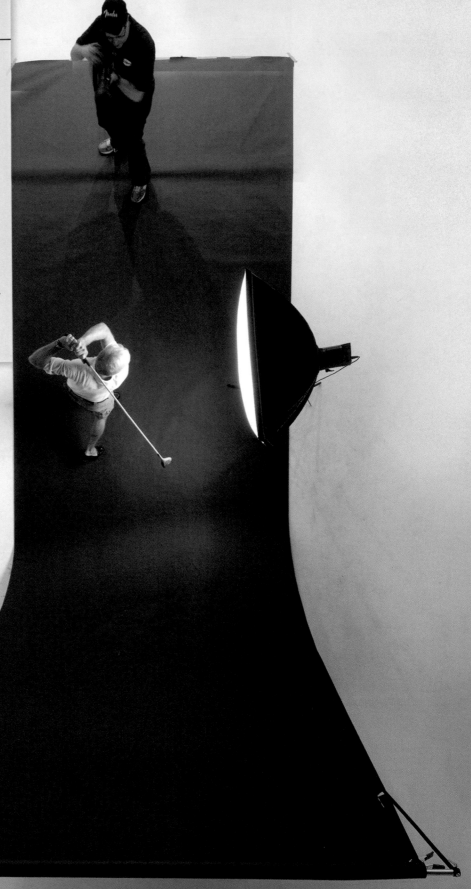

For this dramatic look (perfect for business portraits, the CEO-type shot, and dramatic sports portraits), we just use one single light—a large 39x39" softbox. The softbox goes directly beside the subject, but your subject looks at a 45° angle (so from the camera position, just to your left). That way, the light catches one side of their face, leaving the other side to mostly fall to shadows. If you look on the contact sheet on the previous page, for the shots where he's not swinging the club, I had him position his body at a 45° angle away from me, and I moved the light diagonally behind him, so it was at a 45° angle, aiming back at me.

GEAR GUIDE

STROBE: 500-watt unit
with 39x39" softbox

**STROBE'S POWER
SETTING:** 3.7

CAMERA SETTINGS

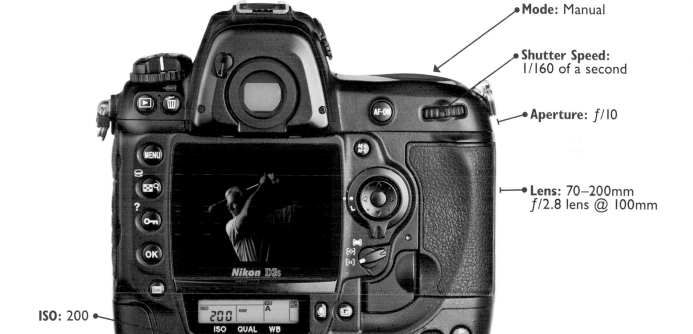

• **Mode:** Manual

• **Shutter Speed:**
1/160 of a second

• **Aperture:** ƒ/10

• **Lens:** 70–200mm
ƒ/2.8 lens @ 100mm

ISO: 200 •

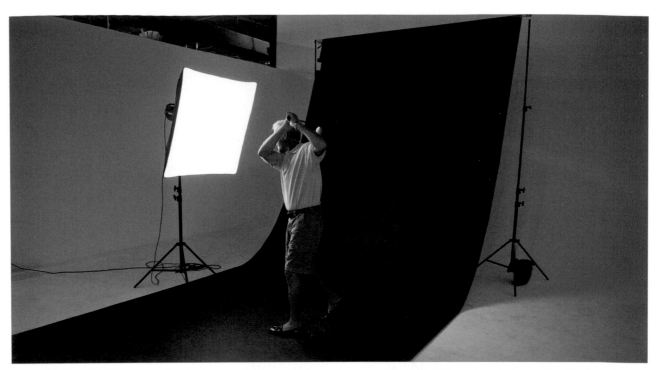

FRONT VIEW: This is a really simple setup using just one strobe and a 39x39" softbox placed directly beside the subject. Of course, since it's only lighting one side of his body, you're going to get a very dramatic look with lots of shadows. You also have to have your subject angled toward the light or they'll be all in shadows.

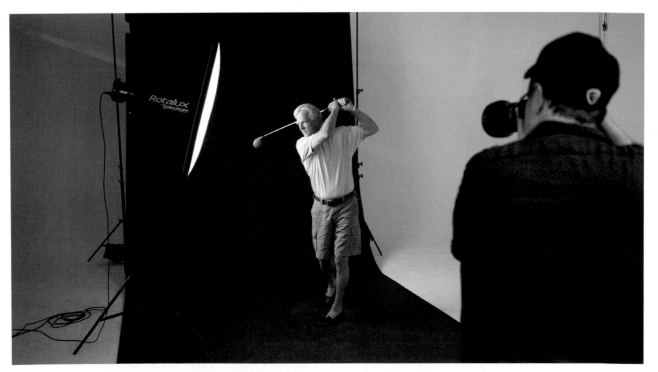

LEFT SIDE: Here, you can really see that the softbox is directly beside him. On the next page, I've included a slight variation on this look, which only requires you moving the softbox a foot or two, and changing its angle, but it makes a big difference (and it's perfect for CEO-style portraits).

RIGHT SIDE: I used a larger softbox here, because I knew I had to light more than just our subject—I had to have light fall on the clubhead, as well. Without the club, you can get away with a much smaller softbox, like a 24x24".

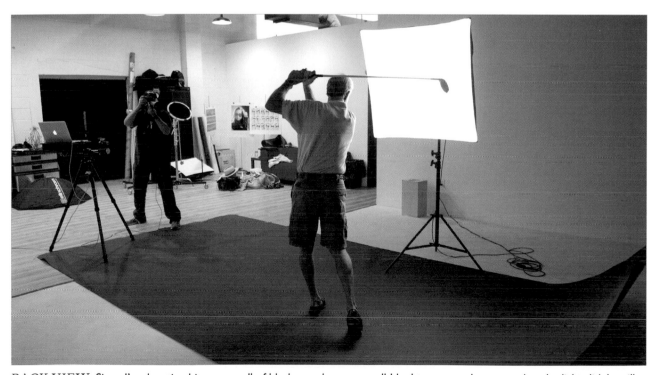

BACK VIEW: Since I'm shooting him on a roll of black seamless paper, all I had to worry about was that the light didn't spill onto the background, making it look more like a dark gray. If you run into that problem, just move your subject, and the light, farther away from the background.

FINAL IMAGE: Here's the final image we're looking to create, and you can see that light is falling on both sides of his face (you want to make sure some light is falling on the side of his face closest to the camera). Note that I'm standing directly in front of him, but I had him angle his body to his right to catch the light.

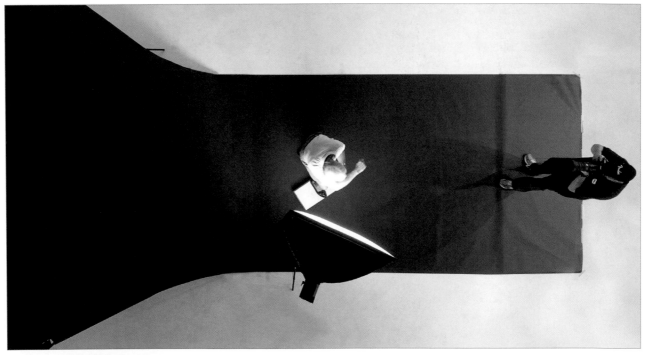

OVERHEAD VIEW: You can see the two small changes we made to the position of the light to get this look: (1) we moved it slightly back behind our subject, and (2) we angled it a bit forward (rather than aiming it right at him from the side).

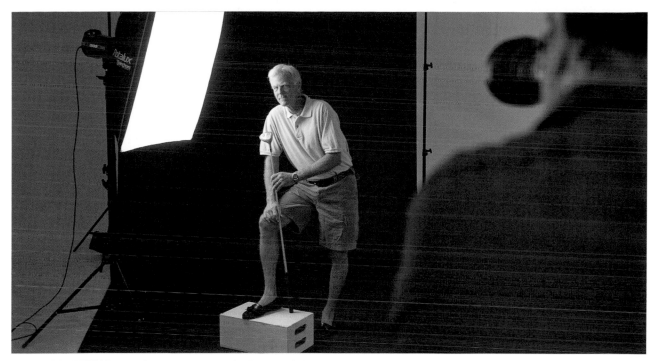

FRONT VIEW: You can have your subject look toward the camera, but make sure you still get some light on the side of their face closest to the camera. If it totally goes to shadows, you'll either have to angle the softbox a bit more, or change their angle more toward the light. The modeling light really comes in handy for stuff like this.

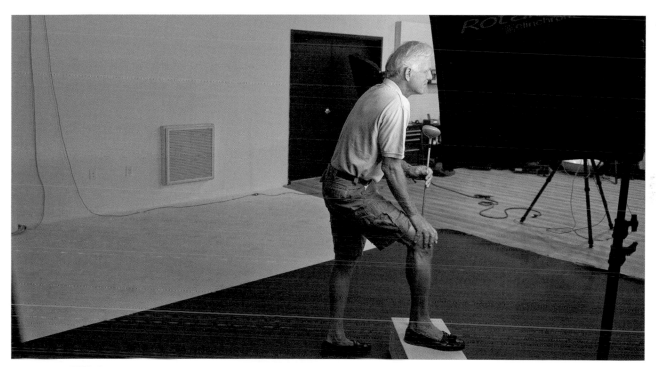

REAR VIEW: From this angle, you can see that the softbox is just a little bit behind him. Also, I had him put one leg up on an Apple Box (B&H sells these for around $30 each), for two reasons: (1) it makes the pose look more casual, and (2) it provided an added benefit, because the club wasn't long enough for him to lean on without it resting on the crate (our subject was pretty tall). Try this alternate version out, and I think you'll like how easy it is to pull off, and how nice the final image will look.

THE POST-PROCESSING

The post-processing on this shot is really pretty simple, but because our subject is (a) a man, and (b) not as young as our other subjects, we need to do our retouching and sharpening a bit differently. The things I think we need to address here are: (1) the white balance is off by quite a bit; (2) the image needs to be cropped tighter; (3) we need to reduce (not remove) his wrinkles; (4) we need to brighten the overall exposure just a bit and brighten his eyes, in particular; and (5) we need to apply sharpening that's appropriate for a male subject.

STEP ONE:

Once I made my pick for the image I wanted to use here, I opened it in Camera Raw, along with the first image from the shoot—the one with our subject, Tom, holding a gray card (the card he's holding is a tear-out from the back of my book, *The Adobe Photoshop CS5 Book for Digital Photographers*). So, select both images, then open them in Camera Raw, as shown here. Next, click the Select All button at the top of the filmstrip on the left side of the window. That way, when you make an adjustment to the first image, it's automatically applied to the other image.

STEP TWO:

Because these shots are so dark, the first thing we'll do is increase the Exposure amount (here, I set it to +1.25) to make it easier to see our white balance fix. Next, get the White Balance tool from the toolbar up top (I; it's the half-filled eyedropper, circled in red here) and click it once on the bottom-left (Camera Raw) swatch to set an accurate white balance (as shown here). Now, here's the thing: while doing that does create an accurate white balance, it doesn't mean it's the "right" white balance for this photo. For example, I think he looks a little too warm (yellow) for my taste, so once I use the swatch to get me in the ballpark, if I think it needs to be less warm, I have to tweak it manually.

STEP THREE:

To make the white balance set by the White Balance tool a little less warm, go to the Temperature slider on the right and drag it a little bit over to the left (toward blue), until it looks right to you. The original Temperature set by the White Balance tool was 4800, but here I moved it over to 4550, which is less warm, but I think it looks more natural. Again, this is just my opinion for this light and this subject, and thankfully there is no International Board of White Balance, so we get to choose whatever white balance looks good to us. Again, what's nice is, since we have both images selected in the filmstrip, our changes to this top image are automatically applied to the image we want to use in this project (it's seen in the next step).

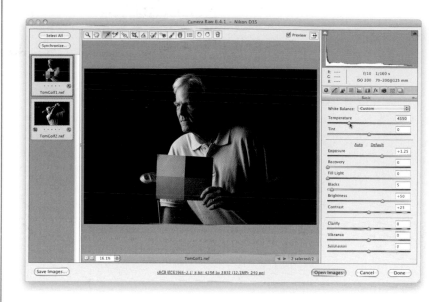

STEP FOUR:

Now, in the filmstrip, click on the bottom image thumbnail, so that only it is selected. If you look at the triangle in the upper-right corner of the histogram in the top-right corner of the window, you'll see that it's red. This means that we're clipping (or losing) highlight detail in some areas of the image, like his shoulder closest to the camera. His forehead and the golf club look a little bright, too. So, we'll need to drag the Exposure slider back to the left a little bit, until that triangle turns black (here, I dragged it over to +0.65).

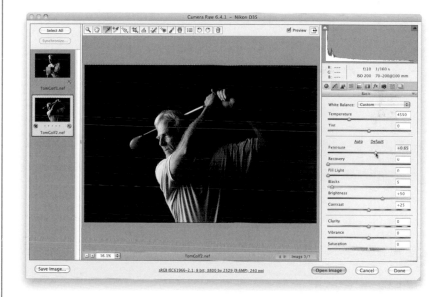

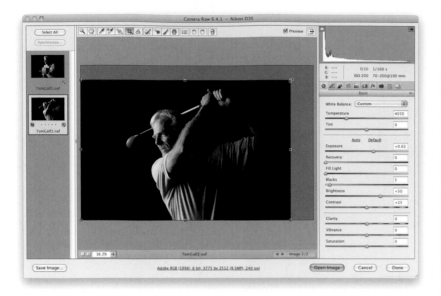

STEP FIVE:

The last thing we need to do here in Camera Raw is crop the image a little tighter (I left too much space above his head and to his right). So, get the Crop tool **(C)** from up in the toolbar and drag it out over the entire image. Now, press-and-hold the Shift key (so it crops proportionally), grab the top-right corner point, and drag diagonally inward to crop the image down to size. To lock in your crop, press **Return (PC: Enter)**. Finally, click the Open Image button to open the image in Photoshop for retouching.

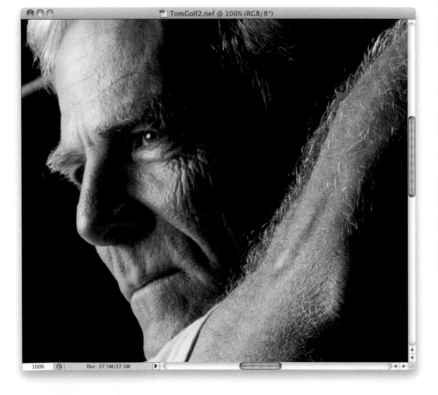

STEP SIX:

The first thing we're going to do is reduce his wrinkles to make him look a bit younger. The key is, though, to shave 10 years off, not make him look like he's 10 years old. So, this has to be a very subtle reduction, so he still looks natural. Zoom in tight on his face, so you can get a good view of where we'll be working.

STEP SEVEN:

Press **Command-J (PC: Ctrl-J)** to duplicate the Background layer, because we'll be using this duplicate shortly to control the actual amount of wrinkles that appear. Now, get the Healing Brush tool (press **Shift-J** until you have it) and start removing every single wrinkle on his face by Option-clicking (PC: Alt-clicking) in a clean area near a wrinkle to sample that area, and then painting a stroke right over the wrinkle to remove it (here, you can see I've started removing the wrinkles under his eye). Good news— you don't have to be super-accurate or super-clean with your removal, because we're going to bring a lot of these wrinkles back later.

STEP EIGHT:

This will take a few minutes, but be patient and remove all his wrinkles, along with the smile lines on his cheeks, the lines on his forehead, the wrinkles leading to his nose, the creases just above the top of his lips—it all has to go. Just remember, it doesn't have to be perfect (as you can see from what I've done here), but try to remove as much as is practical, and don't sweat it being perfect—it doesn't need to be (you'll see why in the next step).

STEP NINE:
Now, we're going to go and bring back about 70% of his wrinkles (hey, most folks would kill for a 30% reduction in their wrinkles) by going to the Layers panel and reducing the Opacity of this layer to 30%. Look at how it brings back all the wrinkles, but they're not nearly as deep or as dark, so it makes him look younger without making him look fake or retouched. If you over-retouch someone at this age, their friends will know it instantly, and while they might not say anything directly to your subject, they will definitely be giggling behind his back, and nobody wants that as a result of their retouch. Make him look a little younger, but don't make him look like a kid.

STEP 10:
As I look at the image, at this point, to see if anything jumps out at me, one thing I notice is that his hair, which should be gray, looks a little yellowish (that's from the warmish white balance we applied at the beginning), but that's easy to fix. Go to the Adjustments panel and click on the Hue/Saturation icon (the second icon from the left in the second row). This adds a Hue/Saturation adjustment layer to the top of your layer stack in the Layers panel (as seen here). Near the top of the Adjustments panel, there's a little tool to the left of the Master pop-up menu—the Targeted Adjustment tool (or TAT, for short). The TAT lets us click on a specific area in our photo that we want to adjust, and it auto-matically knows which colors are predominant in that area. You can then increase or decrease its strength by simply dragging right or left.

STEP 11:

Click on the TAT to get it, then click-and-hold it somewhere on his hair (I clicked it on the front part, as seen here), and then drag your cursor to the left. As you drag, it knows that the predominant colors in his hair are the yellows, so it targets them and starts desaturating them (as seen in the Adjustments panel here). The farther your drag to the left, the more it will remove them. I generally leave a little bit of color, or the area you're adjusting will look like a black-and-white photo. So, don't drag it until the Saturation slider reaches 0 (here, I dragged the TAT over until the Saturation slider read −45). Now, the downside of using this tool is that it removes the yellows from the entire image, not just his hair. But, luckily, when you use an adjustment layer, it comes with its own built-in layer mask.

STEP 12:

Press **Command-I (PC: Ctrl-I)**. to Invert the layer mask on the Hue/Saturation adjustment layer. This makes the mask black, and hides the version of your image with the yellow color removed. Now, get the Brush tool **(B)**, choose a small, soft-edged brush, and with your Foreground color set to white, paint over his hair (as shown here), and only that area has the yellow removed. His eyebrows are also a bit yellow, so I would shrink the brush down in size a bit, zoom in tight, and paint away the yellow in his eyebrows, as well, so his hair and eyebrow color match.

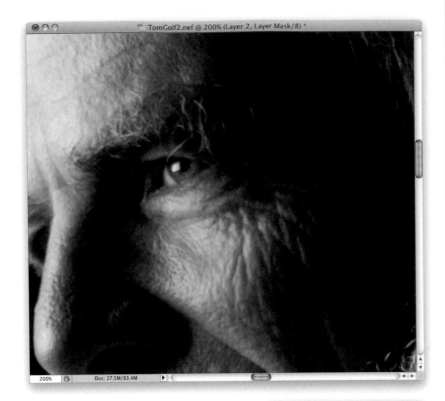

STEP 13:
Now, let's create a merged layer (a new layer that looks like a flattened version of your image) at the top of the layer stack by pressing **Command-Option-Shift-E (PC: Ctrl-Alt-Shift-E)**, and then change the blend mode of this layer to **Screen**. This makes your entire image much brighter, so Option-click (PC: Alt-click) on the Add Layer Mask icon at the bottom of the Layers panel (it's shown circled here in red), which hides this brighter Screen layer behind a black mask. Now, zoom in tight on his eye, so we can brighten the whites and his iris a bit. With the Brush tool (it should already be soft, small, and white), paint over the white of his eye and the inside of his iris, but avoid the dark ring around the outside of the iris (that should stay dark, and so should the pupil). If you make a mistake, switch your Foreground color to black and paint your mistake away. When it looks good, lower the Opacity of this layer to around 50% (as shown here).

STEP 14:

Our final step is to apply some sharpening. We can apply not only a lot more sharpening to men (accentuating a man's skin texture usually looks good, whereas with women's skin, you want to avoid it), but you can apply it directly to the full-color image (rather than to the Red channel only, like we do with women). So, create another merged layer, then go under the Filter menu, under Sharpen, and choose **Unsharp Mask**. When the dialog appears: for Amount, enter 90%; for Radius, enter 1.5; for Threshold, enter 3; and then click OK to give you the final image you see on the opening page of this chapter.

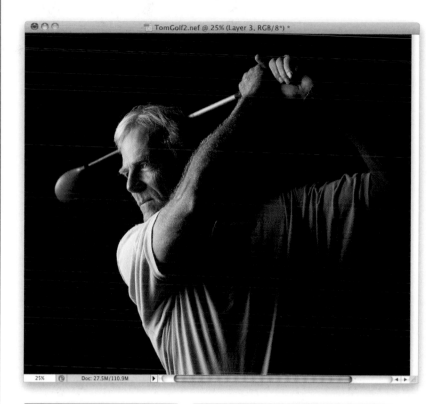

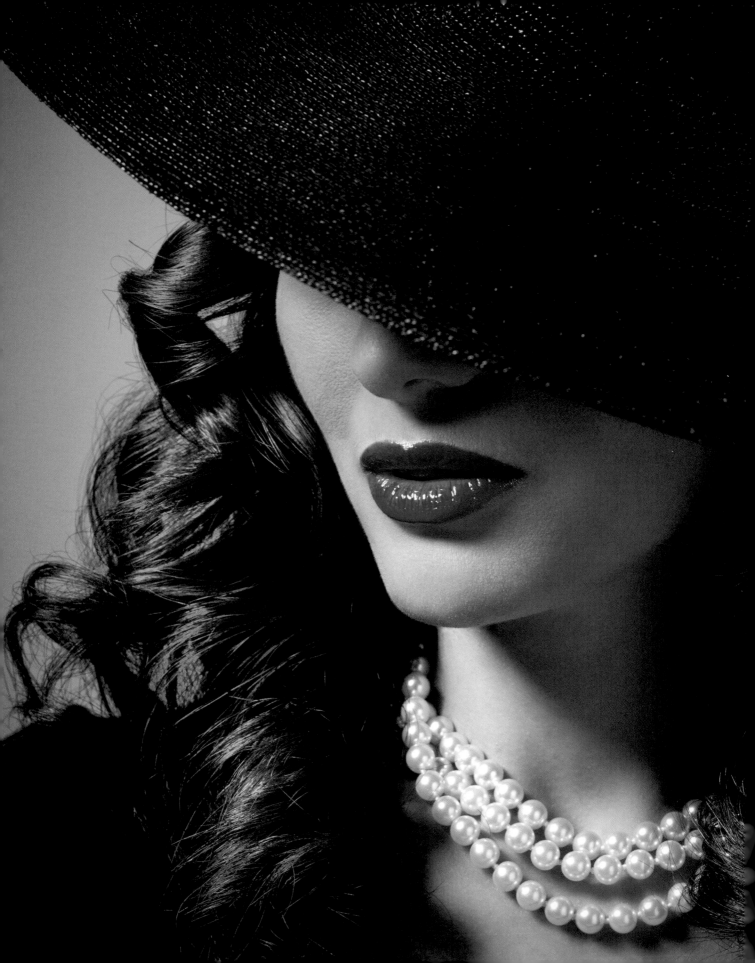

2-LIGHT BEAUTY SETUP
1940s Hollywood-Style Lighting

UNEDITED PROOFS

THE SETUP

For this 1940s-style look, it's a two-light setup, using a beauty dish up close to your subject, but aiming down at a steep angle from the left, and a strobe to light the background. To get this lighting effect on your subject, you want to make sure you place the main light high enough to have the brim of the hat cast a shadow over her face.

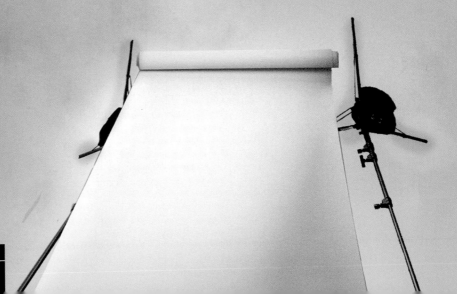

GEAR GUIDE

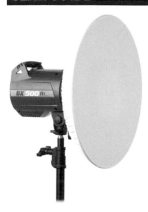

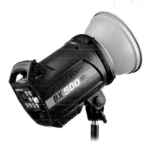

MAIN STROBE: 500-watt unit with 17" beauty dish reflector and diffusion sock

BACKGROUND STROBE: 500-watt unit with 7" reflector

MAIN STROBE'S POWER SETTING: 4.3

BOTTOM STROBE'S POWER SETTING: 2.3 (its lowest setting)

CAMERA SETTINGS

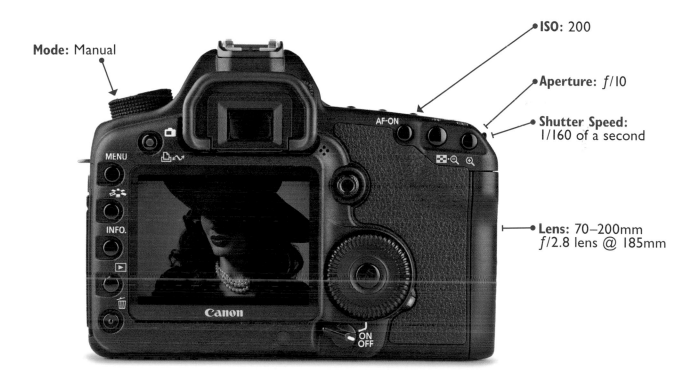

Mode: Manual

ISO: 200

Aperture: f/10

Shutter Speed: 1/160 of a second

Lens: 70–200mm f/2.8 lens @ 185mm

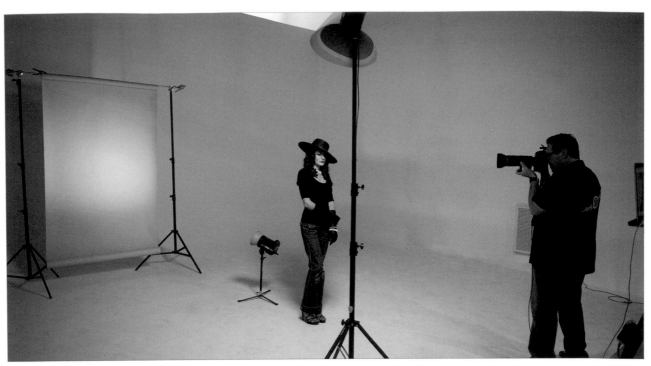

FRONT VIEW: You can see how high and steep the angle is for our main light. It's a strobe with a beauty dish, and I added the diffusion sock so the light wasn't quite as punchy. Also, if you look, you'll notice that I'm not positioned directly in front of the subject—I'm off to the right side a bit, so her face is partially obscured by the brim of the hat.

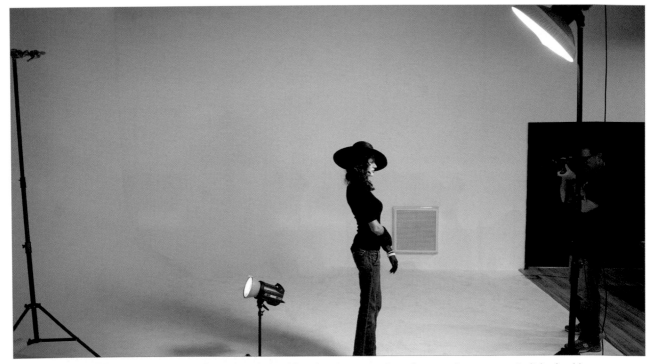

LEFT SIDE: We're using white seamless paper behind her, but because it's so far away from our main light (and because our light is aiming down at such a steep angle), the light from the beauty dish isn't hitting the background. So, you're going to have to add a background light, at a low setting, and aim it at the seamless, or it will become very dark gray or black.

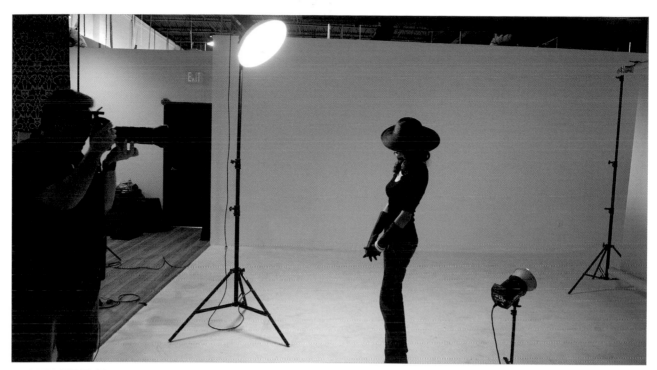

RIGHT SIDE: Here, you can see how steep the front light is, and how far away from the background the background light is positioned (the closer you place the background light to the seamless paper, the more defined the circle of light will be. By moving it back farther like this, it just gives a nice wash of light to create a medium-to-light gray background).

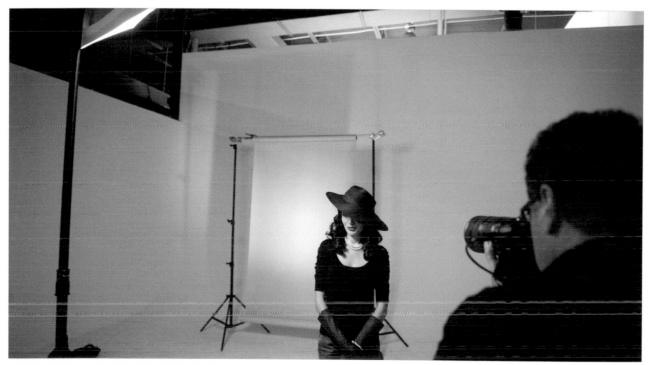

OVER-THE-SHOULDER VIEW: Here, you can see how far off to the side I'm standing. When I stood directly in front of her, I could see her eyes clearly, so to hide both and just see her nose and lips, I had to shoot from the side. Why not just turn the subject sideways? Because then we'd have to move the lighting—it's easier to move the photographer.

THE POST-PROCESSING

For this image, the post-processing is pretty straightforward, but if you want to go from a 1940s Hollywood-style look to more of a dark, film noir style, I went ahead and included a fun little effect you can pull off when you're done with the basic retouch. The effect reminds me of the old detective movies, and ideally, I would have her in long black gloves, holding one of those elegant long cigarette holders (like the one in that famous photo of Audrey Hepburn), but then I'd get letters complaining that I'm promoting smoking, so we'll just roll with this.

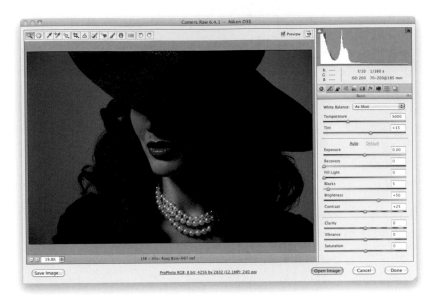

STEP ONE:
Here's the original image opened in Camera Raw, and to me it looks a little dark (although I like the way the background looks, with that round glow from the background light at a low power setting hitting the white seamless to create a medium gray background). The problem is that, if we brighten things up, it's going to brighten the background, too, but it needs to be done, so we'll deal with the background later.

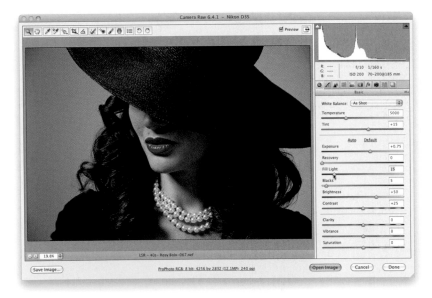

STEP TWO:
Let's start by increasing the overall exposure. Drag the Exposure slider to the right to brighten things up (I dragged it over to +0.75). Also, while we're here, to bring out the details in the hat and her hair, let's go ahead and bring up the Fill Light amount, too (I dragged it over to 15), to give us the look seen here.

STEP THREE:

At this point, there are two other tweaks that I think we can do here that will give us a much better starting place when we get over to Photoshop: (1) we need to darken the highlights on her hat (it was the closest thing to the light, and even though it's black, you don't want those highlights to pull any attention away from her face), and (2) we'll bring out the highlights in her hair. Let's start with her hair: Get the Adjustment Brush **(K)** from the toolbar, and over in the Adjustment Brush panel, click the + (plus sign) button to the right of the Exposure slider twice to reset the other sliders to 0, and set the Exposure slider to +1.00. Now, take the brush and paint over the highlights in her hair (as seen here) to really bring them out.

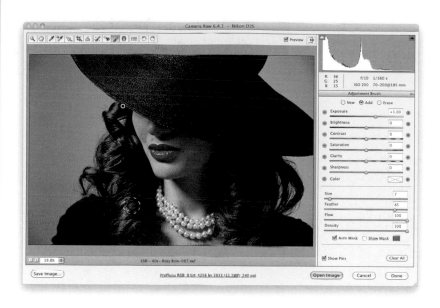

STEP FOUR:

Next, let's make a separate adjustment on the hat. Click the New radio button at the top of the panel, then click the – (minus sign) button to the left of the Exposure slider twice (so it reads 1.00). Now, take the brush and paint over the front of her hat to darken those highlight areas (as seen here). That's really all we need to do here in Camera Raw, so just click the Open Image button to open the photo in Photoshop.

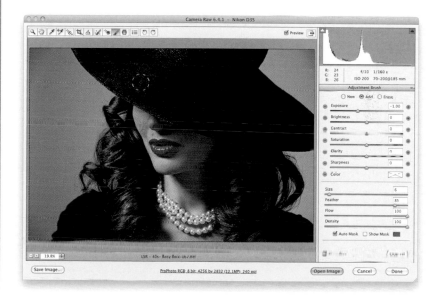

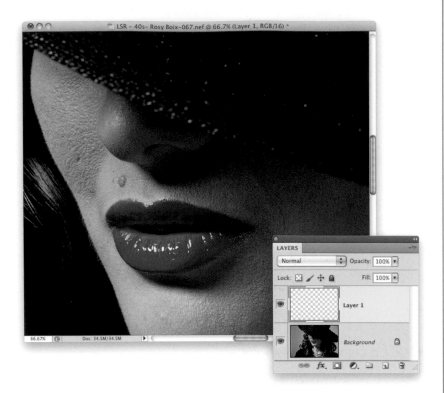

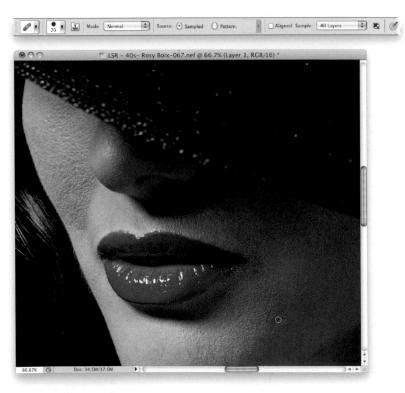

STEP FIVE:

Go ahead and zoom in tight on her face, so we can do some minor retouching. There are just a few blemishes on her cheek, and she has a beauty mark above her lip. The beauty mark is a tough call, because if you're shooting a professional model, it could be part of their trade-mark look (just ask Cindy Crawford or Erin Wasson), or if it's just a really prominent part of any subject's face, removing it would call more attention to it from their friends and family. In this case, we're going to remove it, because so much of the focus is on that immediate area of her face, but just keep this in mind when you're retouching. Click on the Create a New Layer icon at the bottom of the Layers panel to create a new layer (just in case you change your mind later).

STEP SIX:

Now, let's remove any blemishes and/or little wrinkles. Get the Healing Brush tool (press **Shift-J** until you have it) and set the Sample pop-up menu in the Options Bar to **All Layers.** Then, Option-click (PC: Alt-click) in a clean area nearby the blemish you want to remove, make your brush size slightly larger than the blemish you want to remove, then move your brush cursor over the blemish and just click once to remove it. Go ahead and spend a few minutes removing blemishes from the face (as shown here, where I just removed one on her jaw line), along with any wrinkles. Remember, these changes are on their own separate layer, so if you change your mind about her beauty mark, you can just erase over your healing. Now, let's create a merged layer (a new layer that looks like a flat-tened version of your image) by pressing **Command-Option-Shift-E (PC: Ctrl-Alt-Shift-E)**.

STEP SEVEN:

While we're in tight, working on her face, we can make her lips a little shinier with this trick: Go under the Select menu and choose **Color Range**. When the dialog appears, from the Select pop-up menu up top, choose **Highlights**, and click OK to load the highlights in the photo as a selection (as seen here). You can see some highlights on her chin, on top of, beside, and on her lips, and some scattered on her cheek, as well.

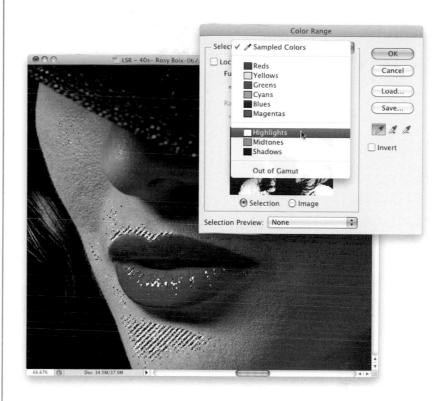

STEP EIGHT:

Press **Command-J (PC: Ctrl-J)** to put these selected highlights up on their own separate layer. Then, change the blend mode of this highlights layer to **Screen** to make it really bright. The highlights are much brighter now, but of course, we only want the highlights on her lips brighter, so we'll have to hide this brighter Screen layer behind an inverted layer mask, and just paint it on right over her lips. To do that, press-and-hold the Option (PC: Alt) key and click on the Add Layer Mask icon at the bottom of the Layers panel. This puts that Screen layer behind a black layer mask. Get the Brush tool **(B)**, choose a medium-sized, soft-edged brush, make sure your Foreground color is set to white, and paint over her lips to make the highlights in them brighter, which makes them look shinier. It's not a night-and-day difference on this particular image, but since it just takes a few seconds, it's definitely worth doing.

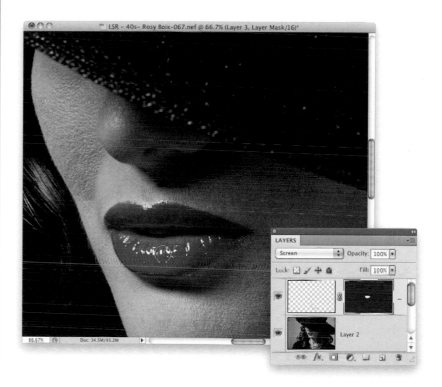

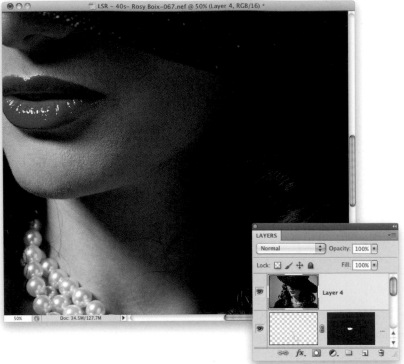

STEP NINE:
Let's see where we stand when we zoom back out a little. I think the next thing we need to do here is to remove all of the little stray hairs on her neck, and on the right side of her face. So, create another merged layer (as seen here).

STEP 10:
Get the Spot Healing Brush (**J**), choose a small brush size, and start tracing over those small stray hairs (remember, with the Spot Healing Brush, you don't have to Option-click to sample an area—it does it automatically. This seems to work pretty well when removing stuff like stray hairs, because it makes use of CS5's Content-Aware Fill, but for more detailed stuff, I think the regular Healing Brush, where you get to choose the spot it samples from, works best). Also, while you're here, get rid of any wrinkles or blemishes on her neck (as seen here), and if you need to remove any tiny hairs, or anything that touches the edge of her face, switch to the Clone Stamp tool (**S**), because the Spot Healing Brush will smudge when it touches an edge.

STEP II:

If you zoom in a bit closer, you'll see we should probably add a little skin softening at this point. We're just going to do a little bit of softening, because we absolutely want to avoid that "plastic skin" look and make certain we retain a decent amount of her skin texture. Because we're photographers (and not high-end retouchers, who dedicate hours to creating perfect skin), we're going to use the quick softening technique we used in Chapter 8. While this technique does blur the skin a little bit, it avoids losing all the texture and the result looks very natural. Start by pressing Command-J (PC: Ctrl-J) to duplicate the current layer.

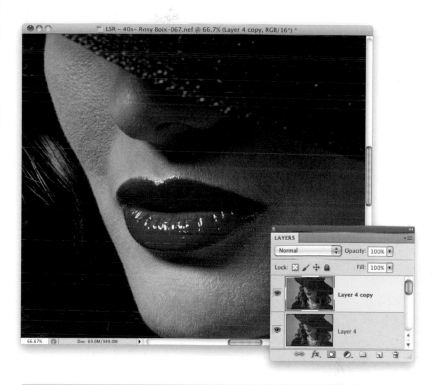

STEP 12:

Go under the Filter menu, under Blur, and choose **Gaussian Blur**. When the dialog appears, enter 20 pixels and click OK. Now, go to the Layers panel and lower the layer's Opacity to 50% (I use 50%, which is a very high setting, just as a starting point because it makes it easier to see the softening as you paint it back in).

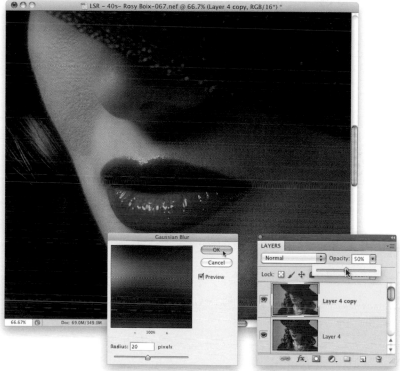

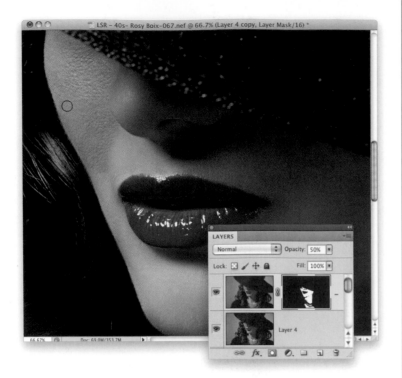

STEP 13:

Press-and-hold the Option (PC: Alt) key and click on the Add Layer Mask icon at the bottom of the Layers panel. This puts a black layer mask over your 50% blurry layer, and hides it from view. Now, make sure your Foreground color is set to white, get the Brush tool again, choose a small, soft-edged brush, and start painting over her skin. Be careful to avoid anything that should stay perfectly sharp, like her lips, nostril openings, hair, eyes, eyebrows, eyelids, the edges of her face and nose, and her pearl necklace. As you paint, it applies the softening to those areas.

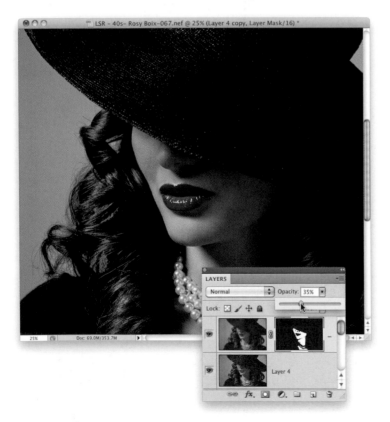

STEP 14:

Once you're finished painting, you'll need to lower the Opacity of this blurry layer until you find that sweet spot where the skin looks softer, but you can still clearly see skin texture. My first starting point is to lower it to 35% (as shown here), and see how that looks. With some subjects, you'll be able to go as low as 20%, and with others, you'll have to raise it up to 40%—it just depends on the subject. For what we'll need to do next, go ahead and create a new merged layer.

STEP 15:

We lost part of our nice background "halo" lighting when we brightened up the entire image in Step Two, so let's not only bring that back, but also enhance it for dramatic effect by adding a strong edge vignette around the image. Go to the Filter menu and choose **Lens Correction**. When the dialog appears (seen here), click on the Custom tab near the top right, then go to the Vignette section, and drag the Amount slider (which determines how dark the edges will be) almost all the way to the left (here, I dragged it over to –96), then drag the Midpoint slider (which determines how far in toward the center of the photo that darkening will extend) to the left, until everything is darkened but her face (in this case, I dragged over to +25). Click OK to apply this darkened edges effect to the image.

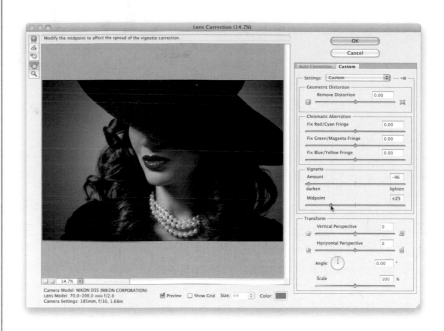

STEP 16:

When you do a very heavy darkening of the edges like we just did, sometimes it can make the overall image look a bit too dark. If that happens (like I think it did a little bit here), add a Levels adjustment layer on top (click on the Levels icon in the Adjustments panel—the second icon in the top row), and then drag the white highlights slider to the left (as shown here) to brighten the overall exposure. If you look at the histogram in the Levels options, you can see the right side of it (the part where the highlights are represented) is flat, so we can increase the highlights without worrying about clipping the highlights at all. That completes the image you see on the opening page of this chapter, but now, let's look at an optional set of steps to give your image that dark, noir, old detective movie look.

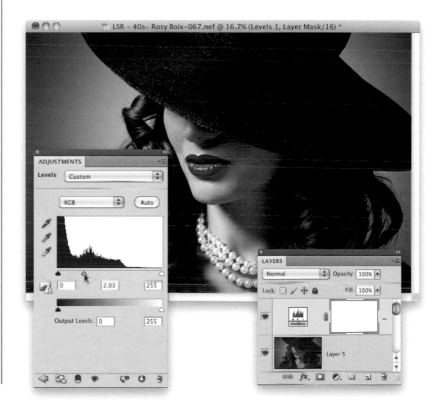

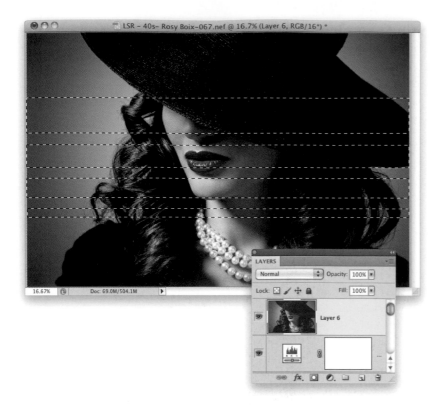

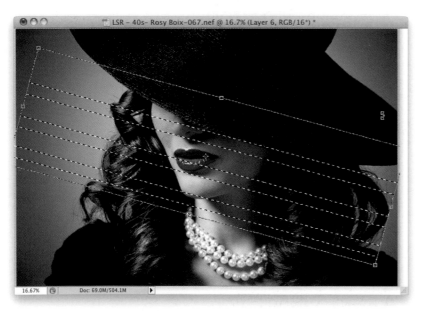

STEP 17:

Start by creating a new merged layer at the top of your layer stack, then get the Rectangular Marquee tool **(M)**, and draw a series of horizontal rectangles across the image, right across her face, that extend all the way from the left side of the image to the right (like the ones you see here). After you draw one rectangle, press-and-hold the Shift key to add more rectangles. Once you've got them in place, we're going to rotate just the selections themselves.

STEP 18:

To do this, we can't use Free Transform, or it would actually rotate rectangular chunks of the image. Instead, we'll use a Free Transform–like function that was designed just for transforming selections. Go under the Select menu and choose **Transform Selection**. A bounding box will appear around your selections (just like the Free Transform bounding box), so move your cursor outside it, and your cursor will change into a two-headed arrow. Now, click-and-drag to rotate your rectangular selections (as shown here). You might have to grab the corner of your window and drag it out to expand the area enough to see the transform handles. The shortcut is to press **Command-0** (zero; **PC: Ctrl-0**), and the window will resize automatically so you can reach all the handles. Once the rectangles are rotated, you can see that they stop before they reach the outside edges of the image, but we need them to extend all the way across.

STEP 19:

To extend your selections, grab the right-center handle and stretch them right off the image area (out onto that gray canvas area that surrounds your image area), until they fully extend off the right side of your image. Then, grab the left-center handle (as shown here) and drag them off the left side of the image area. When they're stretched so they fully go from side-to-side in your image, press the **Return (PC: Enter) key** to lock in your transformation. Now, let's soften the edges of these selections, because we're going to make them look like beams of light shining through the shades on the detective's office window. Go under the Select menu, under Modify, and choose **Feather**. When the Feather Selection dialog appears, enter 40 pixels and click OK.

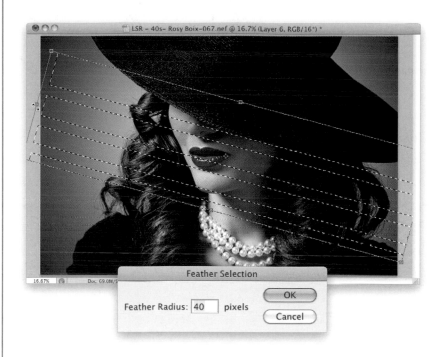

STEP 20:

Click on the Levels icon in the Adjustments panel (or choose Levels from the Create New Adjustment Layer icon's pop-up menu at the bottom of the Layers panel) and, as soon as it appears, since you already had selections in place when you chose it, it automatically creates a layer mask out of your selections. To brighten those selected areas, so they look like beams of lights, go to the Levels options in the Adjustments panel, and drag the gray midtones slider to the left to give you the effect you see here (I dragged mine to 2.03). We're not done yet, though.

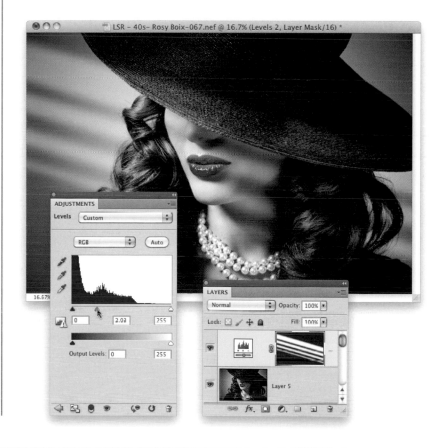

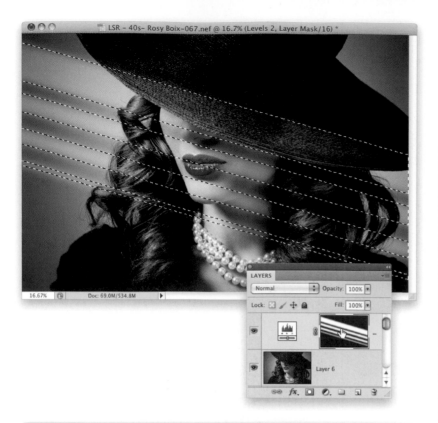

STEP 21:
We need to get those same selections back again, so press-and-hold the Command (PC: Ctrl) key and click directly on the layer mask for your Levels adjustment layer (as shown here), and it reloads your selections into place.

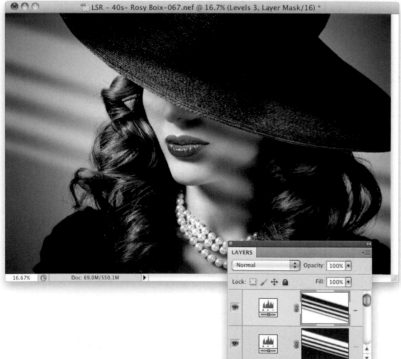

STEP 22:
Now, let's add another Levels adjustment layer, and once again, it will appear with your selections converted into a mask. However, we want to use this mask not to brighten the beams of light, but to darken the rest of the image. So, press **Command-I (PC: Ctrl-I)** to Invert the layer mask, so that changes we make in the Adjustments panel will affect everything but those bright beams of light.

STEP 23:

Go to the Adjustments panel, but this time, drag the gray midtones slider to the right (as shown here), which darkens the areas surrounding the bright beams of light (you can drag it to however dark you want to make the rest of the image. I dragged mine here to 0.53). However, there is one issue: when you make a Levels move like this, because it's over a flesh tone area like her face, it's not just going to make things darker or brighter, it's also going to change their tone a bit (look how orange her skin looks now in the dark shadow areas to the left of her nose and to the lower right of her lips).

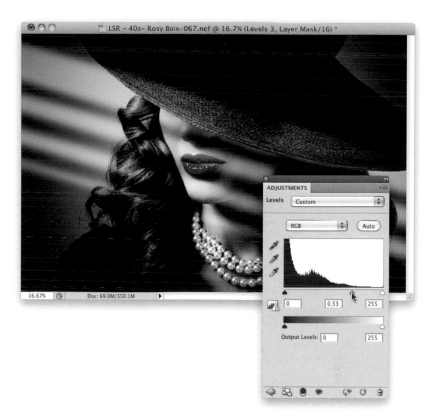

STEP 24:

We can greatly reduce that orangey, burnt-skin look by changing the blend mode for both of these adjustment layers from Normal to **Luminosity** (as shown here). That's all there is to it. Again, this isn't the final image that wound up at the beginning of this chapter (that was the image you saw in Step 16), but I hope you enjoyed this extra optional little effect we applied here at the end.

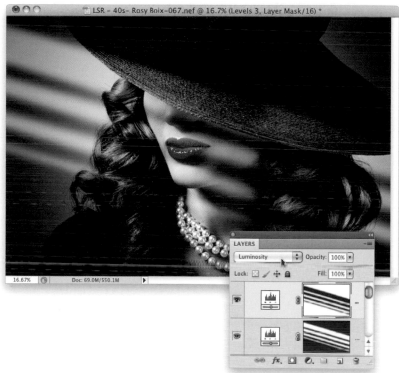

IF YOU USE HOT SHOE FLASH INSTEAD...

...then you're in luck, because there are hot shoe flash versions of nearly all the softboxes and accessories I use here in the book (and by "hot shoe flashes," I mean external flash units that can be used off-camera, like Nikon's SB-900 or Canon's 580EX II, etc.). So, for this chapter, I reshot all the overhead images showing how you'd use hot shoe flashes, softboxes, and accessories to get the same looks shown in each of the previous chapters. Now, while the Elinchrom softboxes that I use are pretty much strictly used with strobes, companies like F. J. Westcott make all sorts of stuff designed specifically for use with hot shoe flashes. At the end of this chapter, I included a gear guide that lists all the hot shoe flash equipment and accessories I use, so you have a reference with the actual makes and models. One last thing: since most people seem to use the PocketWizard Plus II wireless transmitters and receivers with their hot shoe flashes, I used those for these overhead shots, as well.

CHAPTER ONE

3-Light Classic Beauty Setup:
Clamshell Lighting

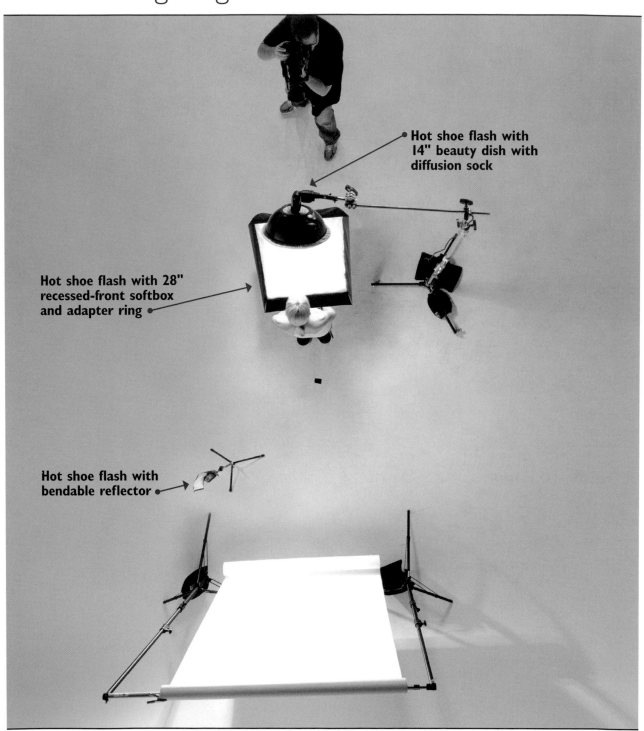

Hot shoe flash with
14" beauty dish with
diffusion sock

Hot shoe flash with 28"
recessed-front softbox
and adapter ring

Hot shoe flash with
bendable reflector

If You Use Hot Shoe Flash Instead…

CHAPTER TWO

2-Light Edgy Setup:
High-Contrast Lighting

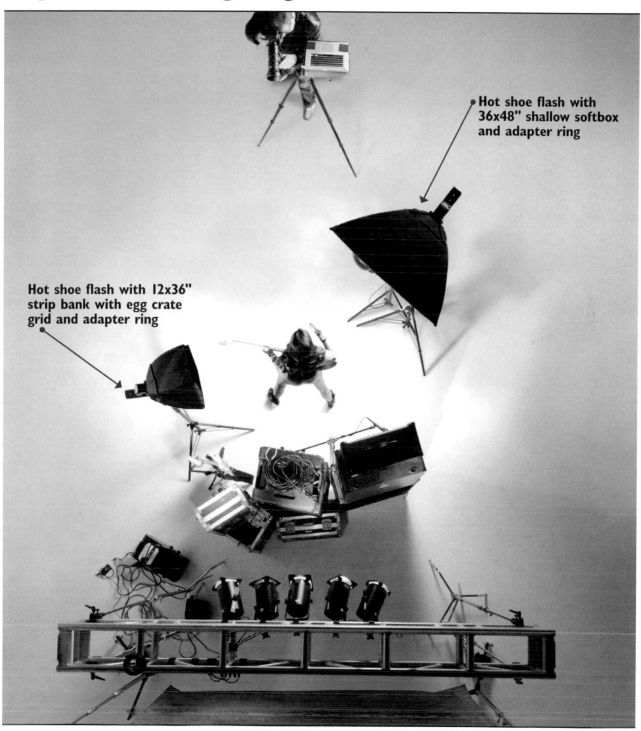

Hot shoe flash with 36x48" shallow softbox and adapter ring

Hot shoe flash with 12x36" strip bank with egg crate grid and adapter ring

CHAPTER THREE

2-Light Dramatic Setup:
Dramatic Glamour Lighting

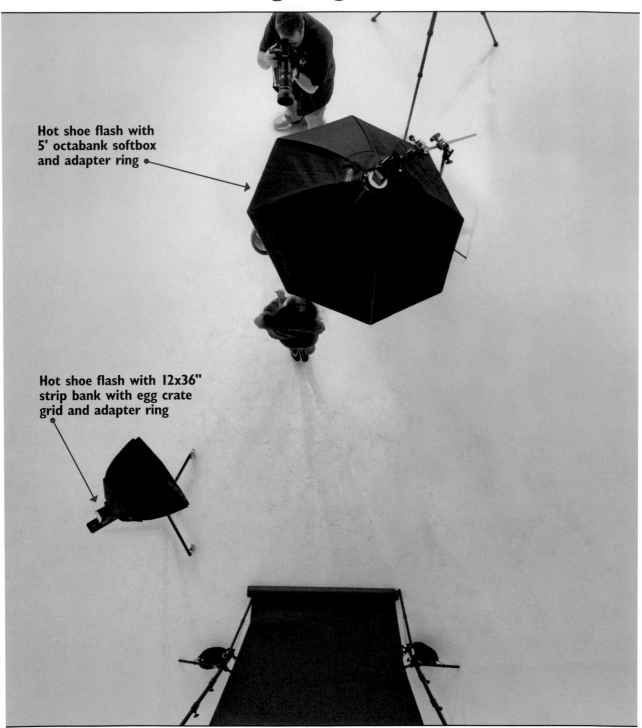

Hot shoe flash with
5' octabank softbox
and adapter ring

Hot shoe flash with 12x36"
strip bank with egg crate
grid and adapter ring

CHAPTER FOUR

3-Light Lens Flare Setup:
Lens-Flare Lighting

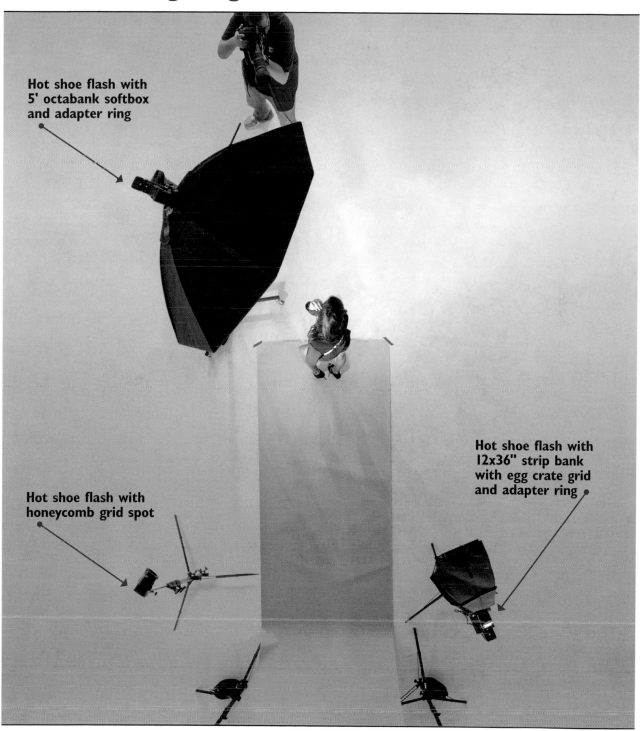

Hot shoe flash with 5' octabank softbox and adapter ring

Hot shoe flash with 12x36" strip bank with egg crate grid and adapter ring

Hot shoe flash with honeycomb grid spot

1-Light Ring Flash Setup:
Using Ring Flash for Fashion Lighting

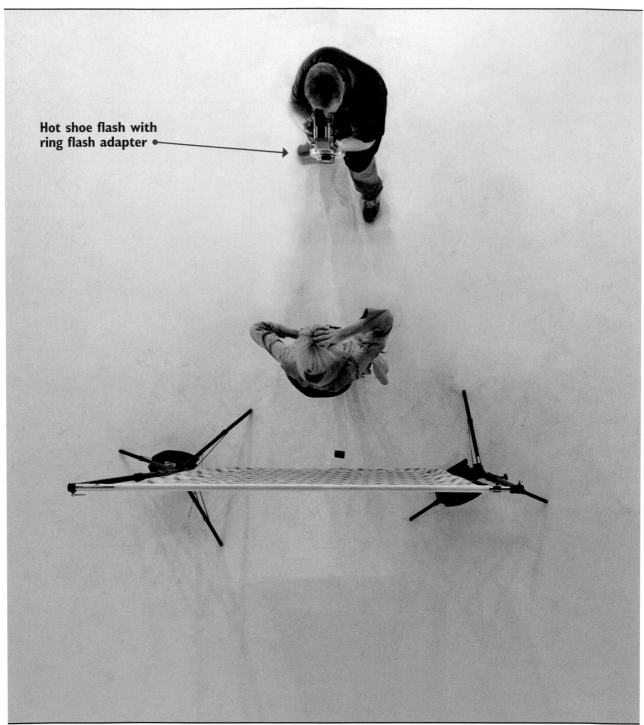

Hot shoe flash with
ring flash adapter

If You Use Hot Shoe Flash Instead...

CHAPTER SIX

3-Light Sports Setup:
Edgy Lighting

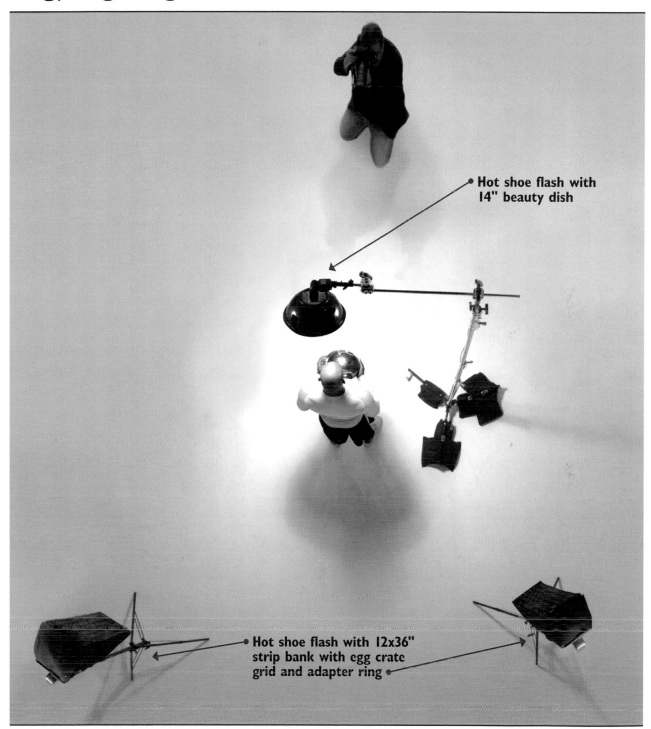

Hot shoe flash with 14" beauty dish

Hot shoe flash with 12x36" strip bank with egg crate grid and adapter ring

1-Light Full-Length Fashion Setup:
Full-Length Fashion Lighting

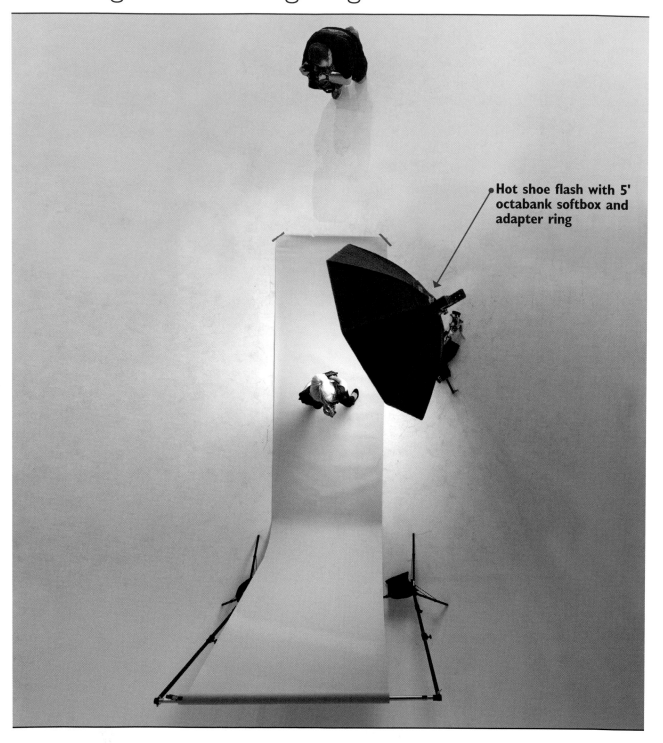

Hot shoe flash with 5' octabank softbox and adapter ring

CHAPTER EIGHT

1-Light Home Interior Setup:
Soft Glamour Lighting

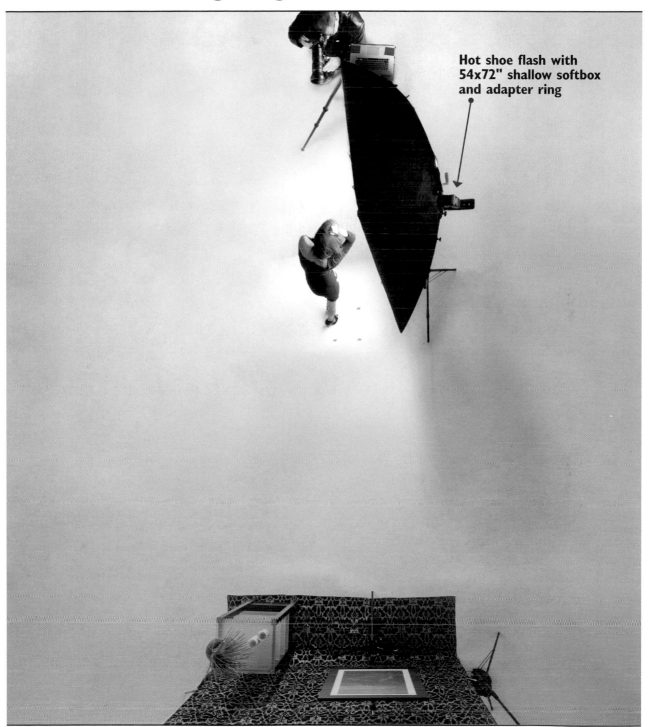

**Hot shoe flash with
54x72" shallow softbox
and adapter ring**

2-Light On-Location Fashion Setup:
Fashion Side Lighting

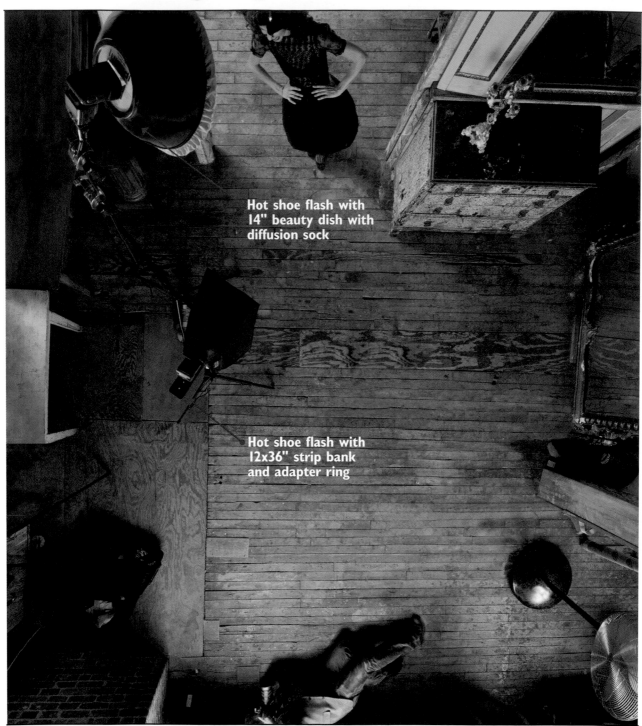

Hot shoe flash with
14" beauty dish with
diffusion sock

Hot shoe flash with
12x36" strip bank
and adapter ring

If You Use Hot Shoe Flash Instead...

CHAPTER TEN

4-Light Sports Composite Setup:
Lighting for Compositing

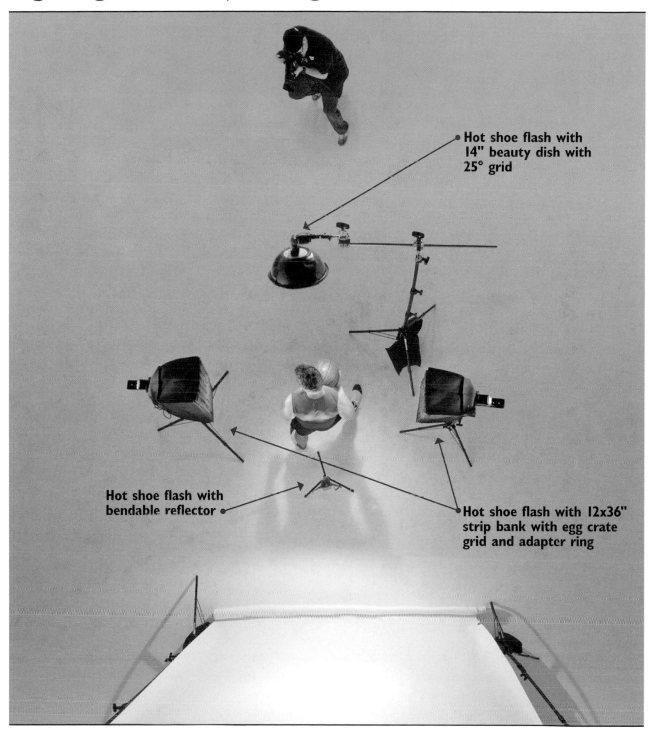

Hot shoe flash with 14" beauty dish with 25° grid

Hot shoe flash with bendable reflector

Hot shoe flash with 12x36" strip bank with egg crate grid and adapter ring

1-Light Dramatic Setup:
Dramatic Side Lighting

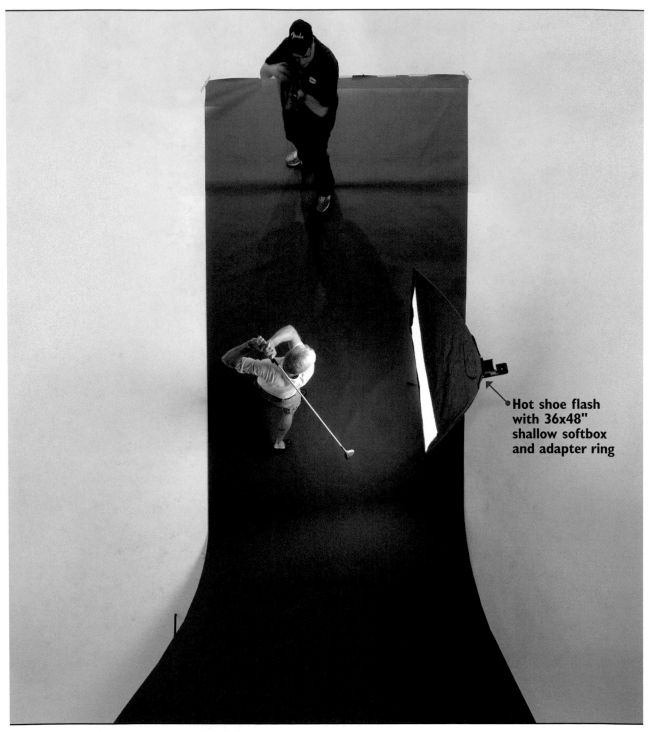

Hot shoe flash with 36x48" shallow softbox and adapter ring

2-Light Beauty Setup:
1940s Hollywood-Style Lighting

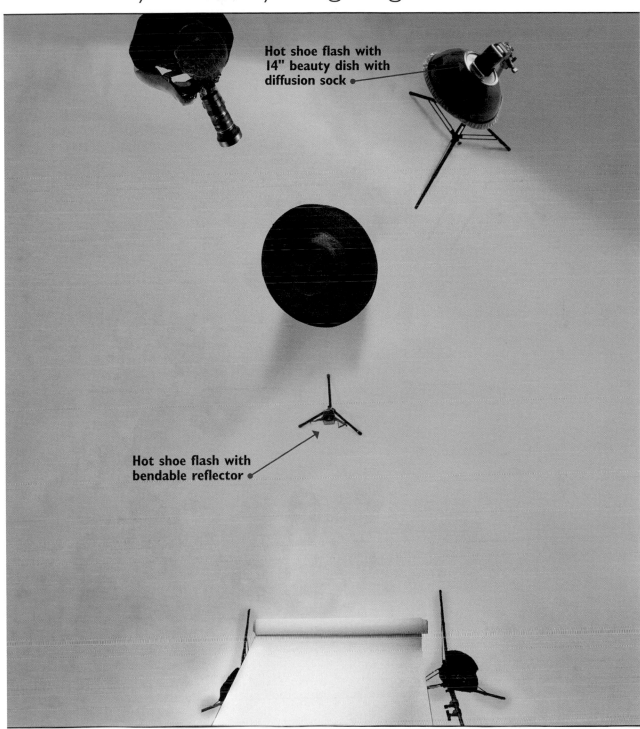

Hot shoe flash with 14" beauty dish with diffusion sock

Hot shoe flash with bendable reflector

GEAR GUIDE

HOT SHOE FLASHES:

SOFTBOXES:

Nikon SB-900 AF Speedlight

Westcott 12x36" Strip Bank

Westcott 36x48"
Shallow Softbox

SOFTBOXES:

Westcott 54x72"
Shallow Softbox

Westcott 28" Recessed
Front Apollo Softbox

Westcott 5'
Octabank Softbox

GEAR GUIDE

SOFTBOX ACCESSORIES:

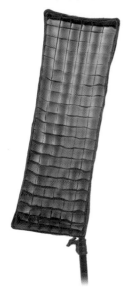

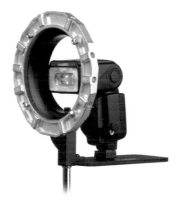

Westcott 40° Egg Crate Grid
*(used to narrow the beam of light
and make it more directional)*

Westcott's Magic Slipper
*(used to attach a hot shoe
flash to a Westcott softbox)*

BEAUTY DISH: BEAUTY DISH ACCESSORIES:

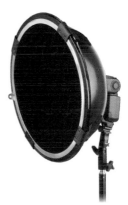

Lumodi 14" Speedlight
Beauty Dish

Lumodi Speedlight Beauty
Dish Softlight Diffusion Sock
*(used to soften the light, while
still keeping it punchy)*

HoneyGrids Lumodi 14"
25° Beauty Dish Grid *(used
to narrow and focus the light)*

GEAR GUIDE

RING FLASH:

FLASH MODIFIERS:

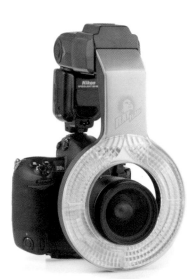

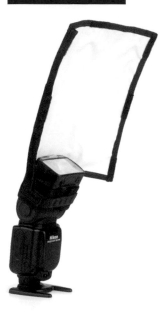

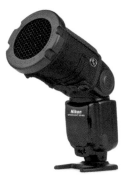

ExpoImaging Ray Flash Ring
Flash Adapter

ExpoImaging Rogue FlashBender
*(used to control and direct the light
through flexible positioning)*

ExpoImaging Rogue 3-in-1
Honeycomb Grid *(used to
narrow and focus the light)*

TRANSMITTER:

PocketWizard Plus II
radio transceiver

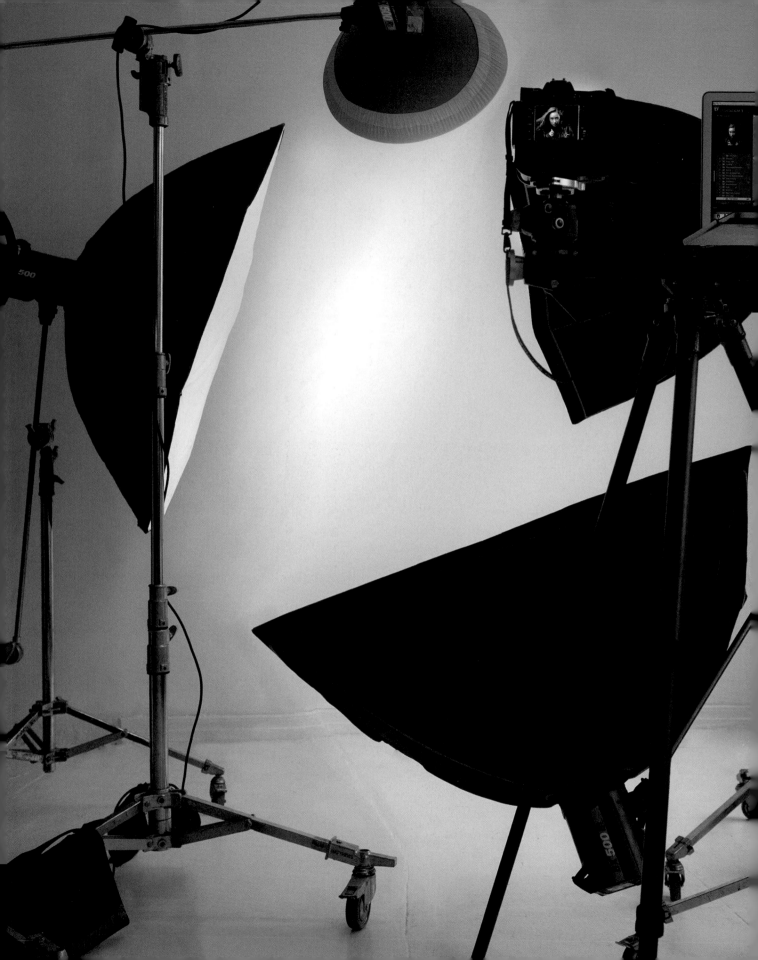

GEAR GUIDE

As I mentioned in "11 Things You'll Wish You Had Known Before Reading This Book" at the beginning of the book, I kept the chapter Gear Guides pretty generic, because you don't need to use the same gear I use to do any of the shoots in the book. But, since I use a lot of different gear throughout the book, I thought you might find it helpful if I included this Gear Guide with the exact make and model of each light, softbox, and accessory that I used in each shoot. That way, you have an easy reference, in case you want to find out more about a particular piece of gear I used.

Now, what you'll find here is just the gear I used in each chapter's shoot here in the book. If you want to look at all my camera gear (bodies, lenses, tripods, filters, and so on), just visit my daily blog at www.scottkelby.com and click the My Gear link found on the left side of the page. If you want to keep up with the latest gear I'm using, you can follow me on Twitter at www.twitter.com/scottkelby or on Facebook at www.facebook.com/skelby.

GEAR GUIDE

CAMERA AND LENSES:

Nikon D3s DSLR camera with Nikon AF-S
Nikkor 70–200mm f/2.8G ED VR II Lens

Nikon AF-S Nikkor 24–70mm
f/2.8G ED Lens

STROBES: ### CONTINUOUS LIGHTS:

Elinchrom BXRi 500
compact flash unit

Westcott Spiderlite TD6 Light Head
with Tilter Bracket and 6 Westcott
50-Watt Daylight Fluorescent Lamps

GEAR GUIDE

SOFTBOXES:

Elinchrom Rotalux
27x27" Softbox

Elinchrom Rotalux
39x39" Softbox

Elinchrom Rotalux
39" Deep Octa Softbox

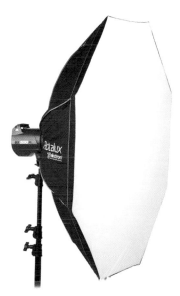

Elinchrom Rotalux 53" Midi
Octa Softbox

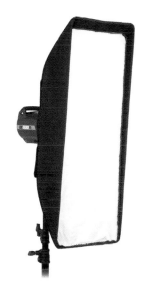

Westcott 12x36"
Strip Bank

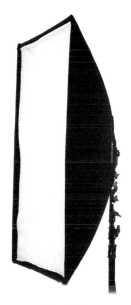

Westcott 36x48"
Shallow Softbox

SOFTBOXES:

SOFTBOX ACCESSORIES:

Westcott 54x72"
Shallow Softbox

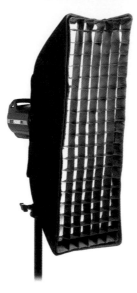

Westcott 40° Egg Crate Grid
*(used to narrow the beam of light
and make it more directional)*

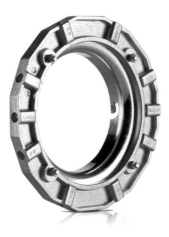

Westcott's Elinchrom Adapter
Ring *(used to attach an Elinchrom
strobe to a Westcott softbox)*

REFLECTOR:

REFLECTOR ACCESSORIES:

BEAUTY DISH:

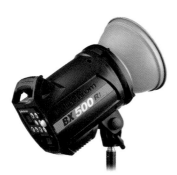

Elinchrom 7"
Grid Reflector

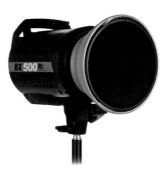

Elinchrom 7" 20° Grid
*(used to narrow the beam
of light; the lower the degrees,
the narrower the beam)*

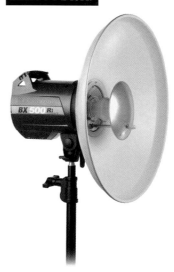

Elinchrom 17" Softlite
80° White Reflector

GEAR GUIDE

BEAUTY DISH ACCESSORIES:

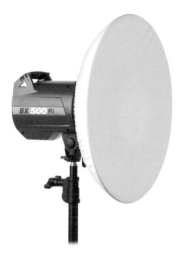

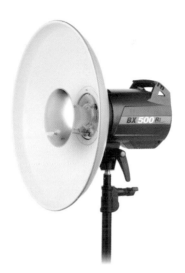

Elinchrom 17" Diffuser
(used to soften the light, while still keeping it punchy)

Elinchrom 5.5" Silver Deflector
(used to eliminate, soften, and tone sharp edges on shadows)

HoneyGrids Elinchrom 44cm Softlite 25° Grid
(used to narrow and focus the beam of light)

RING FLASH: TRANSMITTER:

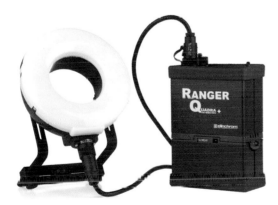

Elinchrom Ranger Quadra Ringflash ECO with Elinchrom Ranger Quadra RX battery pack

Elinchrom EL-Skyport Transmitter SPEED

GEAR GUIDE

HAIR FAN:

BLOWiT Personal Cooling System
(http://blowitfans.com)

APPLE BOX:

Matthews Apple Box –
Full – 20x12x8"

BACKGROUNDS:

Pasha Modern Vintage
Background from F.J. Westcott

Modern Platinum Cloth PC513
Background from Background
Outlet

FlexTex® Brick Background
from Denny Manufacturing

Index

W

Z